

lin, John
yth, Sophia
dway, Ralph
dway, Marie
yle, Teresa
ggins, Michael
odward, Chas.
ith, Frank
ith, Mary Ann
ith, Mary
gg, Stewart
th, Harold
ns, Louis
ns, George
ughderty, Marg't
ugherty, Jennie
es, Evan
es, Harriet Celia
es, Sallie
naghan, Michael
dwin, Harry
dwin, Samuel John
wford, Thomas
wford, William
bert
dy, Mary
yes, Robert
lan, James
gren, Katherina
nnan, Patrick
lly, John
llywood, Peter
kes, Albert Edward
ge, Edward
ssane, Michael
san, Patrick
gers, Margaret
nt, Walter
nagan, Paddie
Nally, Michael
cter, Jessie
stron, James
Keown, Rebecca
Keown, Vincent
tzman, Brandel
tzman, Scheindel
tzman, Simon
cker, Elka
cker, Sloima
cker, Sura
cker, Alter
ing, Hersch
ing, Basha
ing, Clara
ing, Elka
ing, Sloma
dstein, Blima
dstein, Yetta
dstein, Baile
dstein, Mary
dstein, Morris
dstein, Kiwe
dstein, Rivika
rmacher, Laja
rmacher, Hinde
rmacher, Chiel
ver, Sara
ver, Herzil
ver, Nuta
ver, Feige
lbrill, Nathan
gel, Chaja
onsky, Golda
zario, Scanzano
mico, Nicola
mico, Michele
rtolotti, Giuseppe
nti, Rafaele
cente, Domenico
cale, Giovanni
cca, Antonio
tella, Giuseppe
ssat, Felix
ll, Luillansue
fe, Eisik
Lams, Jean
tzler, Nikolaus
toniak, Michele
nzink, Adam
sik, Jean
ghide, Giuseppe
sa, Giambatisto
ller, Louis
hler, Joseph
derick, Albert
rny, Franz
telli, Gerolomo
nodaks, Antoni
rics, Ysioko
fi, Rudolf
pp, Yanos
al, Istran
ik, Ferencz
lares, Guilherme
lares, Maria L.
pes, Adelio
pes, Mary S.
mpbell, John Reid
mpbell, Helen
mpbell, Jean
Knight
rne, John J
nandez, Victor
nandez, Inocencia
nandez, Matilde
nandez, Noemia
nandez, Ermelindo
eed, Frank O.
az Gomez, Angel
oreira, Thiers V.
enezes, Rodrigo
Paulo R.
labrini, Lino
sasanta, Donato
Long, Johannes

Column 2

Gizi, Vincenzo
Leombrumo, Luigi
Pronuto, Costanzo
Prizzo, Pietro
Curto, Saverio
Totera, Rosina
Barbetta, Nicola
Gallo, Santo
Gallo, Carmine
Pane, Gaetano
Tallarico, Giovanni
Coppola, Domenico
Aliberti, Michele
Mancino, Salvatore
Giugliano, Aristide
Longobardi, Casello
Tortora, Aniello
Berardi, Gaetano
Muccilla, Sabatino
Imbrogno, Pasquale
Chirico, Francesco
Testa, Ferdinando
d'Angela, Giuseppe
Bentivegna, Vincenzo
Spagnoli, Antonio
Spagnoli, Giustino
Buenasorti, Gennaro
Argentieri, Francesco
Plant, Eugene
Shields, William
Earley, Roy
Lipton, Thomas
Young, Louis
Stephenson, Milton
O'Malley, John
Herzer, Pauline
Byrne, Thomas
Knudsen, David
Schofield, James
Roberts, Walter
Ingham, Frederick
Russell, John
Blackman, Thomas
Clarke, Arthur
Sheppard, Stanley
Kennedy, David
McCourt, James
Jones, Sydney
Cash, Frederick
Sanquist, Robert
Oliver, Joseph
Rice, Jack
Magliola, Salvatore
Frick, Louis
Walham, Ernest
Fendler, George
Kaliris, John
Karadimitris, Kleanthis
Loidis, Kosntantinos
Naoumis, Stefanos
Koutsoubelis, Georgios
Eleftheriou, Eragelos
Nikolaou, Hristos
Konstantinou, Ilias
Larolas, Nikolaos
Kaskaralas, Dimitrios
Matsikas, Mihail
Giantjos, Panagiotis
Liberis, Anastasios
Filitsis, Vasilios
Vlahopulos, Pantelis
Nicoloudakis, Vasilios
Mihailidis, Emanouil
Hatzialexiou, John
Liakis, George
Molalis, Dimitrios
Saralakis, Efstratios
Keravas, Panagiotis
Athanasiou, Manolis
Daout, Boutros
Michael, Ibrahim
Lamari, Salim
Esapar, Mitri
Saghir, Giorgi
Saghir, Ibrahim
Hannout, Hanna
Olson, Martin
Bjorklund, Johannes
Johnson, Otto
Birsus, H.J.
Pedersen, H.
Larsen, Malen
Helland, Ingeborg
Osgud, K.H.
Osgud, G.
Ilsan, Bertha
Bjorklund, Ellen
Berhlsen, Martin
Berhlsen, Karen
Berhlsen, Chs. J.
Ludvigsen, S.L.
Olsen, Emilia
Olsen, Ch. O.
Olsen, Ch. A.
Helland, S.
Helland, Krisi
Helland, Edward
Helland, Mikal
Helland, Karine
Helland, S.
Helland, Josefine
Helland, Lina
Olsen, Jens
Fenson, T.
Hangen, B.
Hangen, Eli
Hangen, Al...t
Gosling, H.
Ogola, Frans M.
Kason, A.
Sikta, Mikael
Svensk, Samuel
Ylikokka, Yakks
Makki, Isak
Nikkola, Frans
Kalega, Ida
Gasse, Joh
Anderson, Kaisa
Devitt, James M
Devitt, Bridget

Column 3

Sundell, Johan
Holmlund, Jakob
Nass, Johan M.
Hoglund, Matts
Kass, J.H.
Beck, Gustaf
Barbetta, Nicola
Jakobson, Simon
Napnan, Anders M.
Blank, Karl J.
Drinker, Gysber
Dame, Gertrude
Dame, Jessie
den Rooyen, Johannes
Aarts, Peter M.
Spoelstra, Wintje
Spoelstra, Hilda
Spoelstra, Jan
Spoelstra, Jennie
Spoelstra, Martha
Spoelstra, Janna A.
Tahedl, Johanna
Koch, Anna
Koch, Rudolf
Stejskal, Christina
Legenstein, Josef
Legenstein, Franz
Kotrosits, Nikolaus
Honicka, Frantiska
Korinek, Katerina
Friedman, Elias
Belemer, Jakob J.
Judelewsky, Josel
Judelewsky, Sora
Smith, Frank
Sweers, Agnes
Herzer, Pauline
Brener, Kaethi
Parrott, L.
Parrott, Cl.
Parrott, Daisy
Barber, A.
Kelbel, F.
Morris, C.
Morris, Mrs.
Claudins, C.
Steiner, Jacob
Fich, Jacob
Miller, W.S.
Miller, Mrs.
Steinhardt, C.C.
Steinhardt, Mrs.
Hahn, Y.W.
Claudins, C.A.
Peschard, Ch.
Lautrec, Toulouse
Kondziola, Anna
Kondziola, Karol
Kondziola, Max
Karadimitris, Kleanthis
Loidis, Kosntantinos
Naoumis, Stefanos
Koutsoubelis, Georgios
Kondziola, Heinrich
Konkal, Miloslaw
Konkal, Yulie
Auchli, Alois
Yosefson, Leon
Yosefson, Liza
Yosefson, Lisela
Yosefson, Hermann
Yosefson, Yacques
Nachbur, Urs
Nachbur, Albertina
Nachbur, Bertha
Nachbur, Marie
Nachbur, Paul
Hasck, Emile
De Busscher, Leonie
De Busscher, Rene
Hrzyglud, Yosef
Yudowicz, Leie
Yudowicz, Leib
Czisla, Wladislawa
Balachowski, Reise
Balachowski, Putie
Rutkowska, Marianna
Jacob Landau
Sarah Landau
Raoul Landau
Sara Berson
Morris Wilks
Ruth Landau
Abraham Tarendash
Mayer Flasker
Betty Frauendienst
Samuel Weinfeld
Hannah Rykovetzsky
Rachel Smigelsky
Rose Schwadron
Allen, Louis
Baker, Adelbert
Borkhardt, Henry
Harris, Barney
Hennig, August
Holway, Charles
Jaquith, Harold
Lyon, James
Lyon, Elinor
Maisel, Louis
Maisel, Sophia
Pickford, Helen
Pitzel, Samuel
Ruiz, Rufino
Schonthal, Lee
Schonthal, Irma
Vic, Charles
Banzhaff, Albert
Byrnes, Edward
Carr, Susan
Goadby, William
Goadby, Elsie
Eaton, Francis
Eaton, Harriett
Gibson, Ora
Hunt, William
Johnson, Aymar
Markham, Maud
Roth, Mary
Serrao, Amerigo
Devitt, James M
Devitt, Bridget

Column 4

Laughlin, Philip M
Laughlin, Mary
Doherty, Joseph
Sheils, Mary
Laughlin, Rose Ann
Laughlin, Sarah
Laughlin, Annie
Laughlin, Pat'k
Houton, Michael
Ferry, Charles
Sieyes, Bridget
Johnston, Fannie
Caul, Francis M
Robb, Joseph
Conway, Wm
Havin, Patrick
Hart, Honor
Kelly, Hugh
Mc Carthy, Alexander
Mc Quade, Annie
Faulkner, Charles
Moody, Arthur J.
Moody, Eliza
Carrigan, Annie
Giblin, John
Smyth, Patrick
Rodway, Sophia
Rodway, Ralph
Rodway, Marie
Doyle, Teresa
Higgins, Michael
Woodward, Chas.
Smith, Frank
Smith, Mary Ann
Smith, Mary
Gragg, Stewart
Smith, Harold
Evans, Louis
Evans, Polly
Evans, George
Dougherty, Marg't
Dougherty, Jennie
Jones, Evan
Jones, Harriet Celia
Jones, Sallie
Henaghan, Michael
Baldwin, Harry
Baldwin, Samuel John
Crawford, Thomas
Crawford, William
Robert
Brady, Mary
Hayes, Robert
Nolan, James
Kondziola, Anna
Billgren, Katherina
Brennan, Patrick
Reilly, John
Hollywood, Peter
Wilkes, Albert Edward
Judge, Edward
Cussane, Michael
Dolan, Patrick
Rogers, Margaret
Hunt, Walter
Flanagan, Paddie
McNally, Michael
Shecter, Jessie
Rostron, James
McKeown, Rebecca
McKeown, Vincent
Zaltzman, Brandel
Zaltzman, Scheindel
Zaltzman, Simon
Zucker, Elka
Zucker, Sloima
Zucker, Sura
Zucker, Alter
Spring, Hersch
Spring, Basha
Spring, Clara
Spring, Elka
Spring, Sloma
Goldstein, Blima
Goldstein, Yetta
Goldstein, Baile
Goldstein, Mary
Goldstein, Morris
Goldstein, Kiwe
Goldstein, Rivika
Uhrmacher, Laja
Uhrmacher, Hinde
Uhrmacher, Chiel
Silver, Sara
Silver, Herzil
Silver, Nuta
Silver, Hena
Silver, Feige
Feldbrill, Nathan
Spigel, Chaja
Jablonsky, Golda
Nazario, Scanzano
Damico, Nicola
Damico, Michele
Bertolotti, Giuseppe
Monti, Rafaelle
Valente, Domenico
Pascale, Giovanni
Rocca, Antonio
Rotella, Giuseppe
Gassat, Felix
Grall, Luillansue
Yoffe, Eisik
Le Lams, Jean
Metzler, Nikolaus
Antoniak, Michele
Kenzink, Adam
Kosik, Jean
Raghide, Giuseppe
Fossa, Giambatisto
Muller, Louis
Kohler, Joseph
Frederick, Albert
Cerny, Franz
Ortelli, Gerolomo
Conodaks, Antoni
Marics, Ysioko
Palfi, Rudolf
Papp, Yanos

Column 5

Erlik, Ferencz
Villares, Guilherme
Villares, Maria L.
Lopes, Adelio
Lopes, Mary S.
Campbell, John Reid
Campbell, Helen
Campbell, Jean
McKnight
Cirne, John J.
Fernandez, Victor
Fernandez, Inocencia
Fernandez, Matilde
Fernandez, Noemia
Fernandez, Ermelindo
Creed, Frank O.
Diaz Gomez, Angel
Moreira, Thiers V.
Menezes, Rodrigo
Vaz, Paulo R.
Scalabrini, Lino
Casasanta, Donato
Presutto, Antonio
Petrillo, Vincenzo
Gizi, Vincenzo
Leombrumo, Luigi
Pronuto, Costanzo
Prizzo, Pietro
Curto, Saverio
Totera, Rosina
Barbetta, Nicola
Gallo, Santo
Gallo, Carmine
Pane, Gaetano
Tallarico, Giovanni
Coppola, Domenico
Aliberti, Michele
Mancino, Salvatore
Giugliano, Aristide
Longobardi, Casello
Tortora, Aniello
Berardi, Gaetano
Muccilla, Sabatino
Imbrogno, Pasquale
Chirico, Francesco
Testa, Ferdinando
d'Angela, Giuseppe
Bentivegna, Vincenzo
Spagnoli, Antonio
Spagnoli, Giustino
Buenasorti, Gennaro
Argentieri, Francesco
Plant, Eugene
Shields, William
Earley, Roy
Lipton, Thomas
Young, Louis
Stephenson, Milton
O'Malley, John
Knudsen, David
Byrne, Thomas
Schofield, James
Roberts, Walter
Ingham, Frederick
Russell, John
Blackman, Thomas
Clarke, Arthur
Sheppard, Stanley
Kennedy, David
McCourt, James
Jones, Sydney
Cash, Frederick
Sanquist, Robert
Oliver, Joseph
Rice, Jack
Magliola, Salvatore
Frick, Louis
Walham, Ernest
Fendler, George
Kaliris, John
Karadimitris, Kleanthis
Loidis, Kosntantinos
Naoumis, Stefanos
Koutsoubelis, Georgios
Eleftheriou, Eragelos
Nikolaou, Hristos
Konstantinou, Ilias
Larolas, Nikolaos
Kaskaralas, Dimitrios
Matsikas, Mihail
Giantjos, Panagiotis
Liberis, Anastasios
Filitsis, Vasilios
Vlahopulos, Pantelis
Nicoloudakis, Vasilios
Mihailidis, Emanouil
Hatzialexiou, John
Liakis, George
Molalis, Dimitrios
Saralakis, Efstratios
Keravas, Panagiotis
Athanasiou, Manolis
Daout, Boutros
Michael, Ibrahim
Lamari, Salim
Esapar, Mitri
Saghir, Giorgi
Saghir, Ibrahim
Hannout, Hanna
Olson, Martin
Bjorklund, Johannes
Johnson, Otto
Birsus, H.J.
Pedersen, H.
Larsen, Malen
Helland, Ingeborg
Osgud, K.H.
Osgud, G.
Ilsan, Bertha
Bjorklund, Ellen
Berhlsen, Martin
Berhlsen, Karen
Berhlsen, Chs. J.
Ludvigsen, S.L.
Olsen, Emilia
Olsen, Ch. O.
Olsen, Ch. A.
Helland, S.

Column 6

Holland, Edward
Holland, Mikal
Holland, Karine
Holland, S.
Holland, Josefine
Helland, Lina
Olsen, Jens
Fenson, T.
Hangen, B.
Hangen, Eli
Hangen, Al...t
Gosling, H.
Ogola, Frans M.
Kason, A.
Sikta, Mikael
Svensk, Samuel
Ylikokka, Yakks
Makki, Isak
Nikkola, Frans
Kalega, Ida
Gasse, Joh
Anderson, Kaisa
Long, Johannes
Fillpus, Johan
Sundell, Johan
Holmlund, Jakob
Nass, Johan M.
Hoglund, Matts
Kass, J.H.
Beck, Gustaf
Jakobson, Simon
Napnan, Anders M.
Blank, Karl J.
Drinker, Gysber
Dame, Gertrude
Dame, Jessie
den Rooyen, Johannes
Aarts, Peter M.
Spoelstra, Wintje
Spoelstra, Hilda
Spoelstra, Jan
Spoelstra, Jennie
Spoelstra, Martha
Spoelstra, Janna A.
Tahedl, Johanna
Koch, Anna
Koch, Rudolf
Stejskal, Christina
Legenstein, Josef
Legenstein, Franz
Kotrosits, Nikolaus
Honicka, Frantiska
Korinek, Katerina
Friedman, Elias
Belemer, Jakob J.
Judelewsky, Josel
Judelewsky, Sora
Smith, Frank
Smith, Mary Ann
Smith, Mary
Gragg, Stewart
Smith, Harold
Evans, Louis
Evans, Polly
Evans, George
Dougherty, Marg't
Dougherty, Jennie
Jones, Evan
Jones, Harriet Celia
Jones, Sallie
Henaghan, Michael
Baldwin, Harry
Baldwin, Samuel John
Crawford, Thomas
Crawford, William
Robert
Brady, Mary
Hayes, Robert
Nolan, James
Billgren, Katherina
Brennan, Patrick
Reilly, John
Hollywood, Peter
Wilkes, Albert Edward
Judge, Edward
Cussane, Michael
Dolan, Patrick
Rogers, Margaret
Hunt, Walter
Flanagan, Paddie
McNally, Michael
Shecter, Jessie
Rostron, James
McKeown, Rebecca
McKeown, Vincent
Zaltzman, Brandel
Zaltzman, Scheindel
Zaltzman, Simon
Zucker, Elka
Zucker, Sloima
Zucker, Sura
Zucker, Alter
Spring, Hersch
Spring, Basha
Spring, Clara
Spring, Elka
Spring, Sloma
Goldstein, Blima
Goldstein, Yetta
Silver, Nuta
Silver, Hena
Silver, Feige
Feldbrill, Nathan
Spigel, Chaja
Jablonsky, Golda
Nazario, Scanzano
Damico, Nicola
Damico, Michele
Bertolotti, Giuseppe
Monti, Rafaele

Column 7

Maisel, Louis
Maisel, Sophia
Pickford, Helen
Pitzel, Samuel
Ruiz, Rufino
Schonthal, Lee
Schonthal, Irma
Vic, Charles
Banzhaff, Albert
Byrnes, Edward
Carr, Susan
Goadby, William
Goadby, Elsie
Eaton, Francis
Eaton, Harriett
Gibson, Ora
Hunt, William
Johnson, Aymar
Markham, Maud
Roth, Mary
Serrao, Amerigo
Devitt, James M
Devitt, Bridget
Cuun, Mary M
Laughlin, Philip M
Laughlin, Mary
Doherty, Joseph
Sheils, Mary
Laughlin, Rose Ann
Laughlin, Sarah
Laughlin, Annie
Laughlin, Pat'k
Houton, Michael
Ferry, Charles
Sieyes, Bridget
Johnston, Fannie
Caul, Francis M
Robb, Joseph
Conway, Wm
Havin, Patrick
Hart, Honor
Kelly, Hugh
Mc Carthy, Alexander
Mc Quade, Annie
Faulkner, Charles
Moody, Arthur J.
Moody, Eliza
Carrigan, Annie
Giblin, John
Smyth, Patrick
Rodway, Sophia
Rodway, Ralph
Rodway, Marie
Doyle, Teresa
Higgins, Michael
Woodward, Chas.
Smith, Frank
Smith, Mary Ann
Smith, Mary
Gragg, Stewart
Smith, Harold
Evans, Louis
Evans, Polly
Evans, George
Dougherty, Marg't
Dougherty, Jennie
Jones, Evan
Jones, Harriet Celia
Jones, Sallie
Henaghan, Michael
Baldwin, Harry
Baldwin, Samuel John
Crawford, Thomas
Crawford, William
Robert
Brady, Mary
Hayes, Robert
Nolan, James
Billgren, Katherina
Brennan, Patrick
Reilly, John
Hollywood, Peter
Wilkes, Albert Edward
Judge, Edward
Cussane, Michael
Dolan, Patrick
Rogers, Margaret
Hunt, Walter
Flanagan, Paddie
McNally, Michael
Shecter, Jessie
Rostron, James
McKeown, Rebecca
McKeown, Vincent
Zaltzman, Brandel
Zaltzman, Scheindel
Zaltzman, Simon
Zucker, Elka
Zucker, Sloima
Zucker, Sura
Zucker, Alter
Spring, Hersch
Spring, Basha
Spring, Clara
Spring, Elka
Spring, Sloma
Goldstein, Blima
Goldstein, Yetta
Silver, Nuta
Silver, Hena
Silver, Feige
Feldbrill, Nathan
Spigel, Chaja
Jablonsky, Golda
Nazario, Scanzano
Damico, Nicola
Damico, Michele
Bertolotti, Giuseppe
Monti, Rafaele
Lamari, Salim

Column 8

Valente, Domenico
Pascale, Giovanni
Rocca, Antonio
Rotella, Giuseppe
Gassat, Felix
Grall, Luillansue
Yoffe, Eisik
Le Lams, Jean
Banzhaff, Albert
Antoniak, Michele
Kenzink, Adam
Kosik, Jean
Raghide, Giuseppe
Fossa, Giambatisto
Muller, Louis
Kohler, Joseph
Frederick, Albert
Cerny, Franz
Ortelli, Gerolomo
Conodaks, Antoni
Marics, Ysioko
Palfi, Rudolf
Papp, Yanos
Gaal, Istran
Sundell, Johan
Laughlin, Philip M
Laughlin, Mary
Doherty, Joseph
Sheils, Mary
Laughlin, Rose Ann
Laughlin, Sarah
Laughlin, Annie
Laughlin, Pat'k
Houton, Michael
Ferry, Charles
Sieyes, Bridget
Johnston, Fannie
Caul, Francis M
Robb, Joseph
Conway, Wm
Havin, Patrick
Hart, Honor
Kelly, Hugh
Mc Carthy, Alexander
Mc Quade, Annie
Faulkner, Charles
Moody, Arthur J.
Moody, Eliza
Carrigan, Annie
Giblin, John
Smyth, Patrick
Rodway, Sophia
Rodway, Ralph
Rodway, Marie
Doyle, Teresa
Higgins, Michael
Woodward, Chas.
Smith, Frank
Smith, Mary Ann
Smith, Mary
Gragg, Stewart
Smith, Harold
Evans, Louis
Evans, Polly
Evans, George
Dougherty, Marg't
Dougherty, Jennie
Jones, Evan
Jones, Harriet Celia
Jones, Sallie
Henaghan, Michael
Baldwin, Harry
Baldwin, Samuel John
Crawford, Thomas
Crawford, William
Robert
Brady, Mary
Hayes, Robert
Nolan, James
Billgren, Katherina
Brennan, Patrick
Reilly, John
Hollywood, Peter
Wilkes, Albert Edward
Judge, Edward
Cussane, Michael
Dolan, Patrick
Rogers, Margaret
Hunt, Walter
Flanagan, Paddie
McNally, Michael
Shecter, Jessie
Rostron, James
McKeown, Rebecca
McKeown, Vincent
Zaltzman, Brandel
Zaltzman, Scheindel
Zaltzman, Simon
Zucker, Elka
Zucker, Sloima
Zucker, Sura
Zucker, Alter
Spring, Hersch
Spring, Basha
Spring, Clara
Spring, Elka
Spring, Sloma
Goldstein, Blima
Goldstein, Yetta
Silver, Nuta
Silver, Hena
Silver, Feige
Feldbrill, Nathan
Spigel, Chaja
Jablonsky, Golda
Nazario, Scanzano
Damico, Nicola
Damico, Michele
Bertolotti, Giuseppe
Monti, Rafaele
Lamari, Salim

Column 9

Esapar, Mitri
Saghir, Giorgi
Saghir, Ibrahim
Hannout, Hanna
Gassat, Felix
Grall, Luillansue
Yoffe, Eisik
Le Lams, Jean
Metzler, Nikolaus
Antoniak, Michele
Kenzink, Adam
Kosik, Jean
Raghide, Giuseppe
Fossa, Giambatisto
Muller, Louis
Kohler, Joseph
Frederick, Albert
Cerny, Franz
Ortelli, Gerolomo
Conodaks, Antoni
Marics, Ysioko
Palfi, Rudolf
Papp, Yanos
Gaal, Istran
Sundell, Johan
Holmlund, Jakob
Nass, Johan M.
Hoglund, Matts
Kass, J.H.
Beck, Gustaf
Jakobson, Simon
Napnan, Anders M.
Blank, Karl J.
Drinker, Gysber
Dame, Gertrude
Dame, Jessie
den Rooyen, Johannes
Aarts, Peter M.
Spoelstra, Wintje
Spoelstra, Hilda
Spoelstra, Jan
Spoelstra, Jennie
Spoelstra, Martha
Spoelstra, Janna A.
Tahedl, Johanna
Koch, Anna
Koch, Rudolf
Stejskal, Christina
Legenstein, Josef
Legenstein, Franz
Kotrosits, Nikolaus
Honicka, Frantiska
Korinek, Katerina
Friedman, Elias
Belemer, Jakob J.
Judelewsky, Josel
Judelewsky, Sora
Smith, Frank
Sweers, Agnes
Herzer, Pauline
Brener, Kaethi
Knudsen, David
Byrne, Thomas
Schofield, James
Roberts, Walter
Ingham, Frederick
Russell, John
Blackman, Thomas
Clarke, Arthur
Sheppard, Stanley
Kennedy, David
McCourt, James
Jones, Sydney
Cash, Frederick
Sanquist, Robert
Oliver, Joseph
Rice, Jack
Magliola, Salvatore
Frick, Louis
Spring, Hersch
Spring, Basha
Spring, Clara
Spring, Elka
Spring, Sloma
Goldstein, Blima
Goldstein, Yetta
Silver, Nuta
Silver, Hena
Silver, Feige
Feldbrill, Nathan
Spigel, Chaja
Jablonsky, Golda
Nazario, Scanzano
Damico, Nicola
Damico, Michele
Bertolotti, Giuseppe
Monti, Rafaele
Lamari, Salim
Esapar, Mitri
Rutkowska, Marianna
Jacob Landau
Sarah Landau
Raoul Landau
Sara Berson
Morris Wilks
Ruth Landau
Abraham Tarendash
Mayer Flasker
Betty Frauendienst
Samuel Weinfeld
Hannah Rykovetzsky
Rachel Smigelsky
Rose Schwadron
Allen, Louis
Baker, Adelbert
Borkhardt, Henry
Harris, Barney
Hennig, August
Holway, Charles
Jaquith, Harold
Lyon, James
Lyon, Elinor

Column 10

Balachowski, Putie
Rutkowska, Marianna
Jacob Landau
Sarah Landau
Raoul Landau
Sara Berson
Morris Wilks
Ruth Landau
Abraham Tarendash
Mayer Flasker
Betty Frauendienst
Samuel Weinfeld
Hannah Rykovetzsky
Rachel Smigelsky
Rose Schwadron
Allen, Louis
Baker, Adelbert
Borkhardt, Henry
Harris, Barney
Hennig, August
Holway, Charles
Jaquith, Harold
Lyon, James
Lyon, Elinor
Maisel, Louis
Maisel, Sophia
Pickford, Helen
Pitzel, Samuel
Ruiz, Rufino
Schonthal, Lee
Schonthal, Irma
Vic, Charles
Banzhaff, Albert
Byrnes, Edward
Carr, Susan
Goadby, William
Goadby, Elsie
Eaton, Francis
Eaton, Harriett
Gibson, Ora
Hunt, William
Johnson, Aymar
Markham, Maud
Roth, Mary
Serrao, Amerigo
Devitt, James M
Devitt, Bridget
Cuun, Mary M
Laughlin, Philip M
Laughlin, Mary
Doherty, Joseph
Sheils, Mary
Laughlin, Rose Ann
Laughlin, Sarah
Laughlin, Annie
Laughlin, Pat'k
Houton, Michael
Ferry, Charles
Sieyes, Bridget
Johnston, Fannie
Caul, Francis M
Robb, Joseph
Conway, Wm
Havin, Patrick
Hart, Honor
Kelly, Hugh
Mc Carthy, Alexander
Mc Quade, Annie
Faulkner, Charles
Moody, Arthur J.
Moody, Eliza
Carrigan, Annie
Giblin, John
Smyth, Patrick
Rodway, Sophia
Rodway, Ralph
Rodway, Marie
Doyle, Teresa
Higgins, Michael
Woodward, Chas.
Smith, Frank
Smith, Mary Ann
Smith, Mary
Gragg, Stewart
Smith, Harold
Evans, Louis
Evans, Polly
Evans, George
Dougherty, Marg't
Dougherty, Jennie
Jones, Evan
Jones, Harriet Celia
Jones, Sallie
Henaghan, Michael
Baldwin, Harry
Baldwin, Samuel John
Crawford, Thomas
Crawford, William
Robert
Brady, Mary
Hayes, Robert
Nolan, James
Billgren, Katherina
Brennan, Patrick
Reilly, John
Hollywood, Peter
Wilkes, Albert Edward
Judge, Edward
Cussane, Michael
Dolan, Patrick
Rogers, Margaret
Hunt, Walter
Flanagan, Paddie
McNally, Michael
Shecter, Jessie
Rostron, James
McKeown, Rebecca
McKeown, Vincent
Zaltzman, Brandel
Zaltzman, Scheindel
Zaltzman, Simon
Zucker, Elka
Zucker, Sloima
Zucker, Sura
Zucker, Alter
Spring, Hersch
Spring, Basha
Spring, Clara

ELLIS ISLAND

ELLIS ISLAND

GHOSTS OF FREEDOM

STEPHEN WILKES

WITH AN INTRODUCTION BY SENATOR BILL BRADLEY

W. W. Norton & Company
New York London

Manufacturing by Mondadori A.M.E. Publishing LTD
Book design by SamataMason
Production manager: Andrew Marasia

Library of Congress Cataloging-in-Publication Data

Wilkes, Stephen.
Ellis Island : ghosts of freedom / Stephen Wilkes ; with an introduction by Bill Bradley.
p.m.
ISBN 13: 978-0-393-06145-1
ISBN 10: 0-393-06145-0
1. Ellis Island Immigration Station (N.Y. and N.J.)—Pictorial works.
2. Ellis Island Immigration Station (N.Y. and N.J.)—History. I. Title.
JV6484.W55 2006
304.8'73—dc22 2006045342

W. W. Norton & Company, Inc., 500 Fifth Avenue, New York, N.Y. 10110
www.wwnorton.com

W. W. Norton & Company Ltd., Castle House, 75/76 Wells Street, London W1T 3QT

1 2 3 4 5 6 7 8 9 0

For Jennie & Sam, my most precious gifts

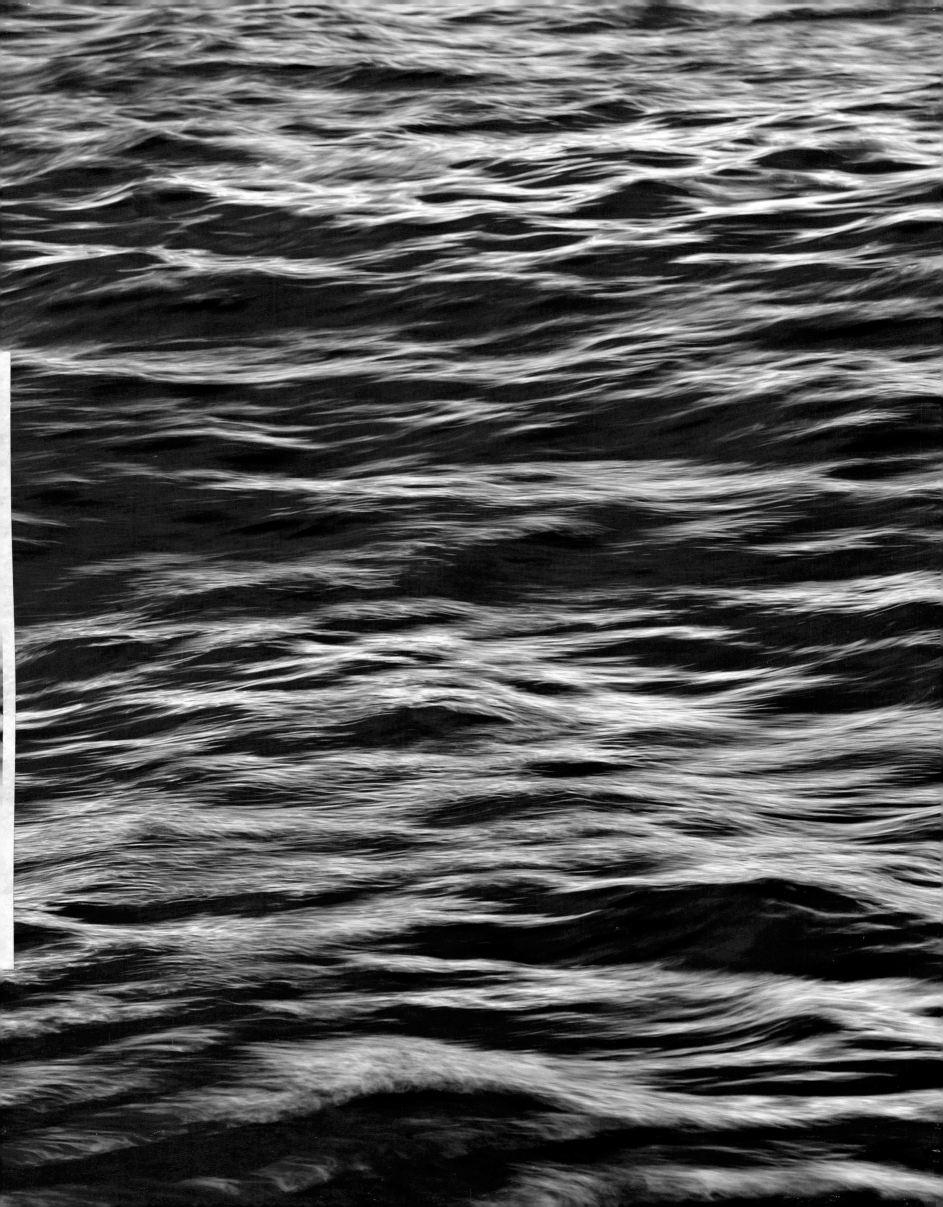

Between 1892 and 1954, Ellis Island served as a major point of entry for immigrants traveling to the United States. During its sixty-two-year tenure, twelve million people passed through it. Approximately 1 percent of the people who arrived in search of a new life were turned away due to health reasons.

Ellis Island housed a hospital complex on a small spit of land south of the Great Hall. It was here that sick individuals with the potential to spread dangerous diseases were separated from their families, and, at least temporarily, from their life dreams. While most were eventually released from the hospital, some perished within those confines. For a small percentage of people, the closest vision of America remained tantalizingly beyond reach—across the expanse of the Hudson River.

Over a five-year period, New York photographer Stephen Wilkes explored and photographed the rooms of the hospital complex. In stark contrast to the duotone photographs that typically define the memory of the immigrant experience, Stephen Wilkes's images offer a startlingly new and at times disturbing vision of the so-called golden gateway to America. Wilkes's photographs, steeped in ephemeral island light, unveil for the first time the unforgettable, often chilling details of past lives in now abandoned rooms.

In Wilkes's photographs, the passage of time is visible in hauntingly beautiful images of lead paint peeling from the walls, in nature's anarchic advance through the floorboards and windows of once-bustling rooms, in the detritus and debris littering each room. Through his exploration of this seminal moment in America's past, Wilkes asks us to reflect on our own humanity. Through his photographs, we are able to enter these rooms, unrestrained by museum ropes or censuring officials. Within these walls, opportunity, chance, and unbridled yearning were often offset by enduring sadness and disillusion. And yet, entire generations of energetic citizens merged into the United States from this extraordinary locale. The human drama that resulted is a defining and cherished chapter of American history.

As of this writing, the hospital buildings on Ellis Island have been stabilized. In the process of preservation, they have been irrevocably changed. In pursuit of his subject, Stephen Wilkes has skillfully captured a national landmark—one abandoned for nearly fifty years.

The movement of people into the United States has continued since the closure of Ellis Island in 1954. But today, people gain entrance to America through multiple channels, rather than through the "waiting room" that was Ellis Island. Here, given the rare combination of an eye that sees far beyond the lens and the technical acumen of a master draftsman, Wilkes takes us on a journey through our collective past.

It is the dark side of the island.

A place where the huddled masses yearning to breathe free remained huddled, remained yearning, many permanently, just inches short of the promised land.

In the shadow of Ellis Island's Great Hall, forgotten by history and woefully ill-equipped for its battle with nature, I came upon the ruins of a vast hospital: contagious-disease wards and isolation rooms for the people whose spirits carried them across oceans but whose bodies failed them a stone's throw from paradise.

The Statue of Liberty loomed over my shoulder, yet I felt no less an archaeologist than those who first ventured into the Mayan tombs. I wore a respirator against the ravages of asbestos and lead paint. I saw the shoes of immigrants long forgotten; shards of mirror; remnants of beds; the ruins of the autoclave, a chamber where tuberculosis-infected mattresses were sterilized with scorching heat. I saw ancient Eveready batteries hooked to strange pipes—what may have been the first electroshock therapy treatment ever conducted on these shores. I saw architecture that was 50 percent the work of man, 50 percent the triumph of nature. A surreal sculpture of vines, leaves, and moss, mingled with shattered plaster, curling paint, and rusted iron, meandered through empty corridors and dead rooms.

But mostly I saw life.

Not in an abstract sense—or in the memory of the thousands who came to Ellis Island dreaming of life in America but who died instead here, across the harbor—but in a tangible sense. I felt the palpable presence of humanity everywhere I turned, in every room. It was an energy in whose presence I felt tremendous humility.

For two weeks after shooting the first group of pictures of Ellis, I was obsessed. I couldn't sleep, I couldn't erase the buildings from my mind. So I went back, many times, every chance I could. What began as a one-hour editorial assignment became a five-year passion. In a place few were ever allowed to enter, I was blessed to be able to study every season. I photographed every corner, every crevice, in every imaginable light. Strange things happened. I'd photograph a mirror that had hung on a wall for half a century, only to return to find its shattered remains. I'd photograph a shoe, which several days later had disappeared though no one had entered the space after me. I photographed the 500-foot-long spine of the hospital, Corridor 9, a long tunnel of decay. In the photograph, a golden glow of sunshine warming the walls at the far end is visible. In all the times I returned to it, I never again saw this glow, nor can I discern its origin.

Somehow, it felt as if I was chosen to do it: to document the light and the energy and the living spirit of this place. I added no light of my own, nor any artifice of the photographic craft. I wasn't interested simply in graphics born from the patina of ruin. I wanted to record the place as I found it.

In the light lies the history of Ellis Island. In some as yet unknown calculus of time and energy, when the light came through the rooms, it energized the past. And that's how I found the island: the act of discovery and the act of photography occurred simultaneously.

The island itself, rising from the water one mile from Lower Manhattan, was originally 3.3 acres in size. Landfill between the years 1892 and 1934 expanded Ellis Island to its current 27.5 acres. The original island became known as Island 1, while the added land was known as Islands 2 and 3. The added land as a whole is also called the south side, and it is on this portion of Ellis Island that the photographs in this book were taken.

Working with the New York Landmarks Conservancy, I made a video. It was presented to Congress. Two years later, they approved a $6 million grant to preserve South Island as a living ruin.

It was a triumph not without irony. In stabilizing the buildings, many repairs have been made and many of the encroachments of nature removed. The place will never again look as it does in these photographs. I was able to document a moment in time between the death of a place to which every one of us can trace a family member, and its final resurrection as a landmark.

Stephen Wilkes
MARCH 2006

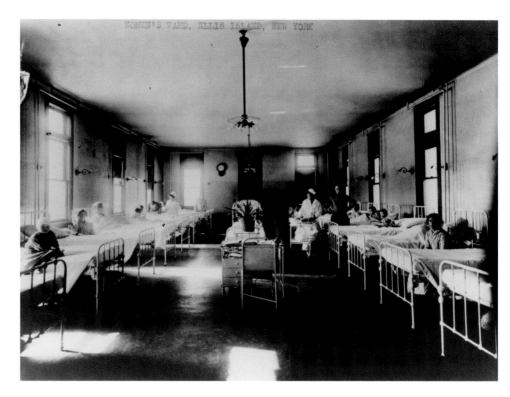

Women's Ward, Island 2, 1917

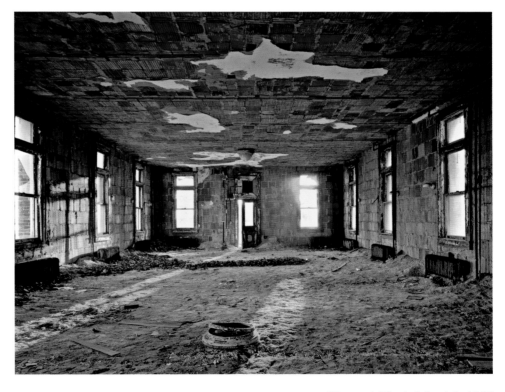

Women's Ward, Island 2, 1998

I WAS ALONE IN A
NEW WORLD THAT
I DIDN'T KNOW
OR UNDERSTAND.

I WAS ALONE IN A
NEW WORLD THAT
I DIDN'T KNOW
OR UNDERSTAND.

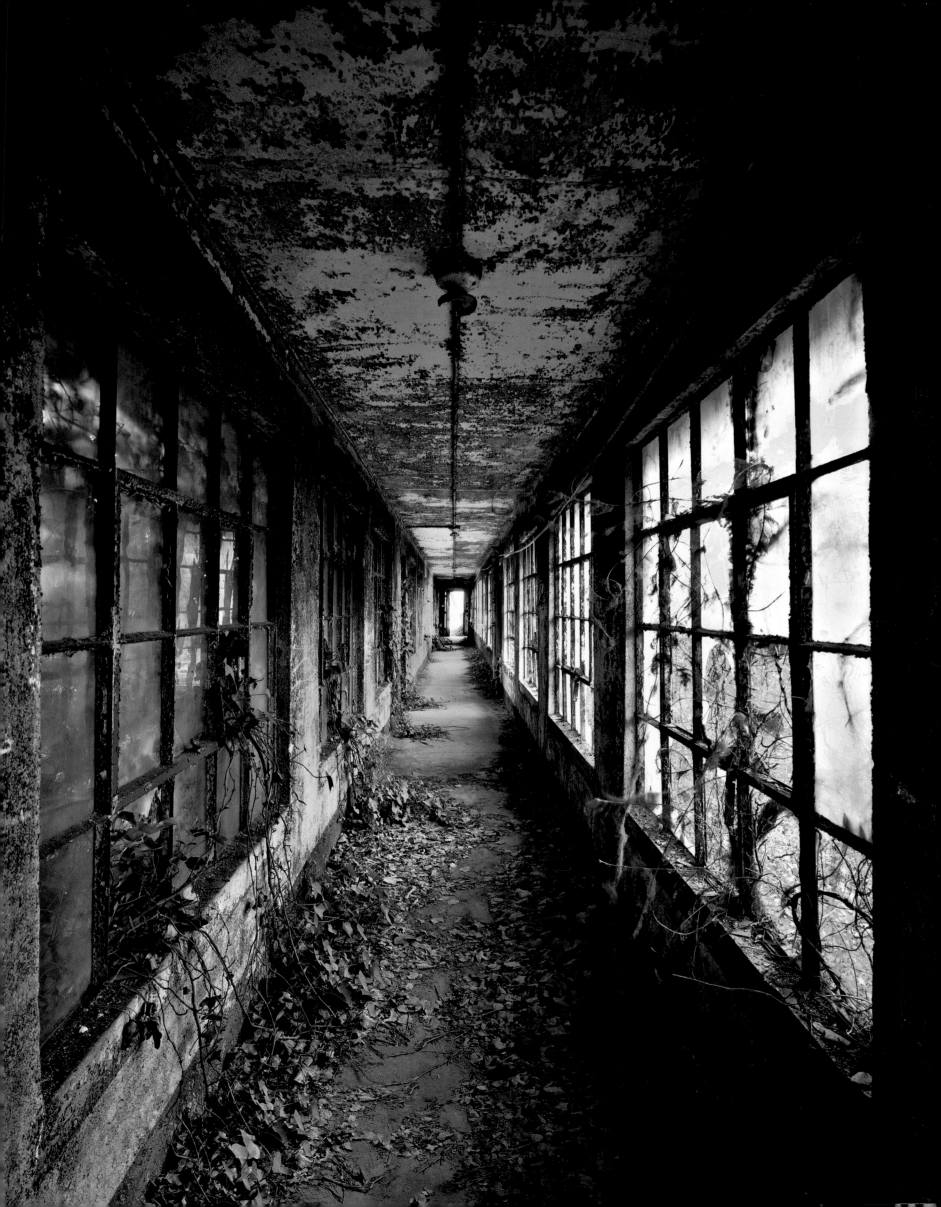

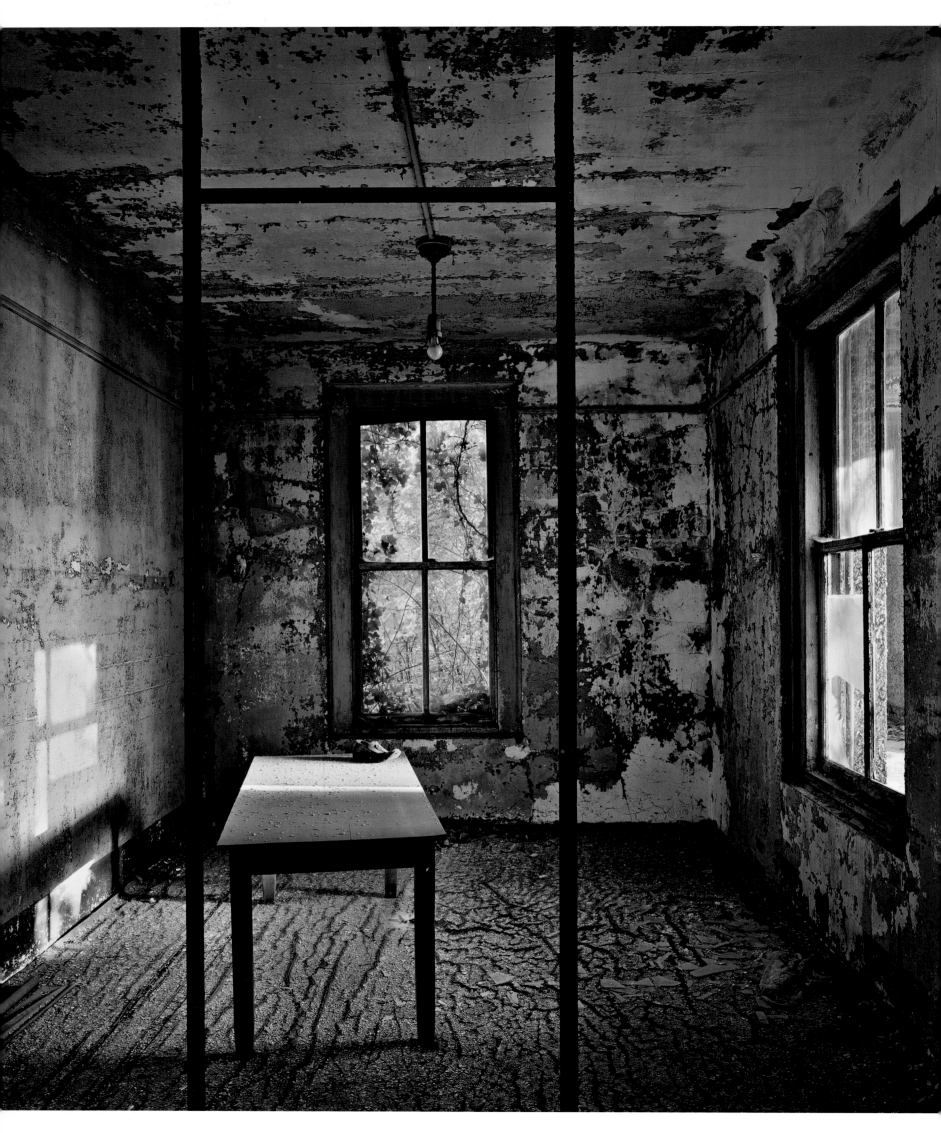

PRECEDING PAGE: Corridor 9. ABOVE: Administration office, single shoe

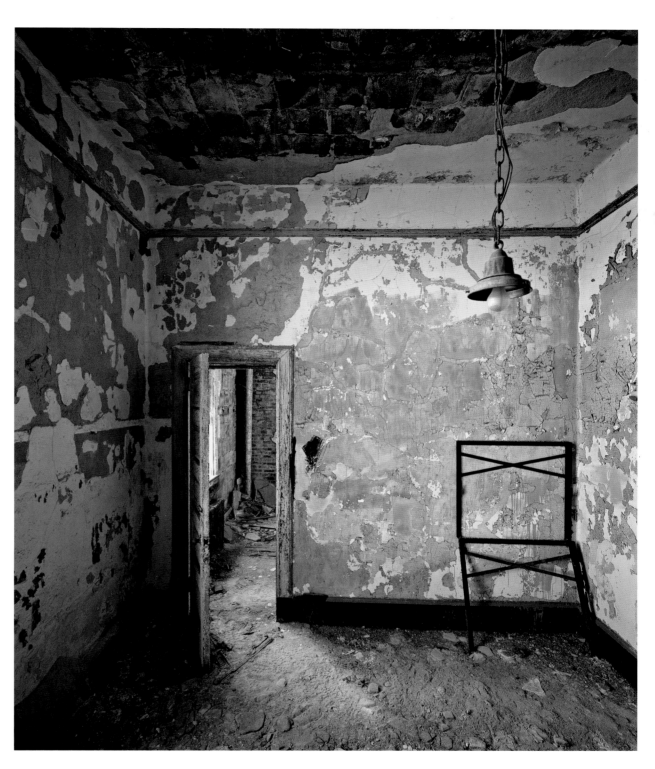

Main hospital, blue room with bed frame

OPPOSITE PAGE: Measles ward, oak file cabinets

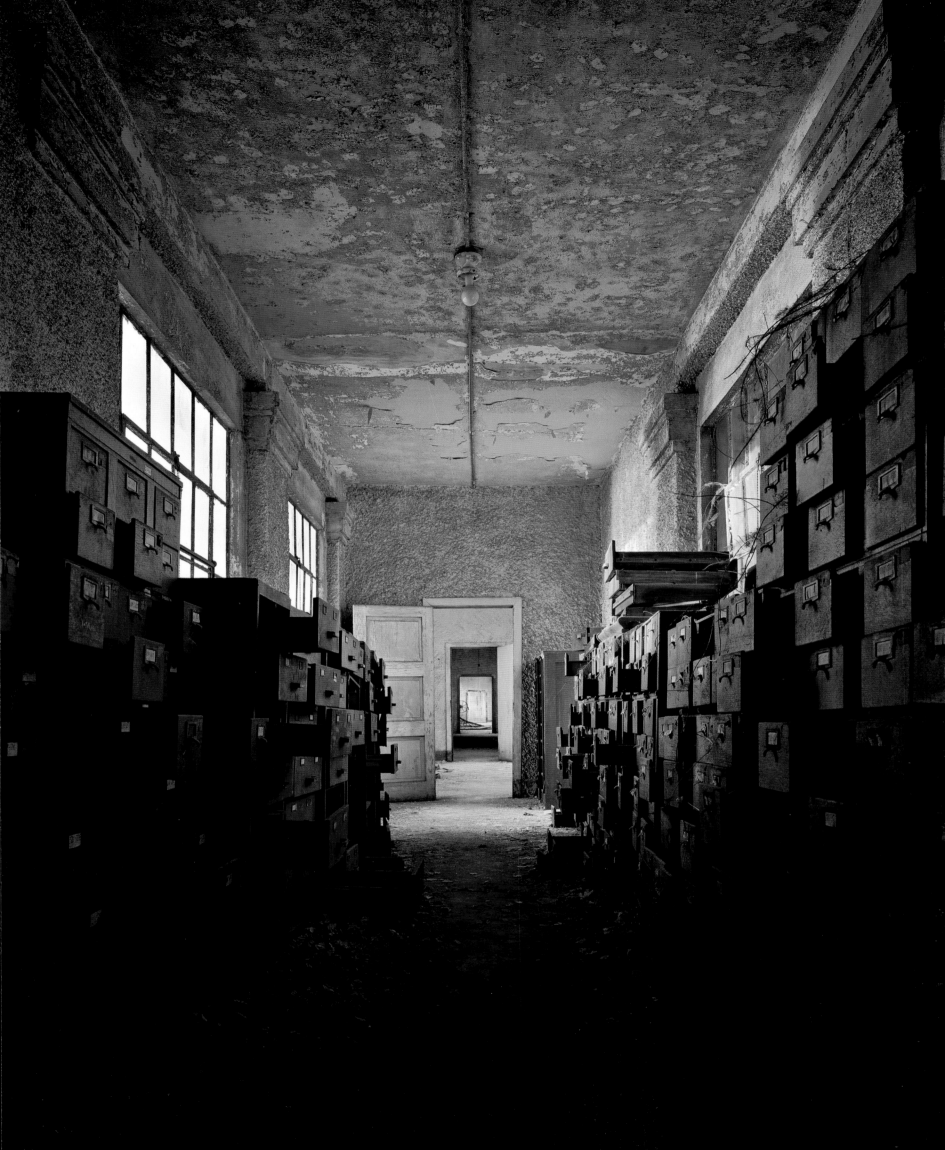

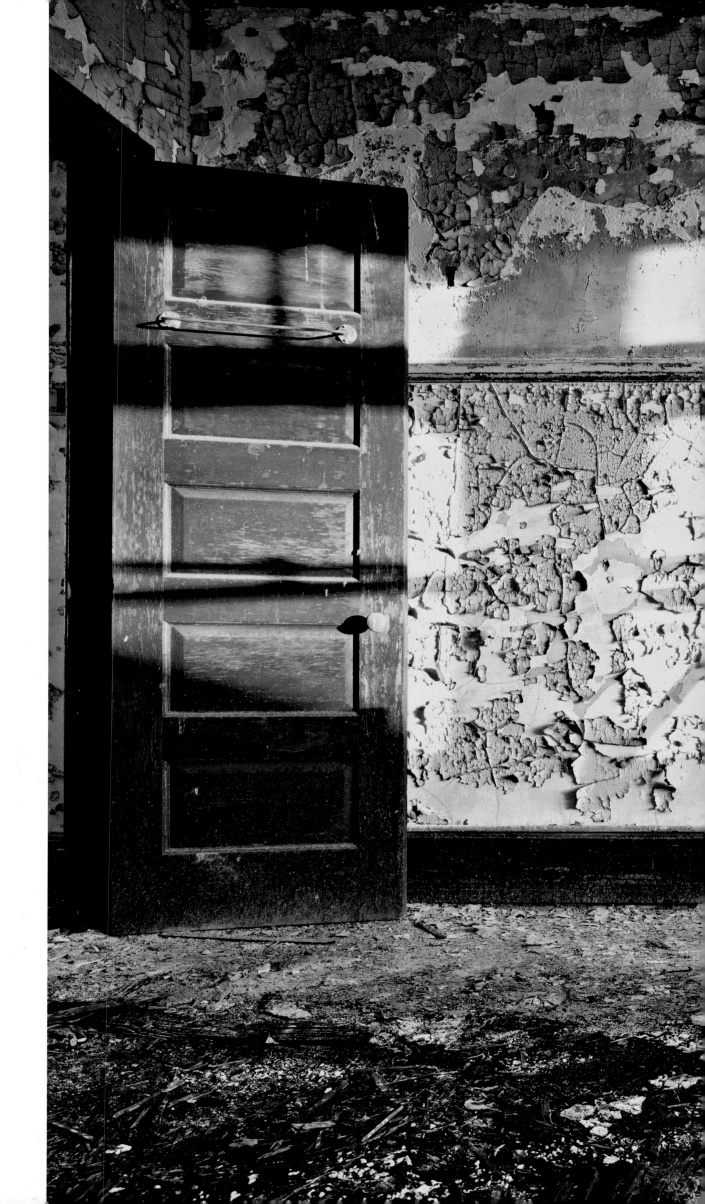

Psychiatric hospital, broom study

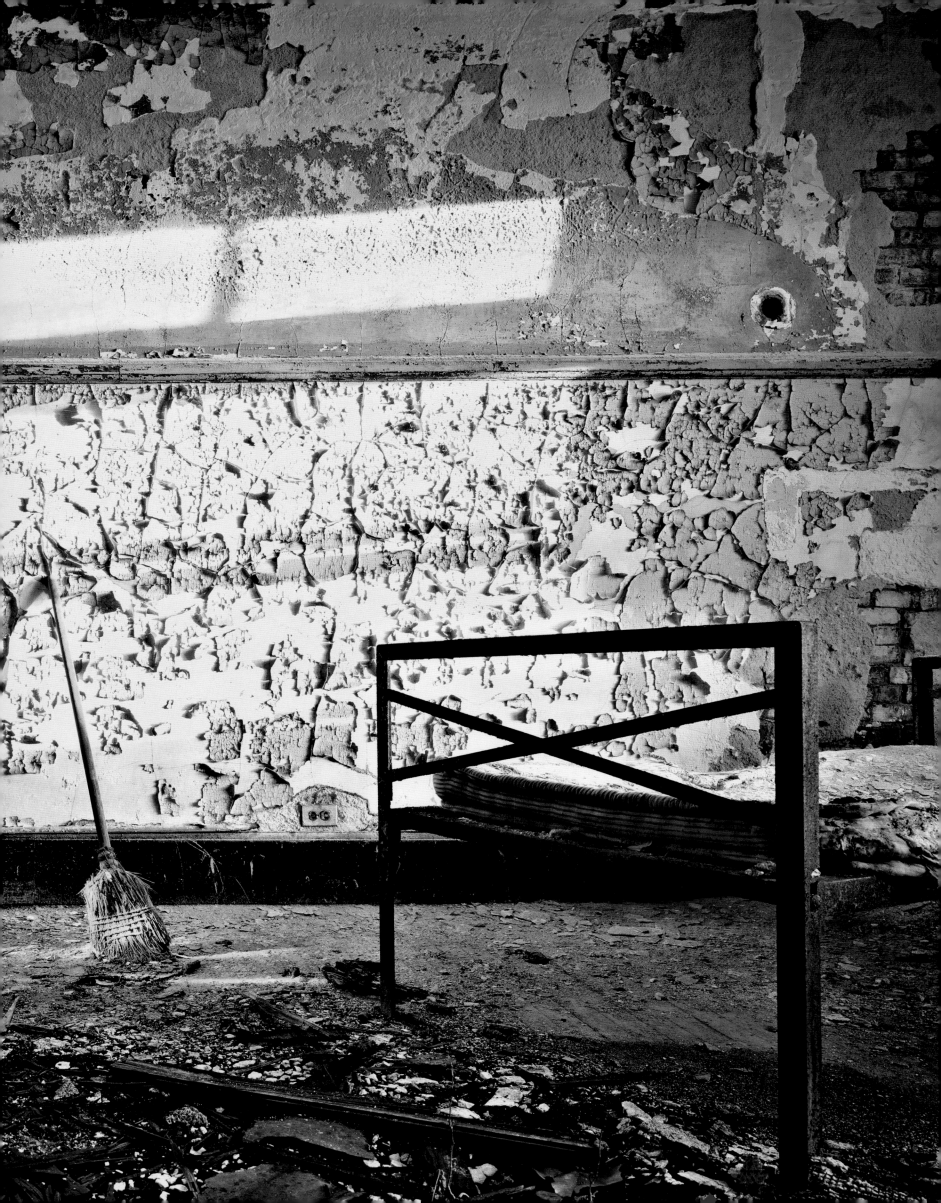

OPPOSITE PAGE: Administration building, dark hallway

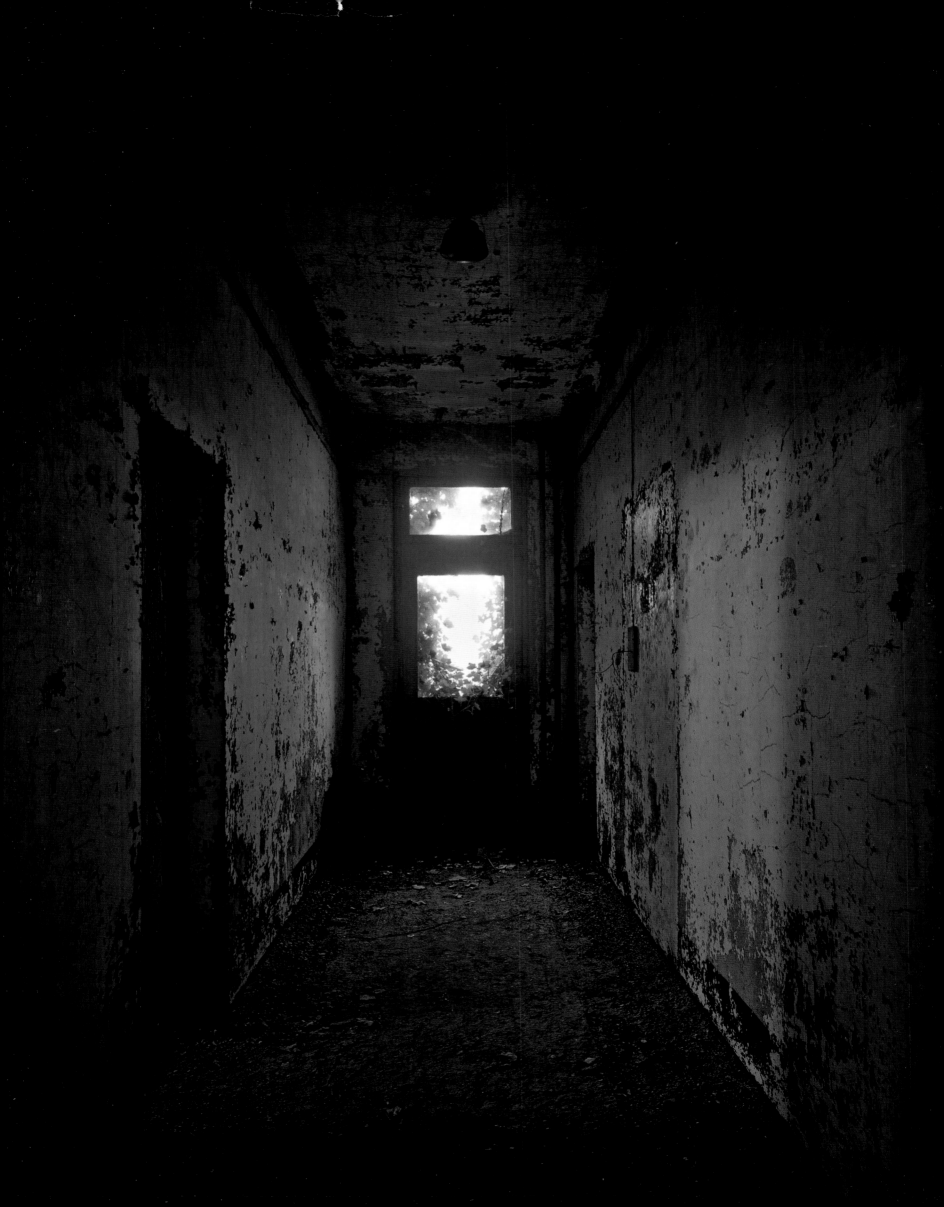

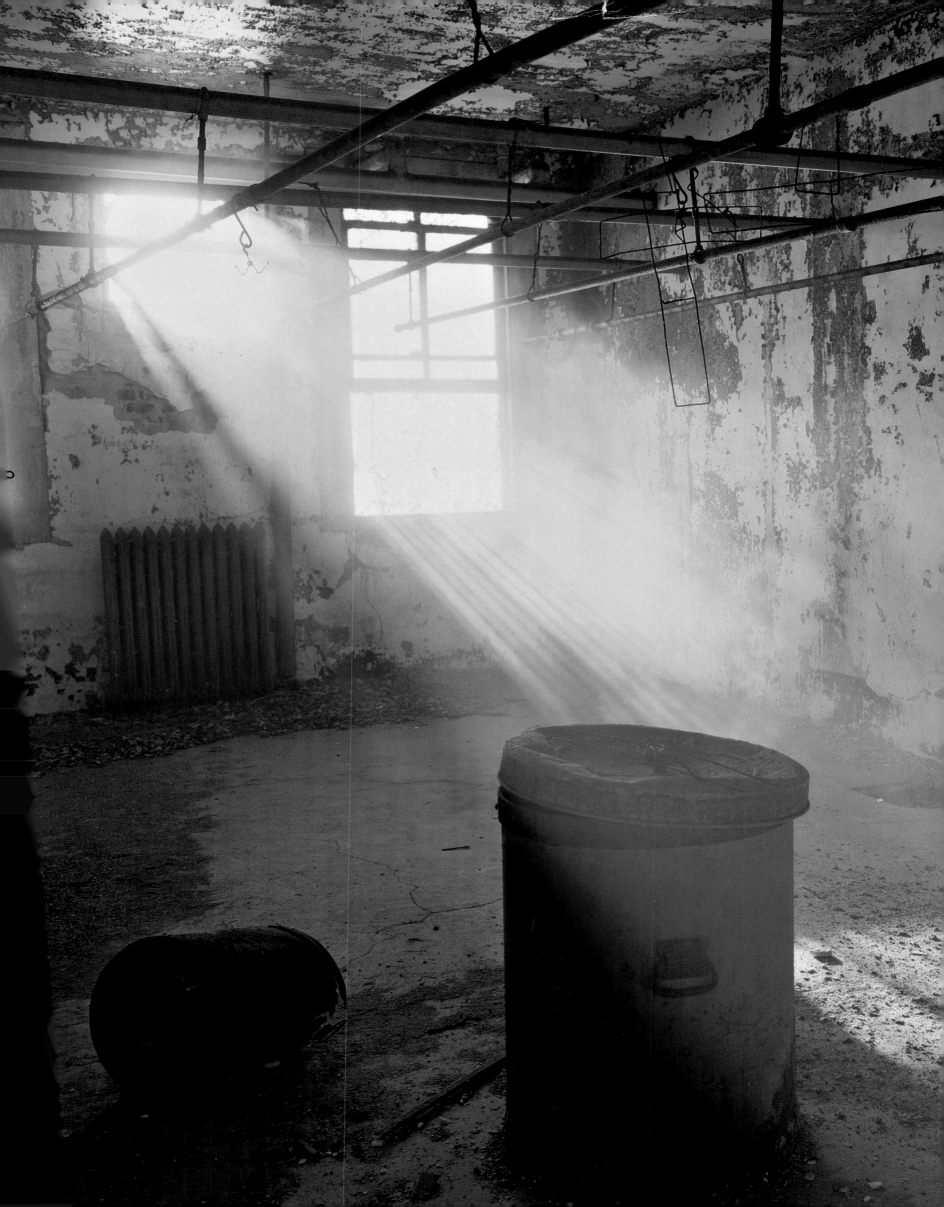

OPPOSITE PAGE: Morgue, prep room

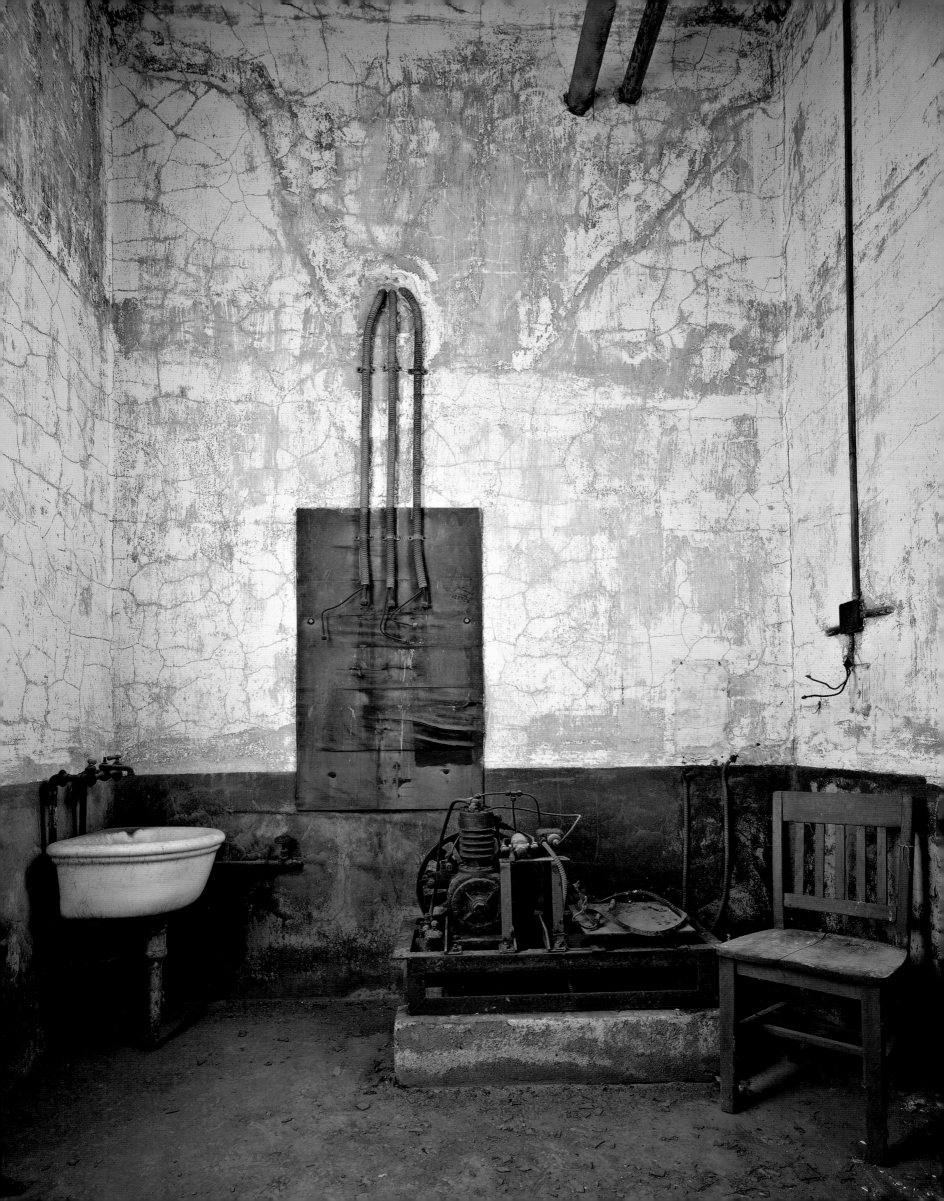

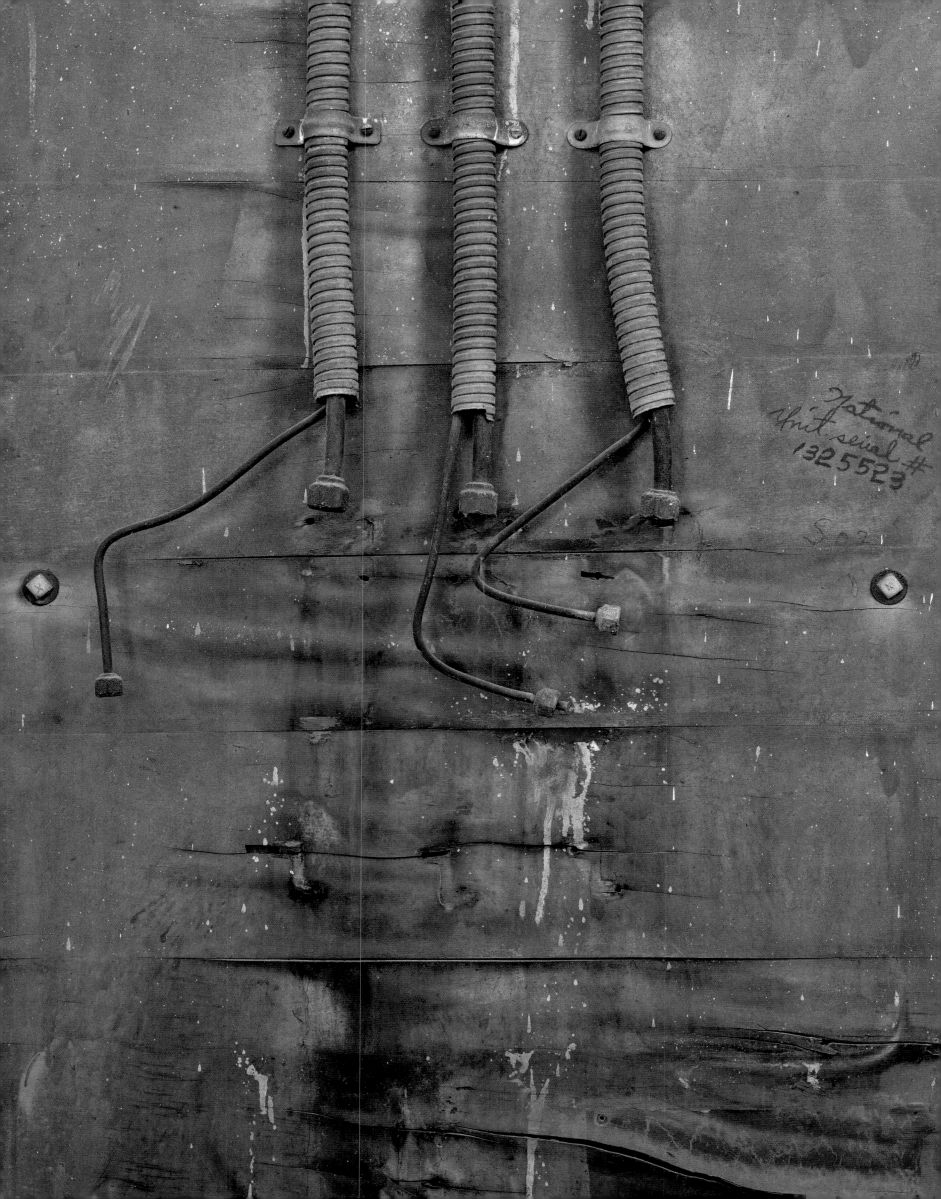

National
Unit serial #
1325523

S021

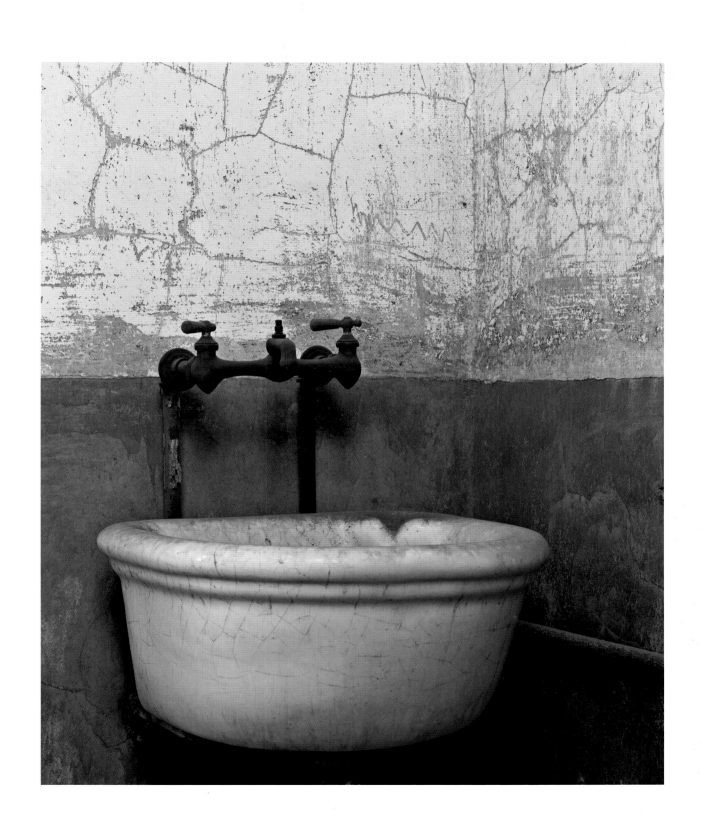

ABOVE: Morgue prep room, sink study
OPPOSITE: Morgue refrigerator (detail)

THE NURSES WERE THERE.

"LADIES IN WHITE,"
WE USED TO CALL THEM....
THEY TALKED TO THE CHILDREN.

THEY STROKED THEIR HAIR.
AND THEY TOUCHED THEIR CHEEKS....
THEY WERE REALLY VERY NICE.

THE NURSES WERE THERE.

"LADIES IN WHITE,"
WE USED TO CALL THEM....
THEY TALKED TO THE CHILDREN.

THEY STROKED THEIR HAIR.
AND THEY TOUCHED THEIR CHEEKS....
THEY WERE REALLY VERY NICE.

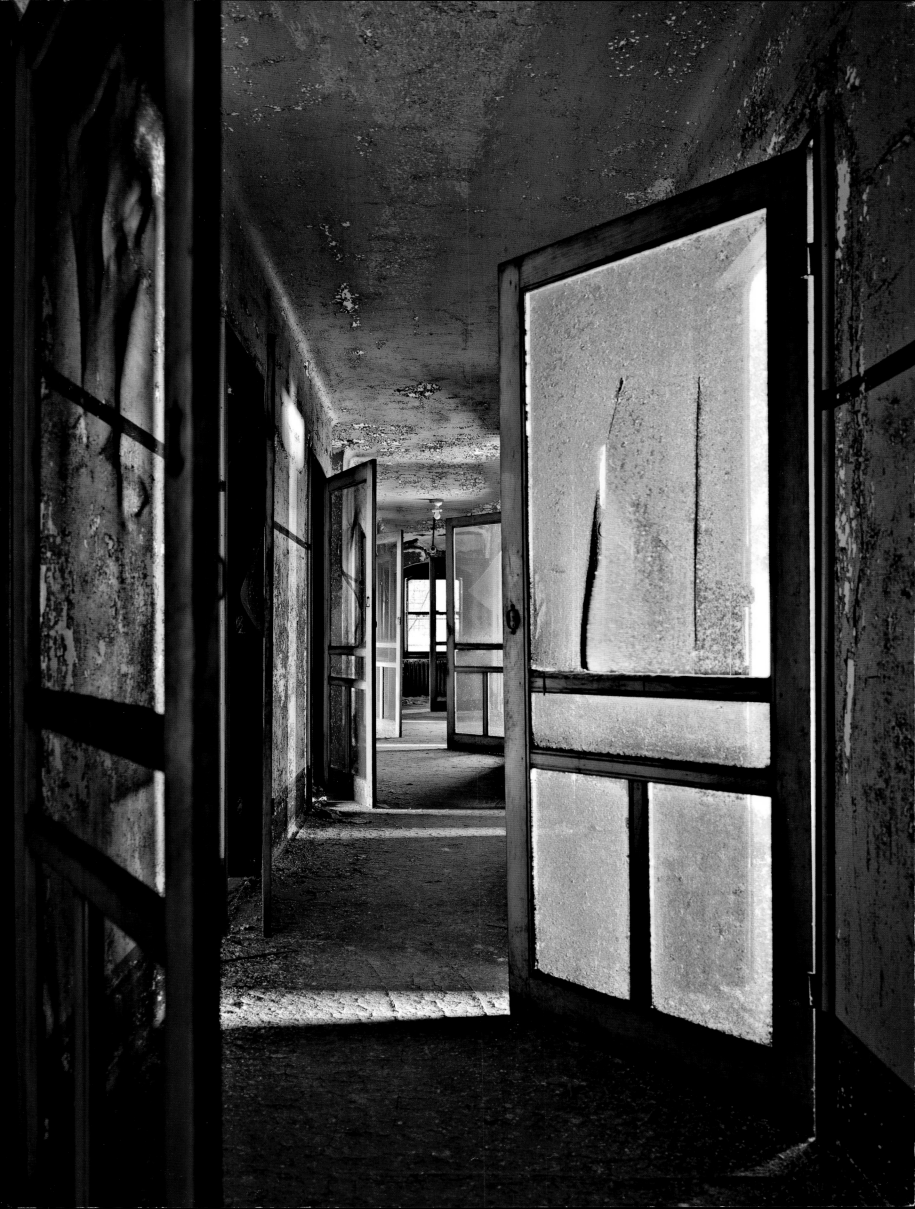

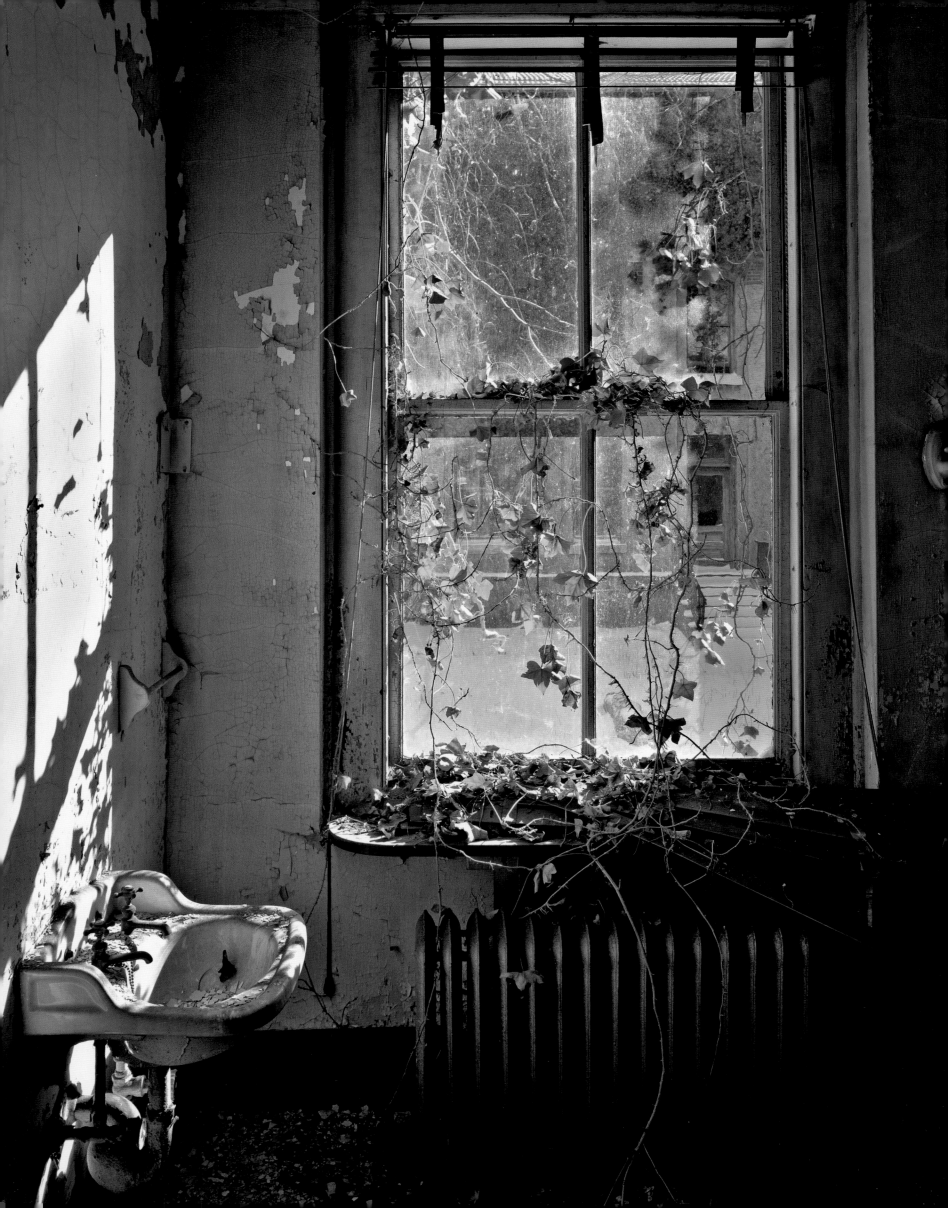

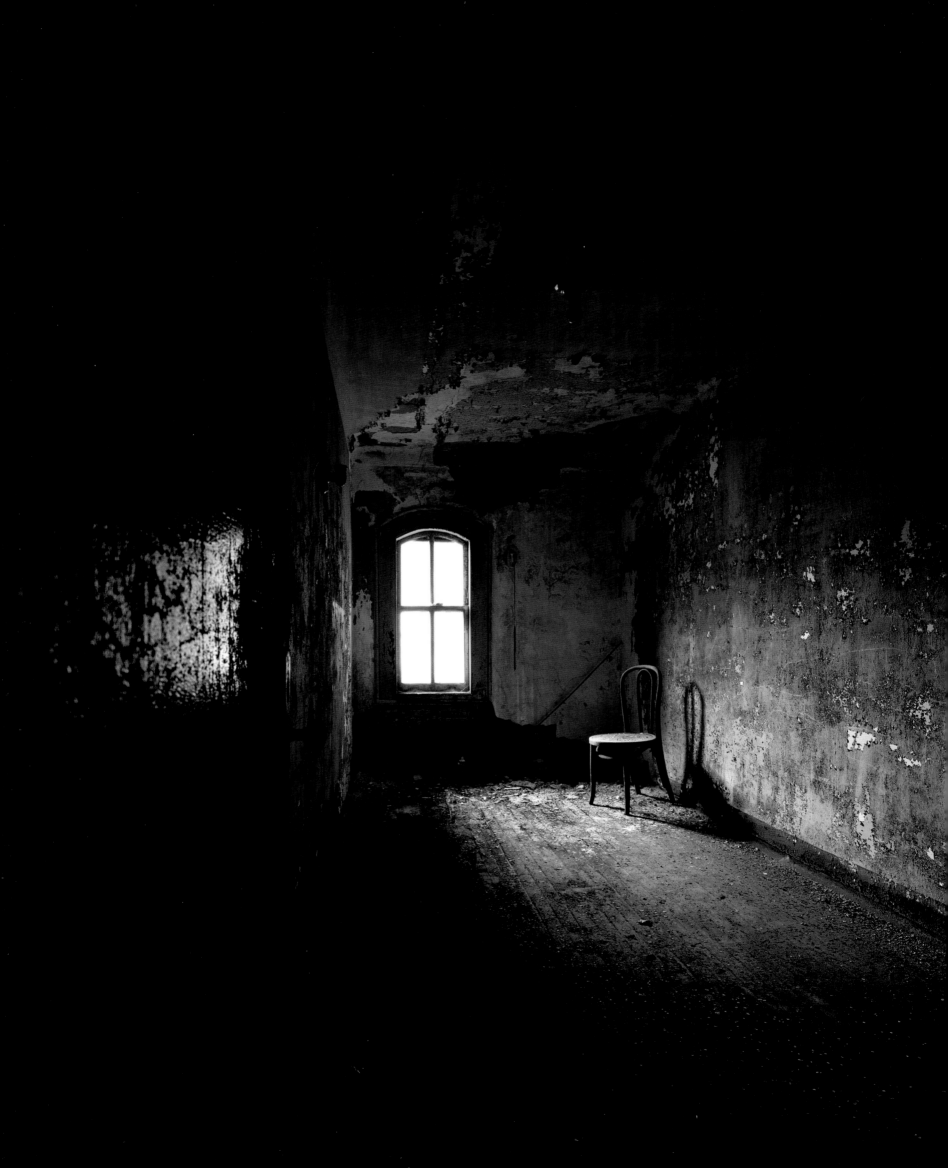

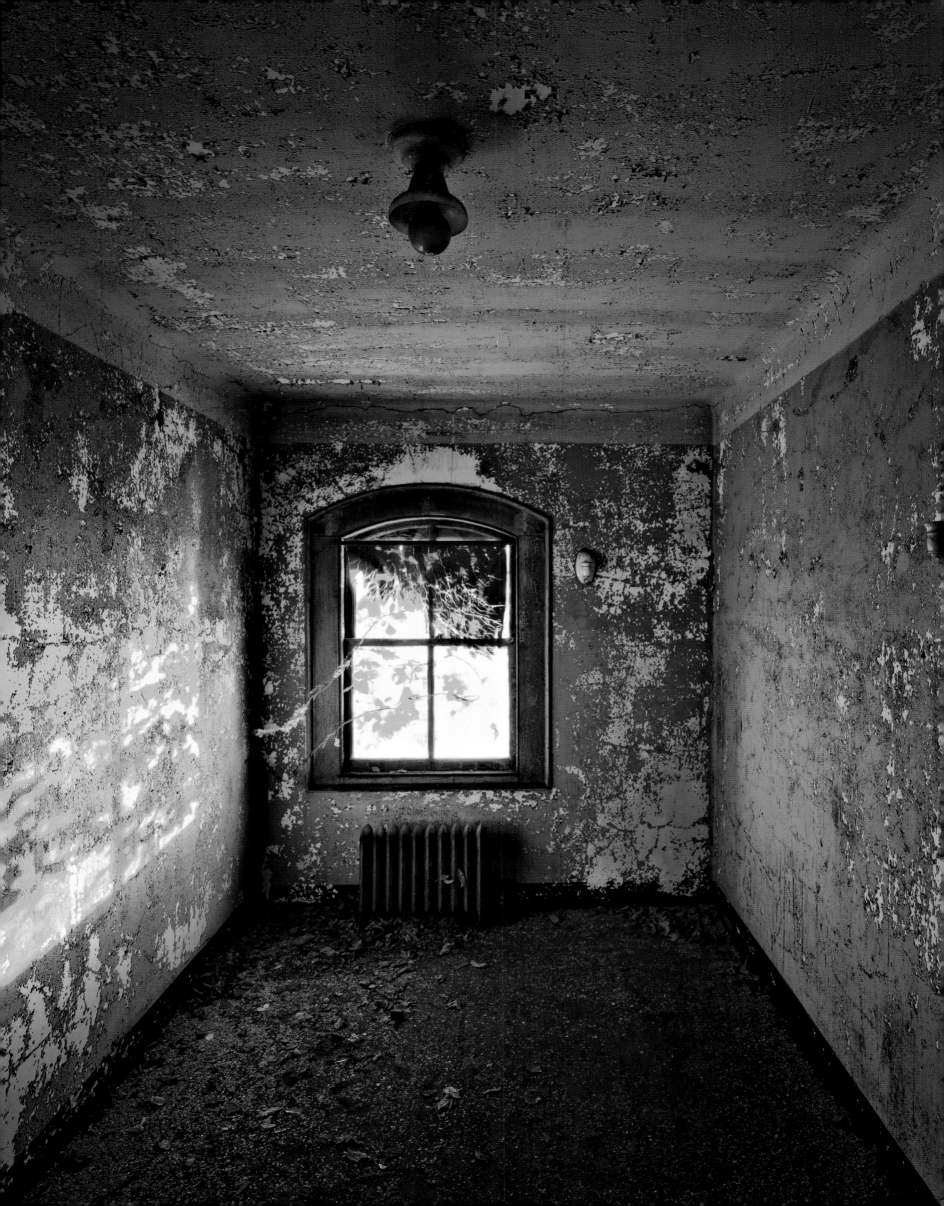

OPPOSITE PAGE: Isolation ward, suitcase

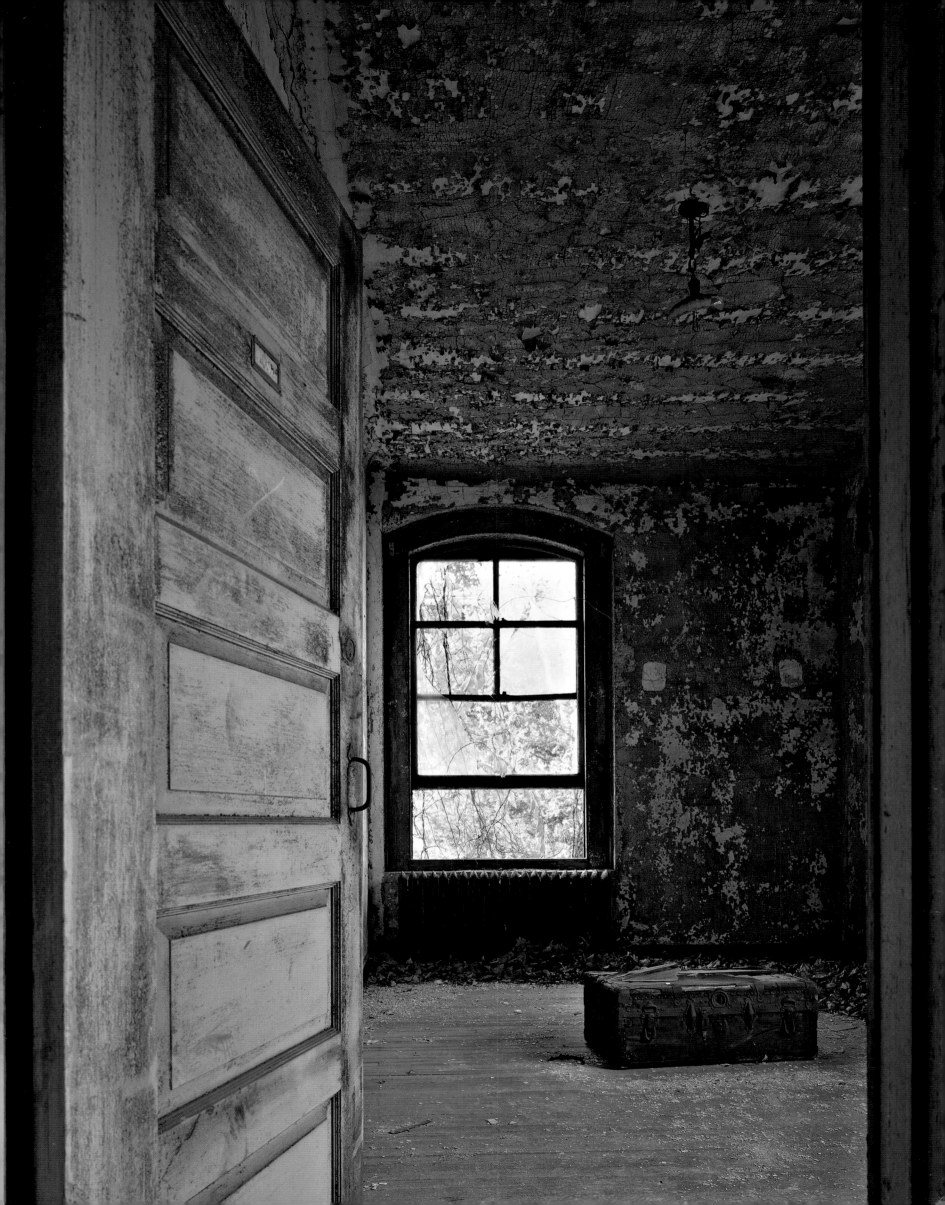

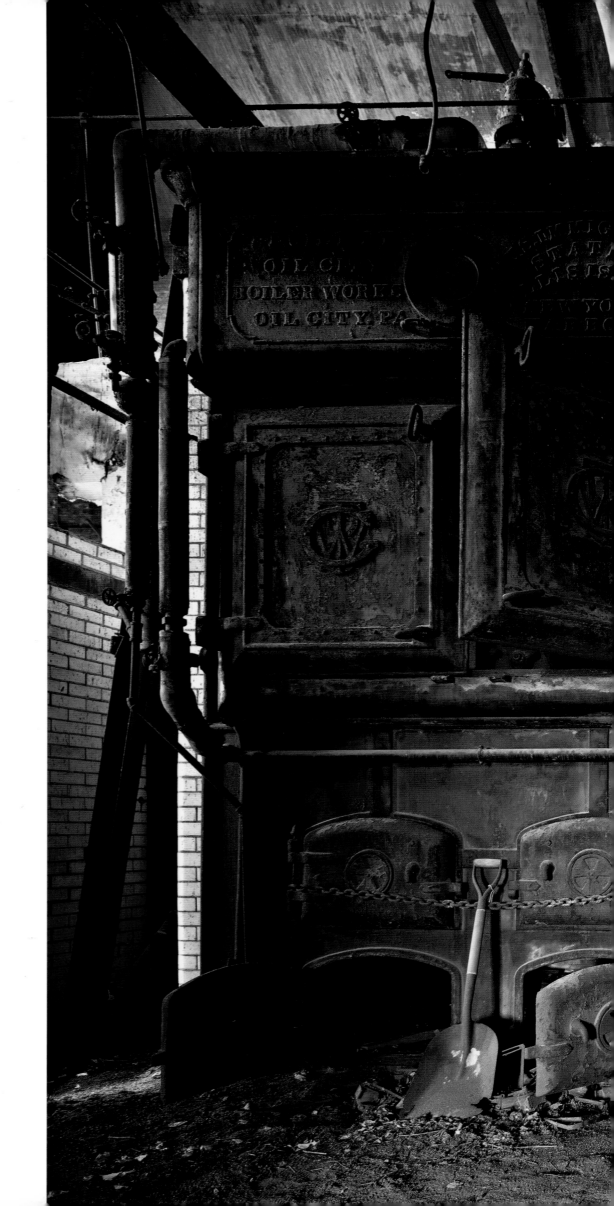

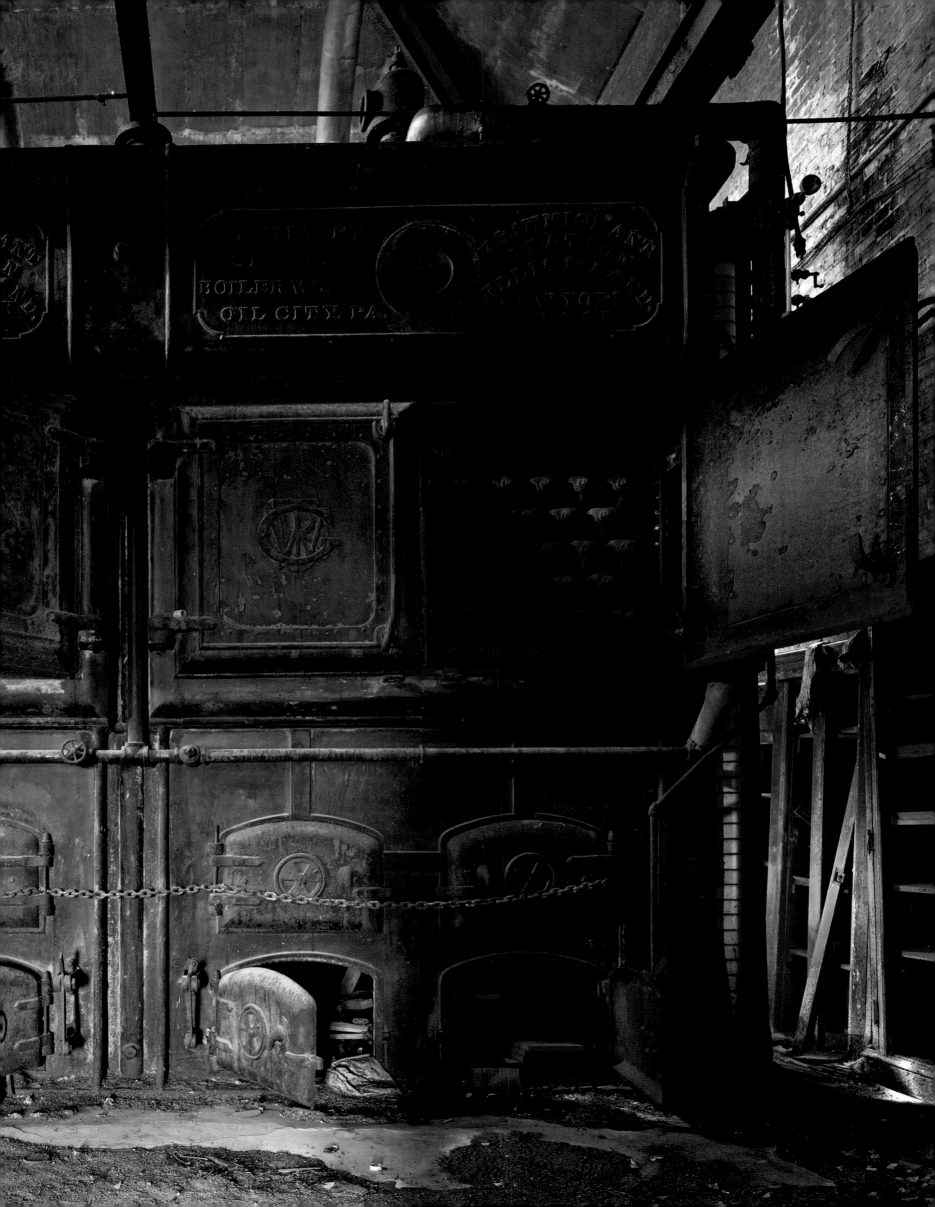

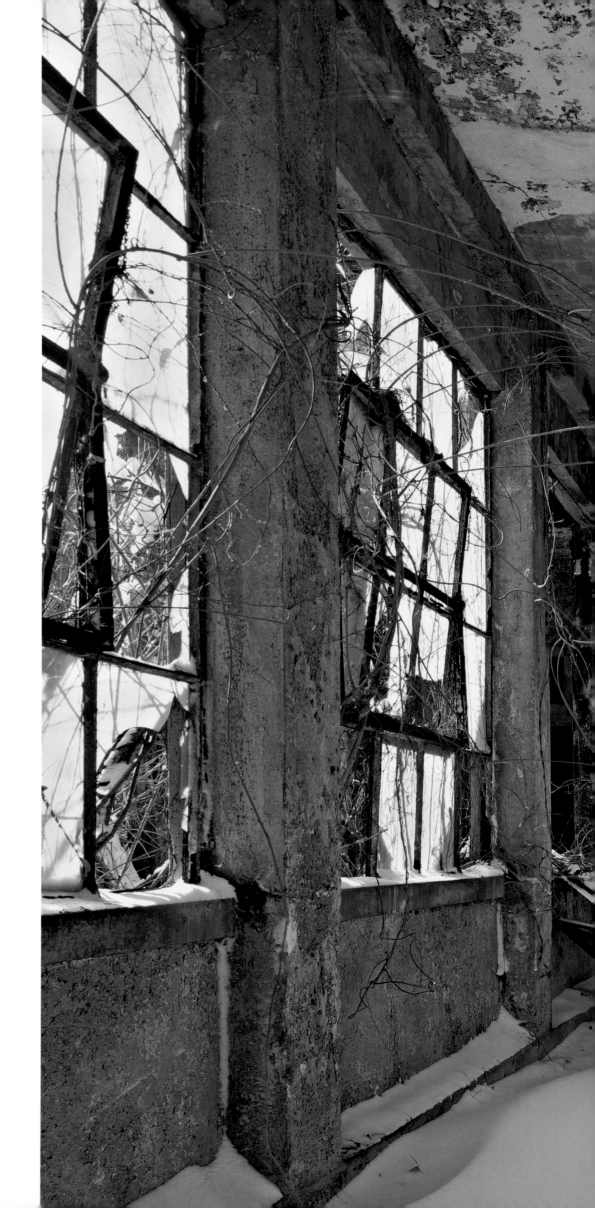

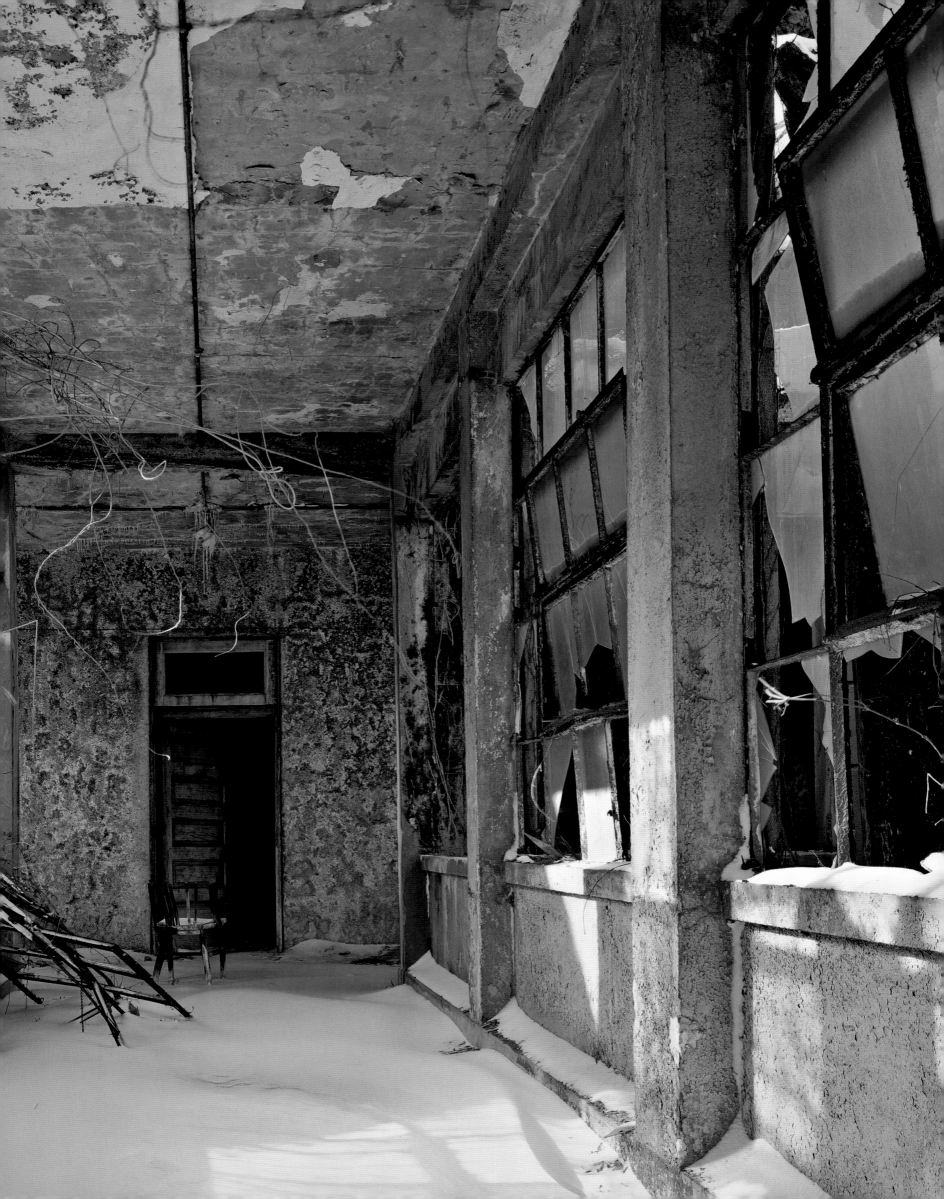

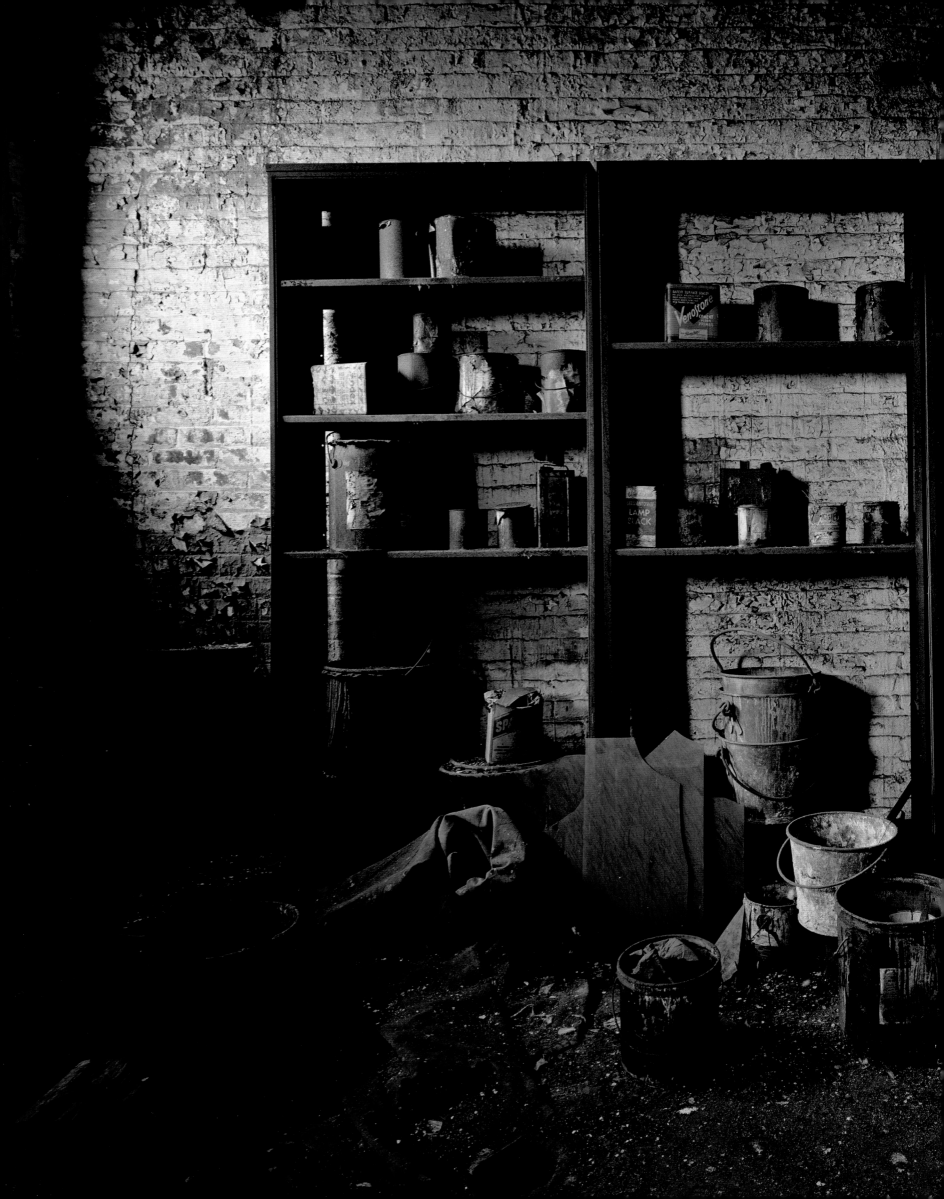

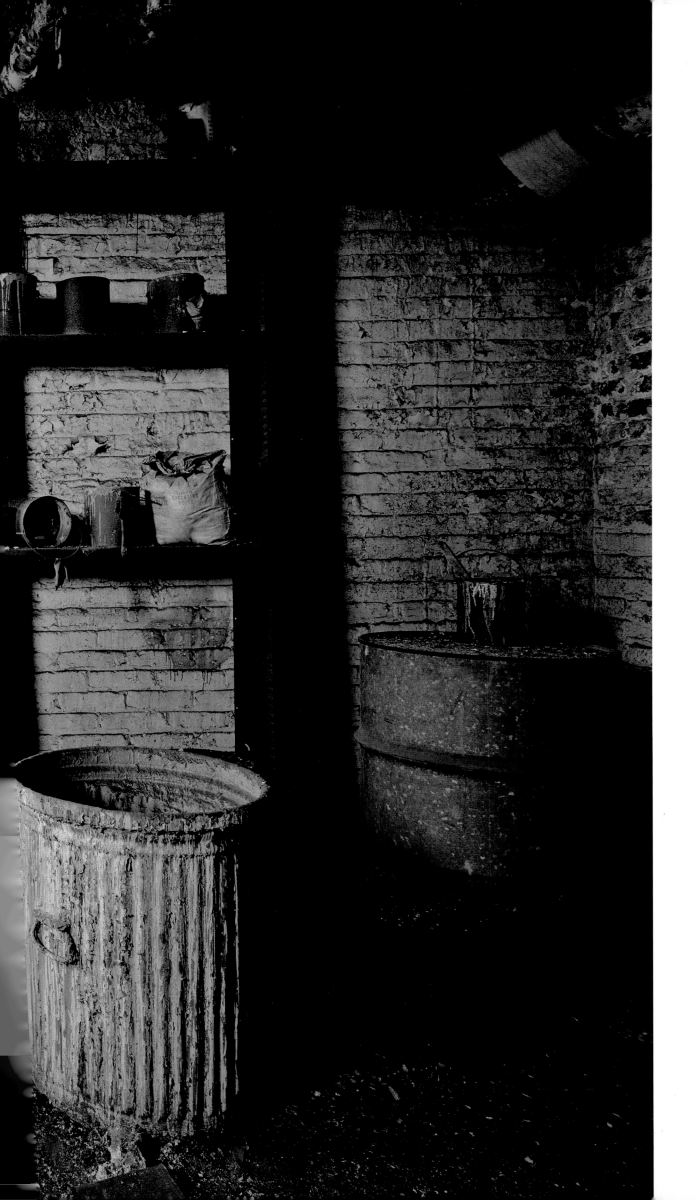

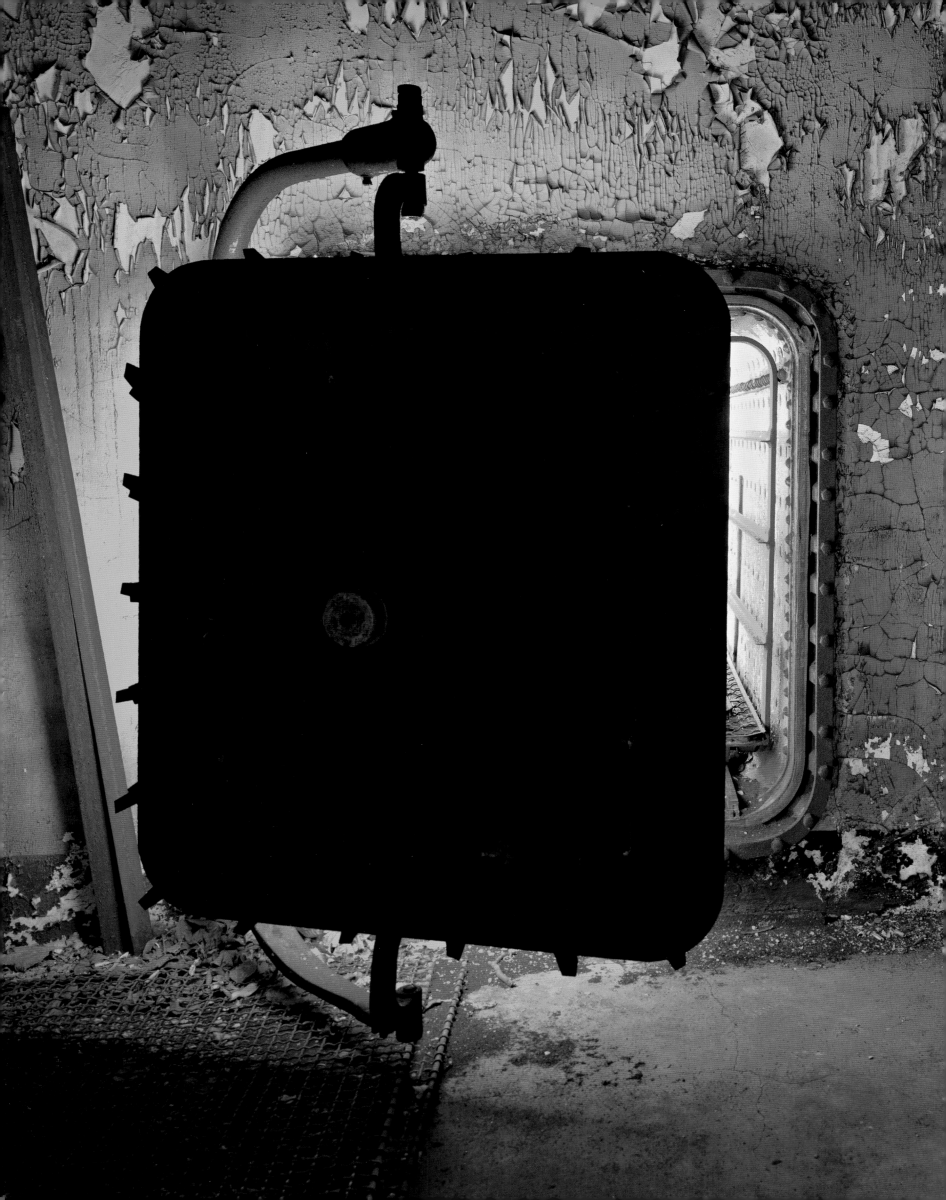

THIS PAGE: The autoclave

ON PAGE 39: Tuberculosis ward,
Statue of Liberty

I DIDN'T DO ANYTHING.
I JUST ROAMED
AROUND THE HOSPITAL,
WENT OUTSIDE TO LOOK
AT THE STATUE OF LIBERTY.
NOBODY TOLD ME
WHAT IT WAS.

I DIDN'T DO ANYTHING.
I JUST ROAMED
AROUND THE HOSPITAL,
WENT OUTSIDE TO LOOK
AT THE STATUE OF LIBERTY.
NOBODY TOLD ME
WHAT IT WAS.

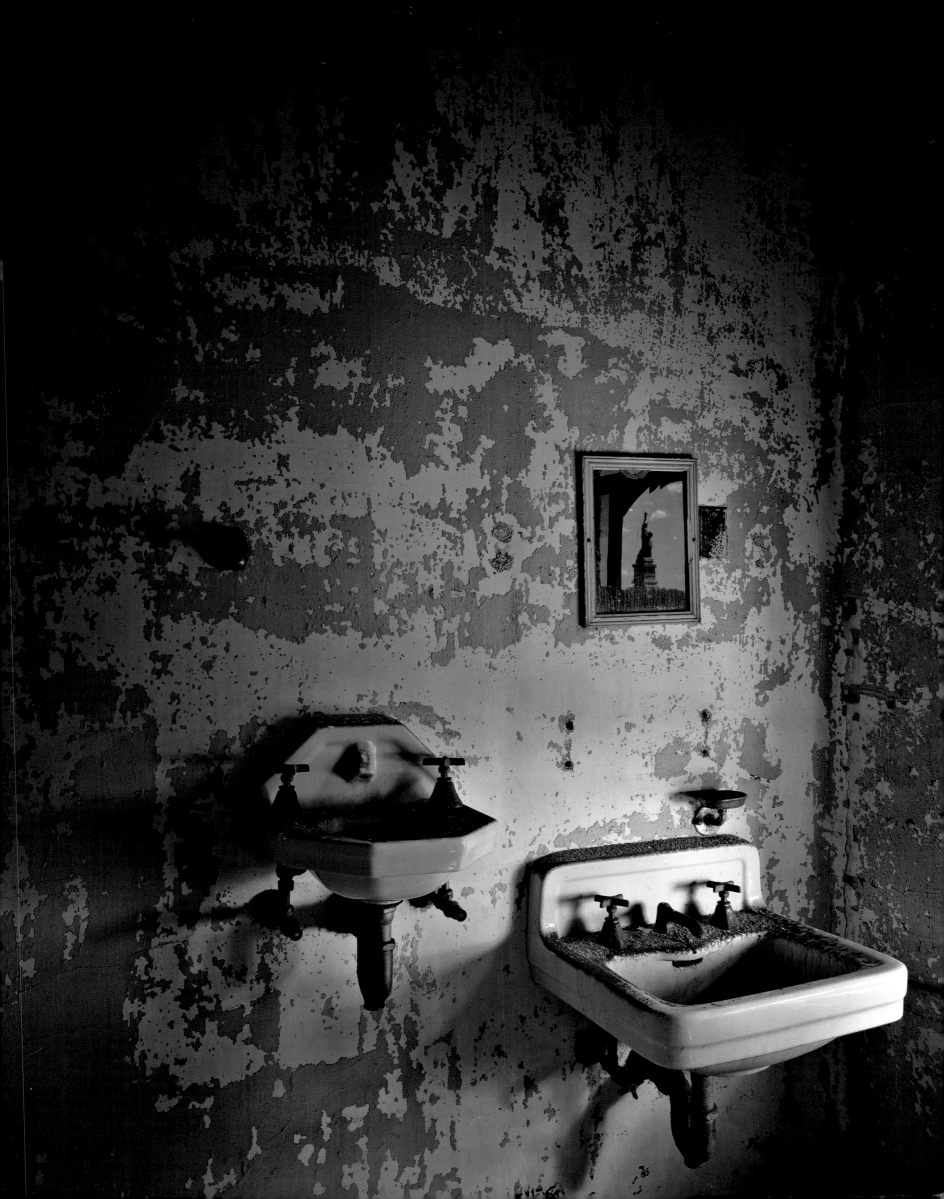

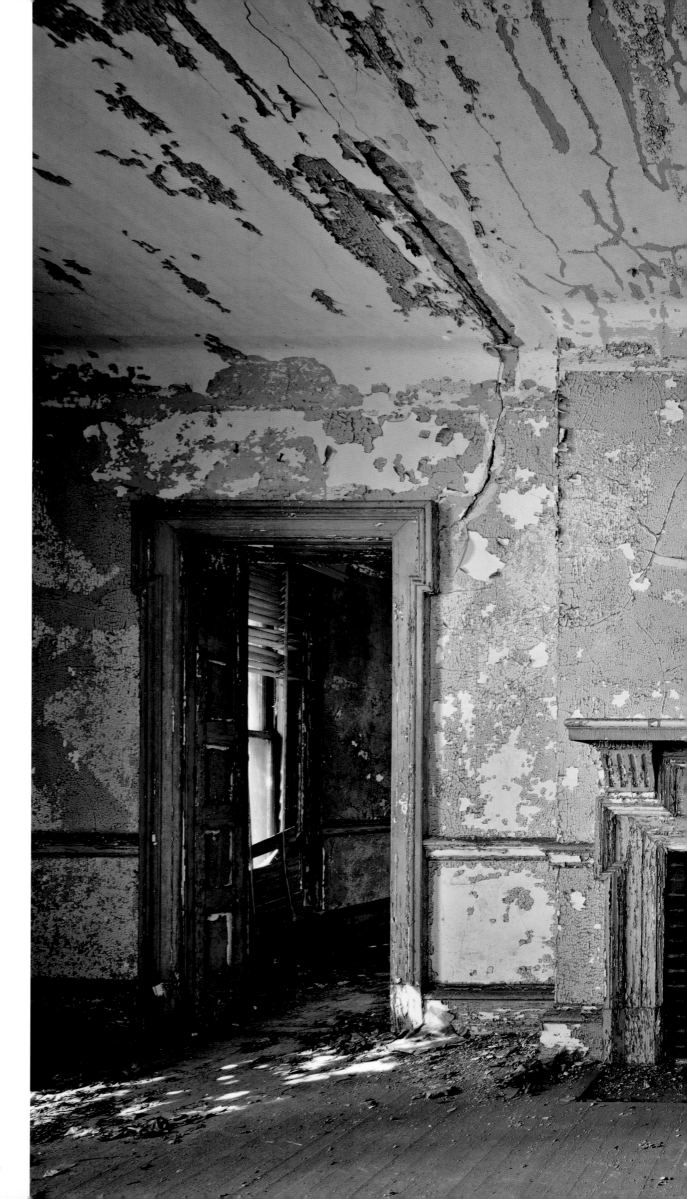

Administrative quarters, staff house

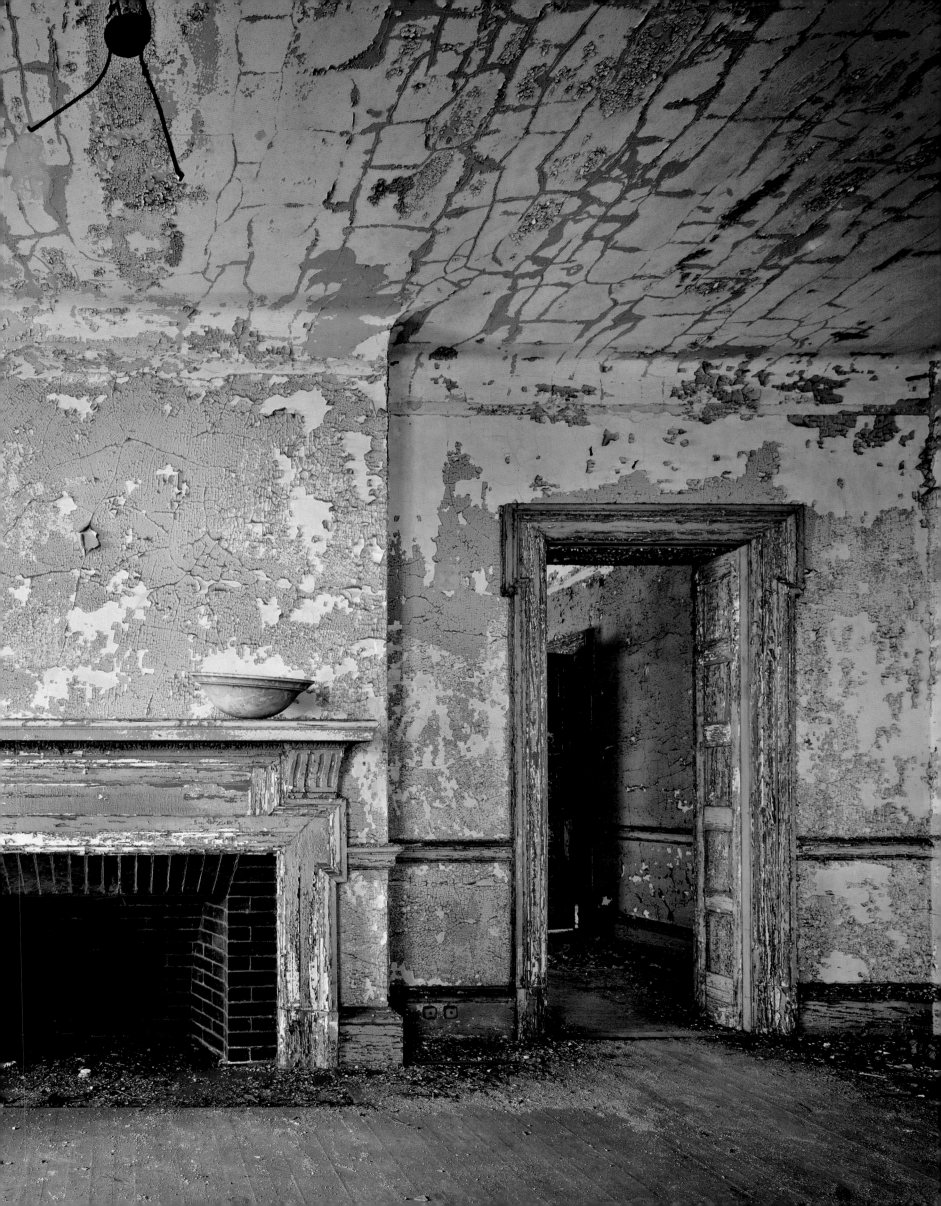

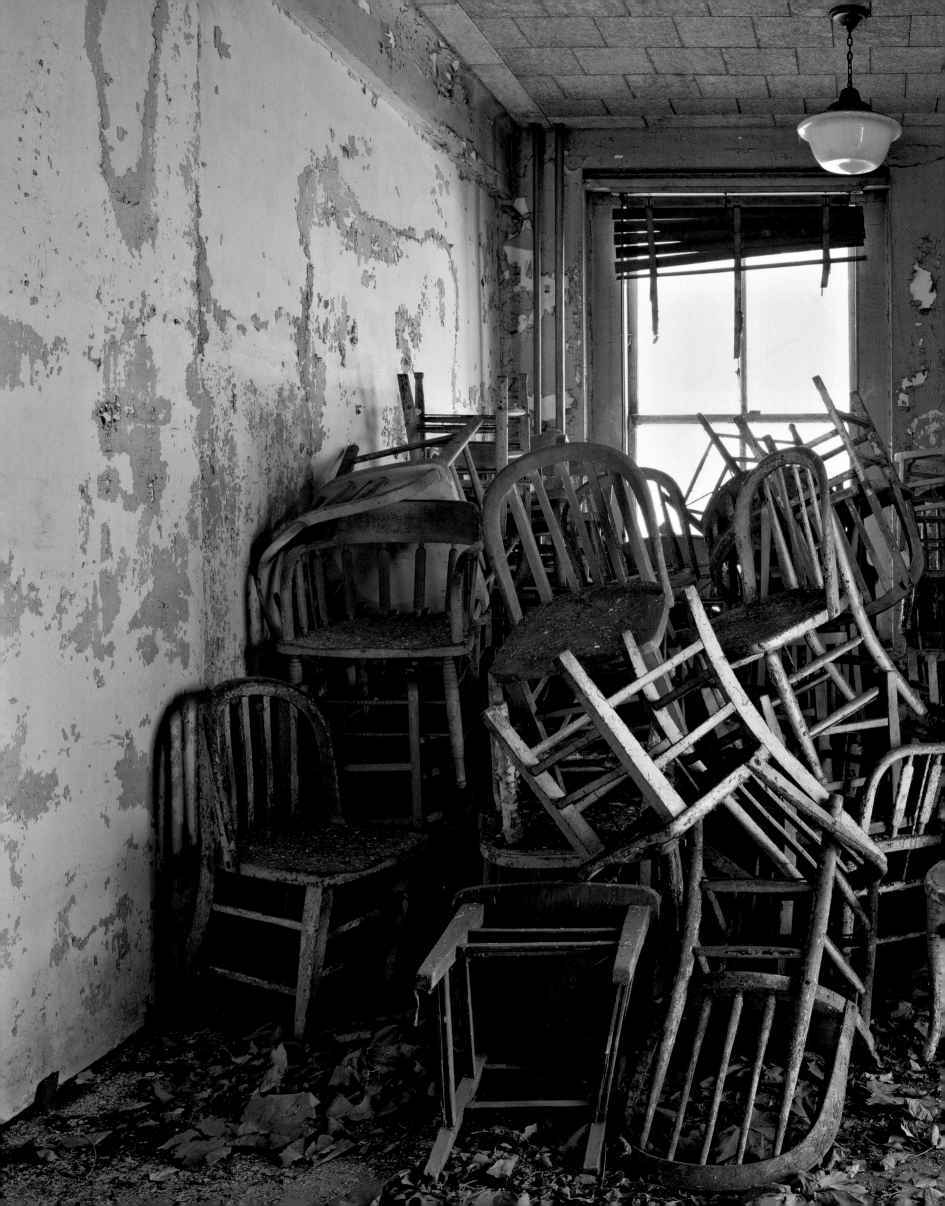

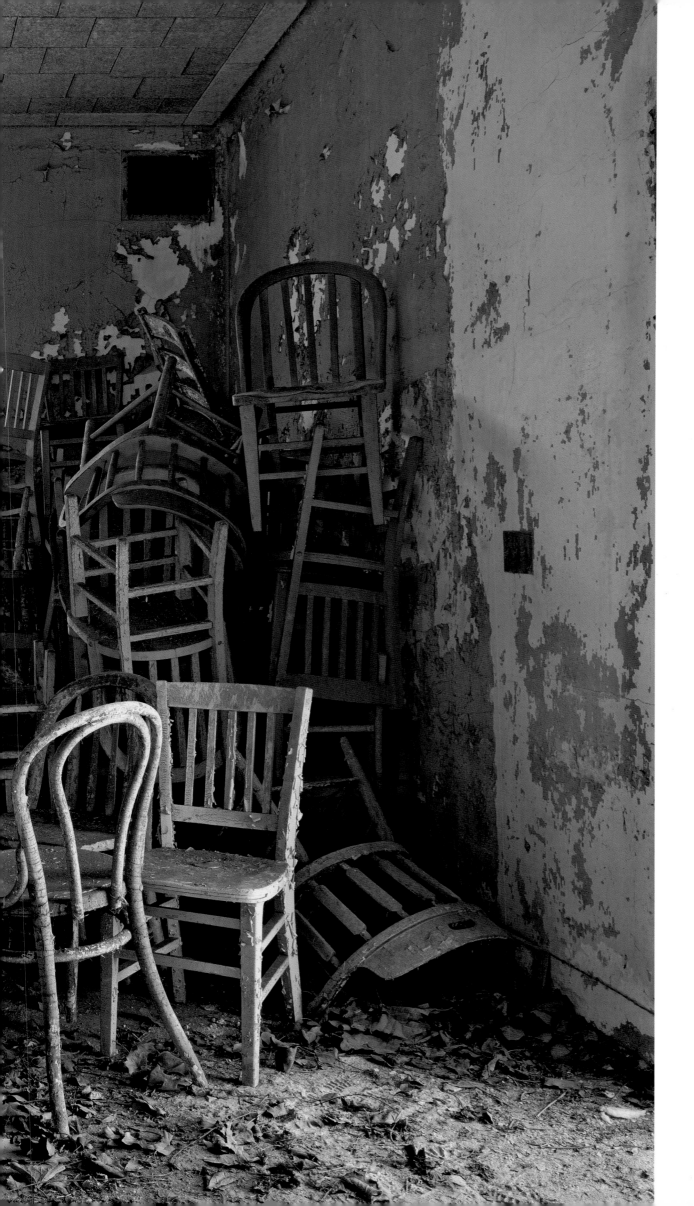

Measles ward, huddled chairs 43

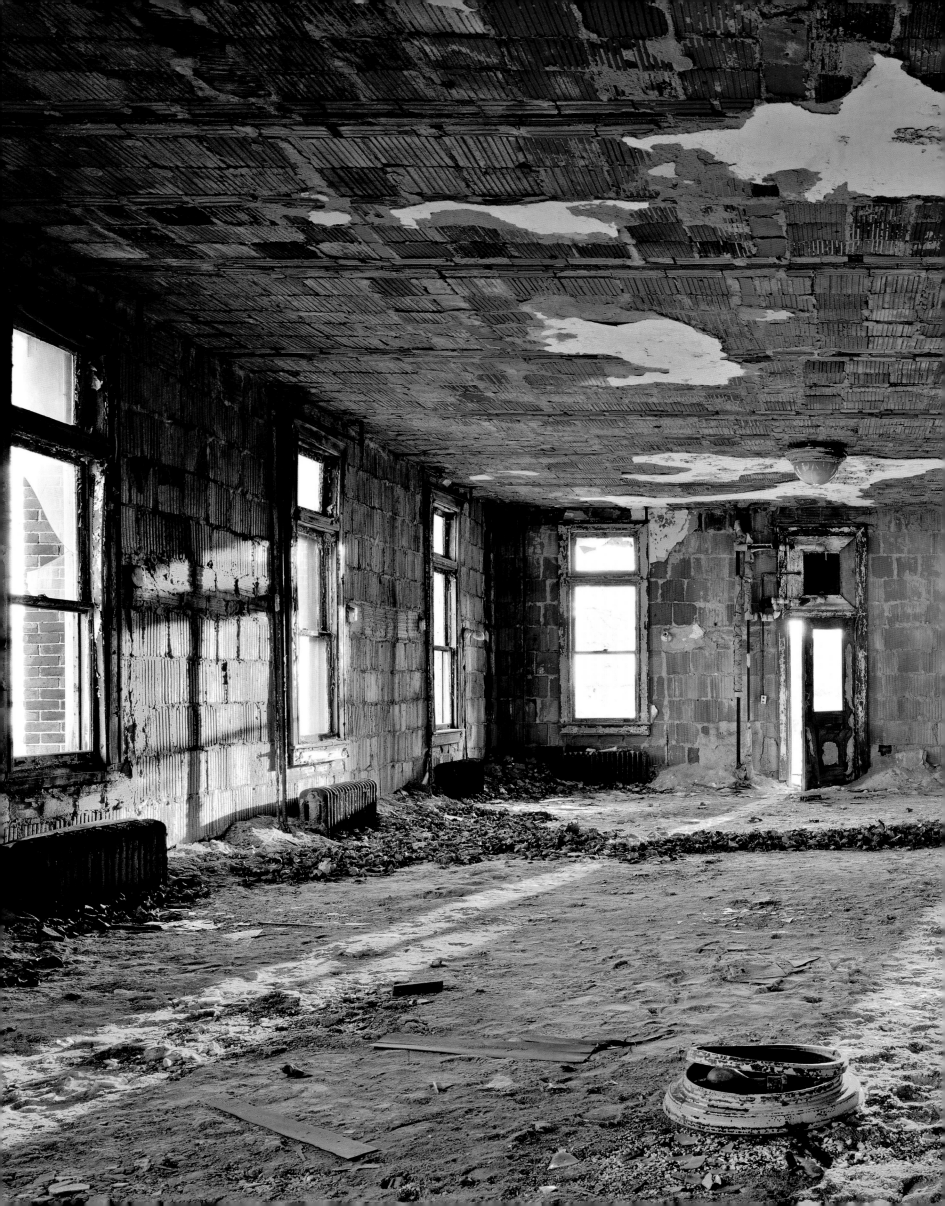

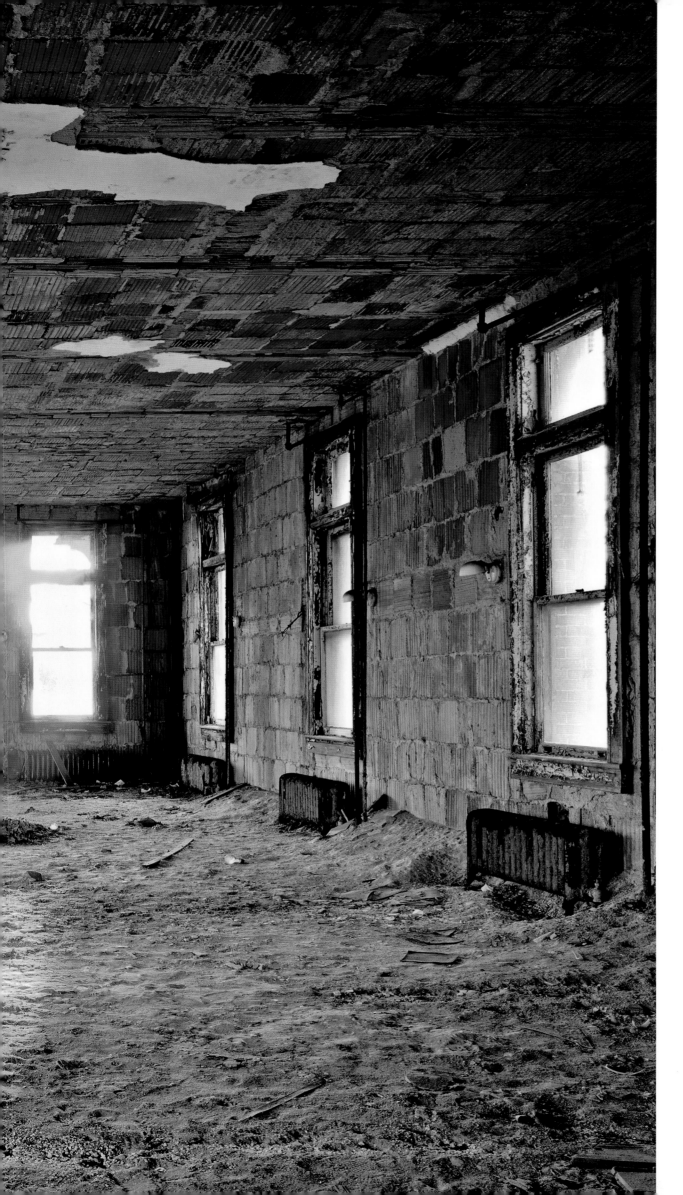

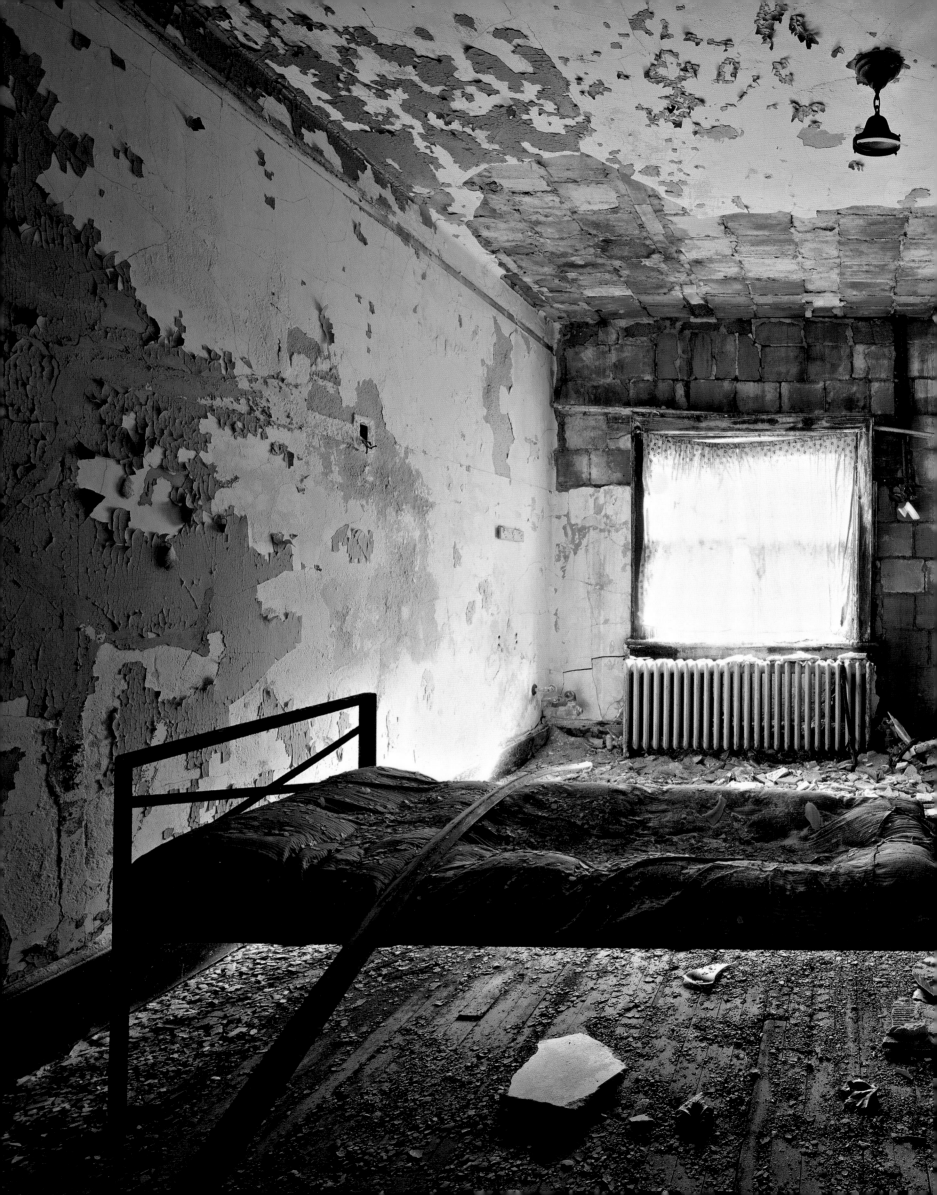

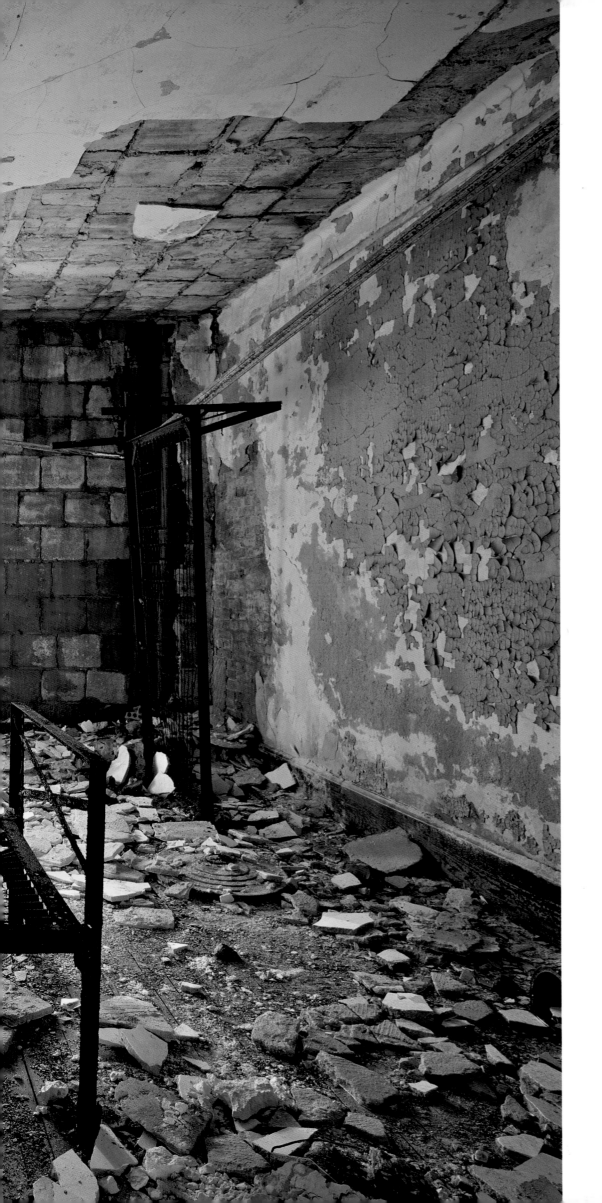

Psychiatric hospital, sunken bed 47

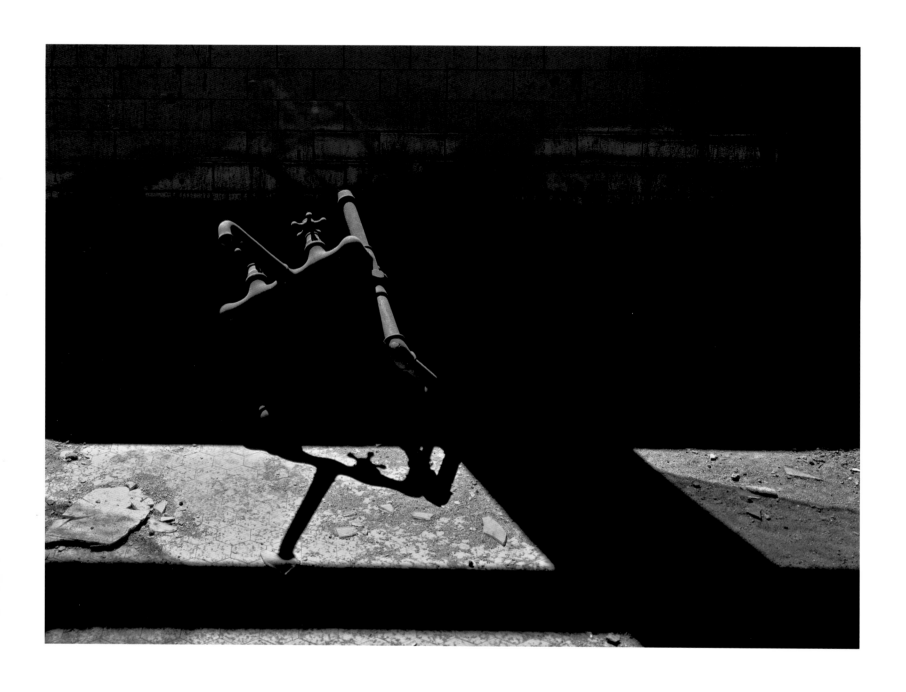

ABOVE AND OPPOSITE: Hospital extension, faucet studies

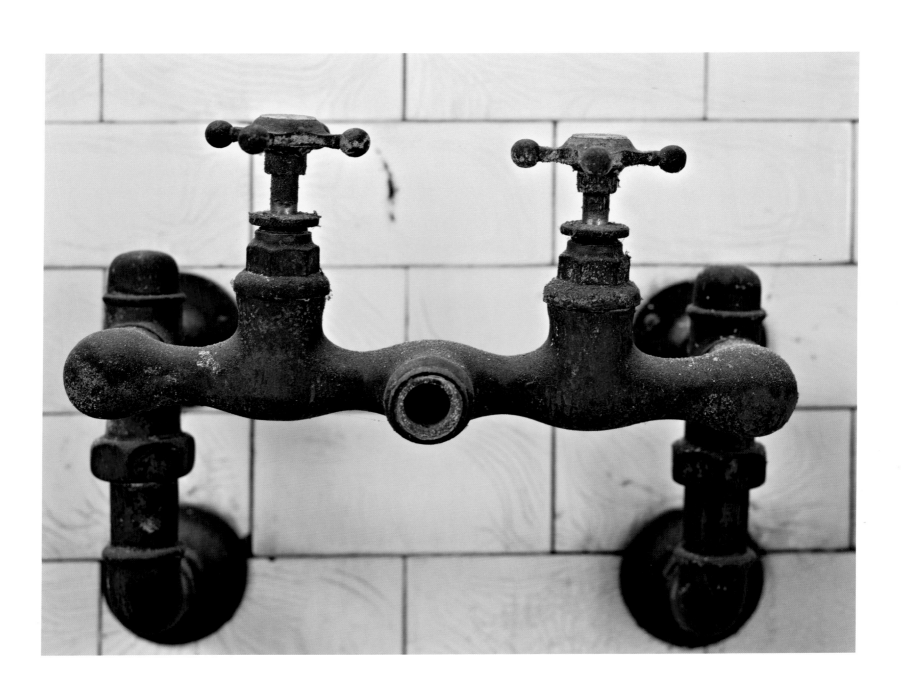

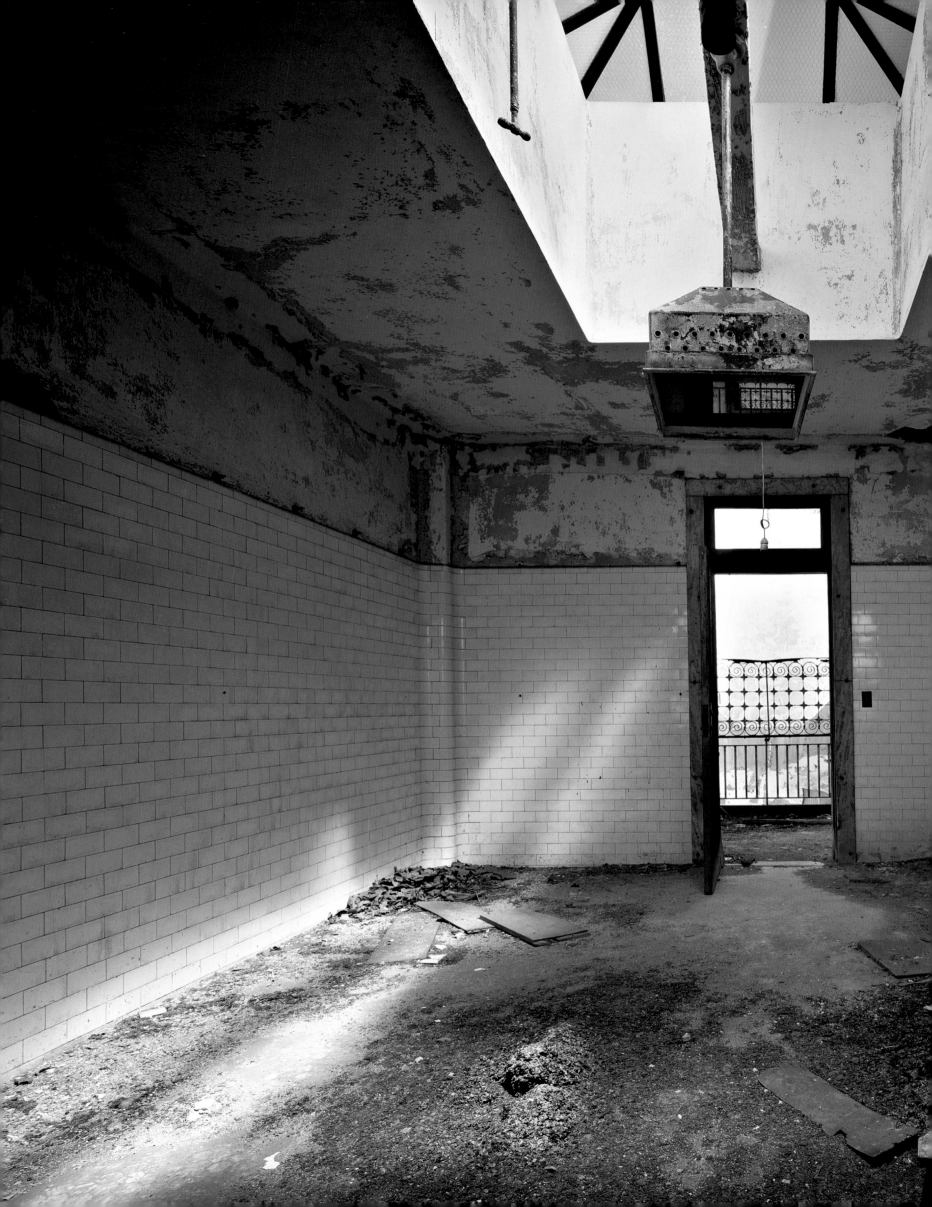

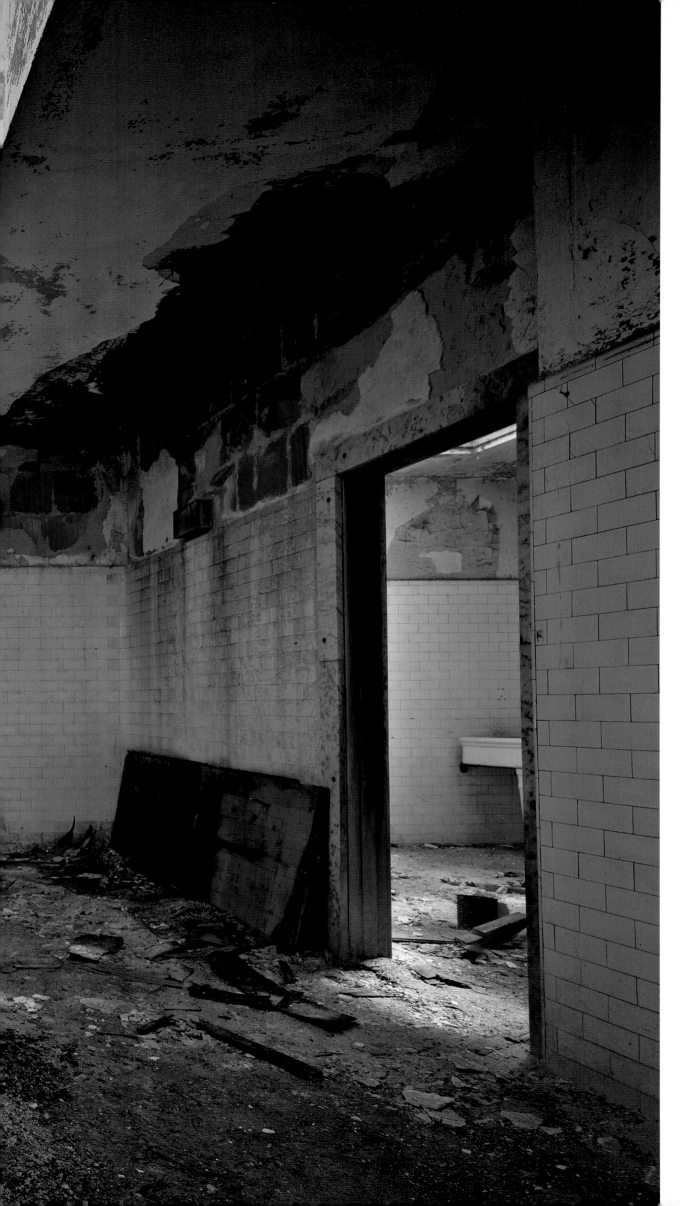

Administration building, room with vines

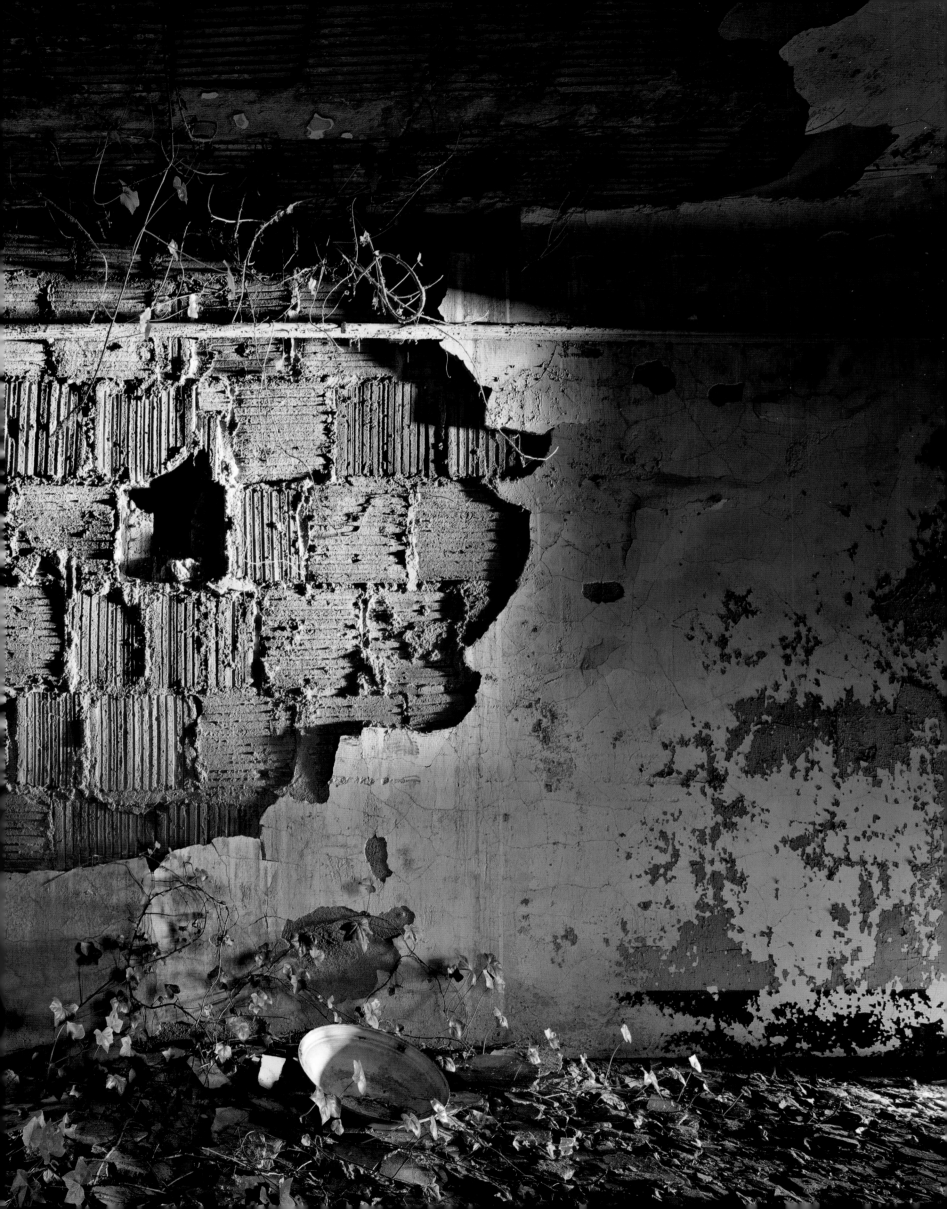

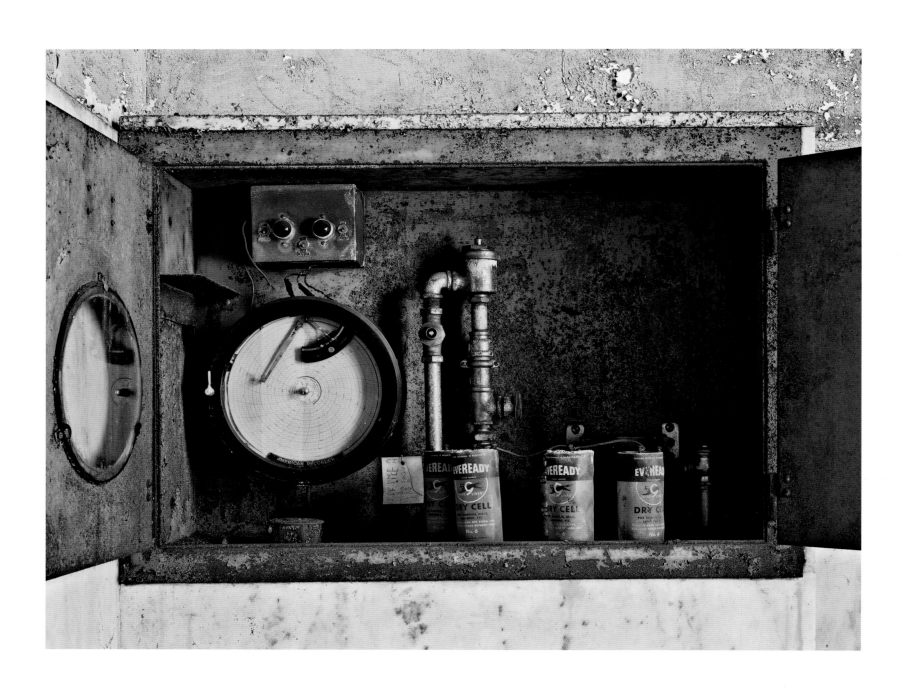

ABOVE: Isolation ward, Eveready batteries
ON PAGE 55: Main hospital, morgue

THIS WAS NOT THE
AMERICA I WAS LED TO
BELIEVE IT WAS GOING
TO BE, AND HERE I WAS,
LITERALLY A PRISONER.

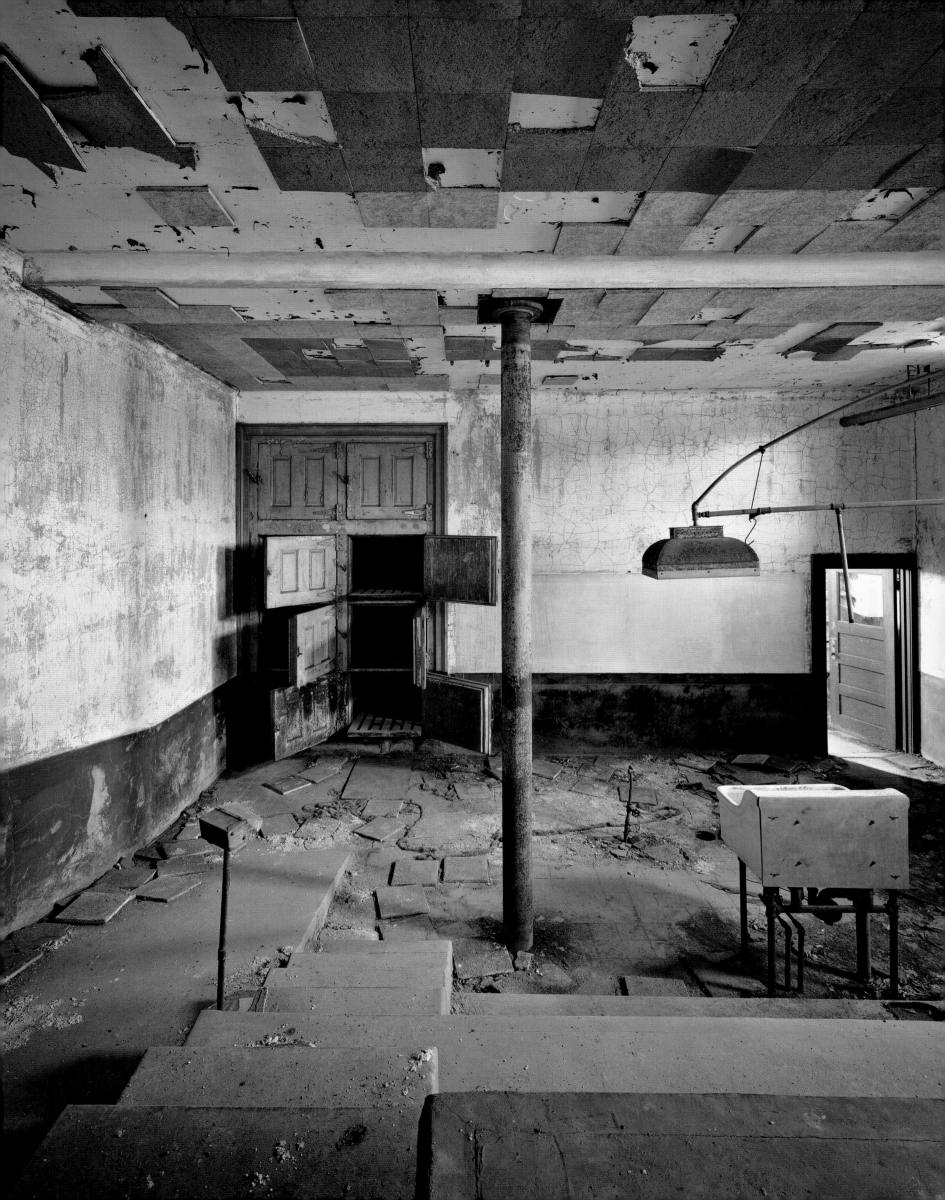

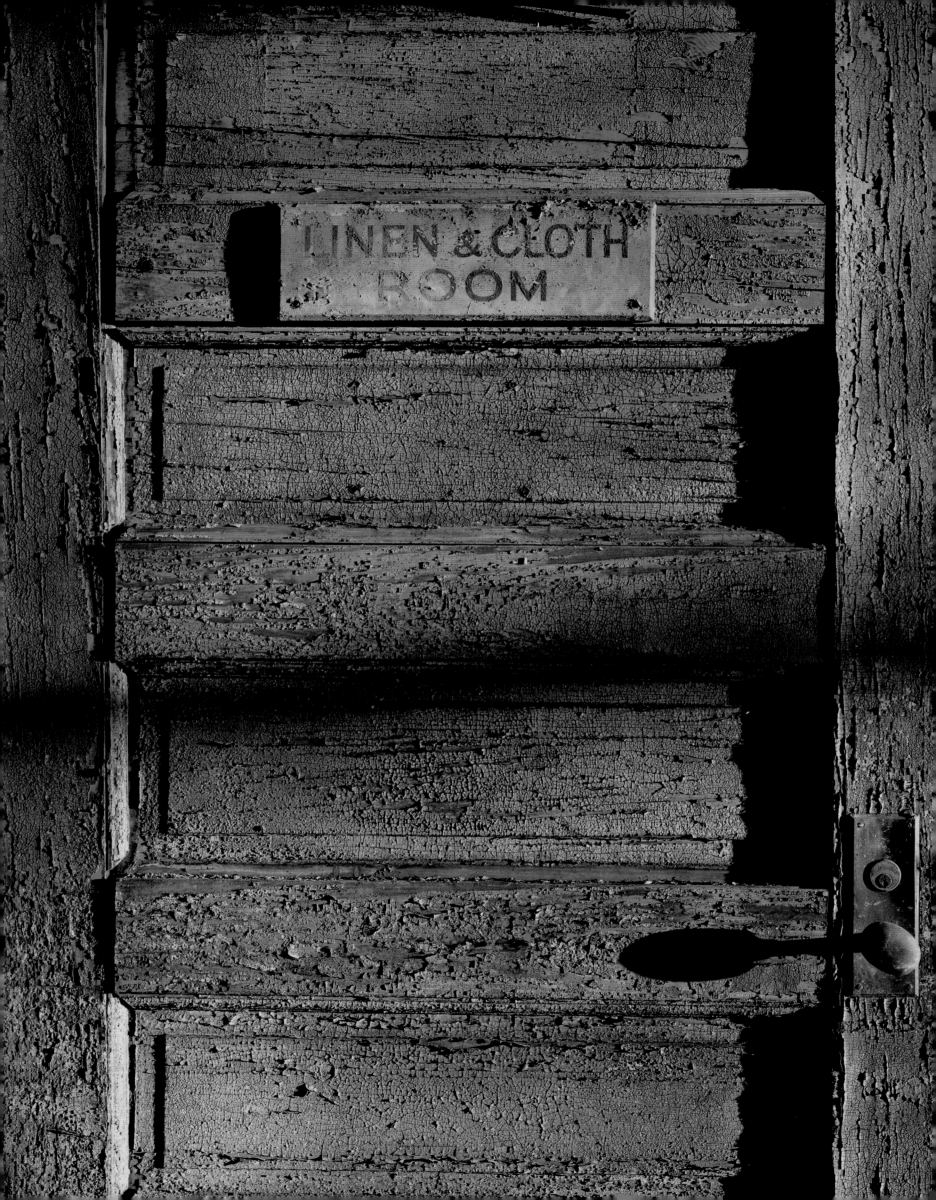

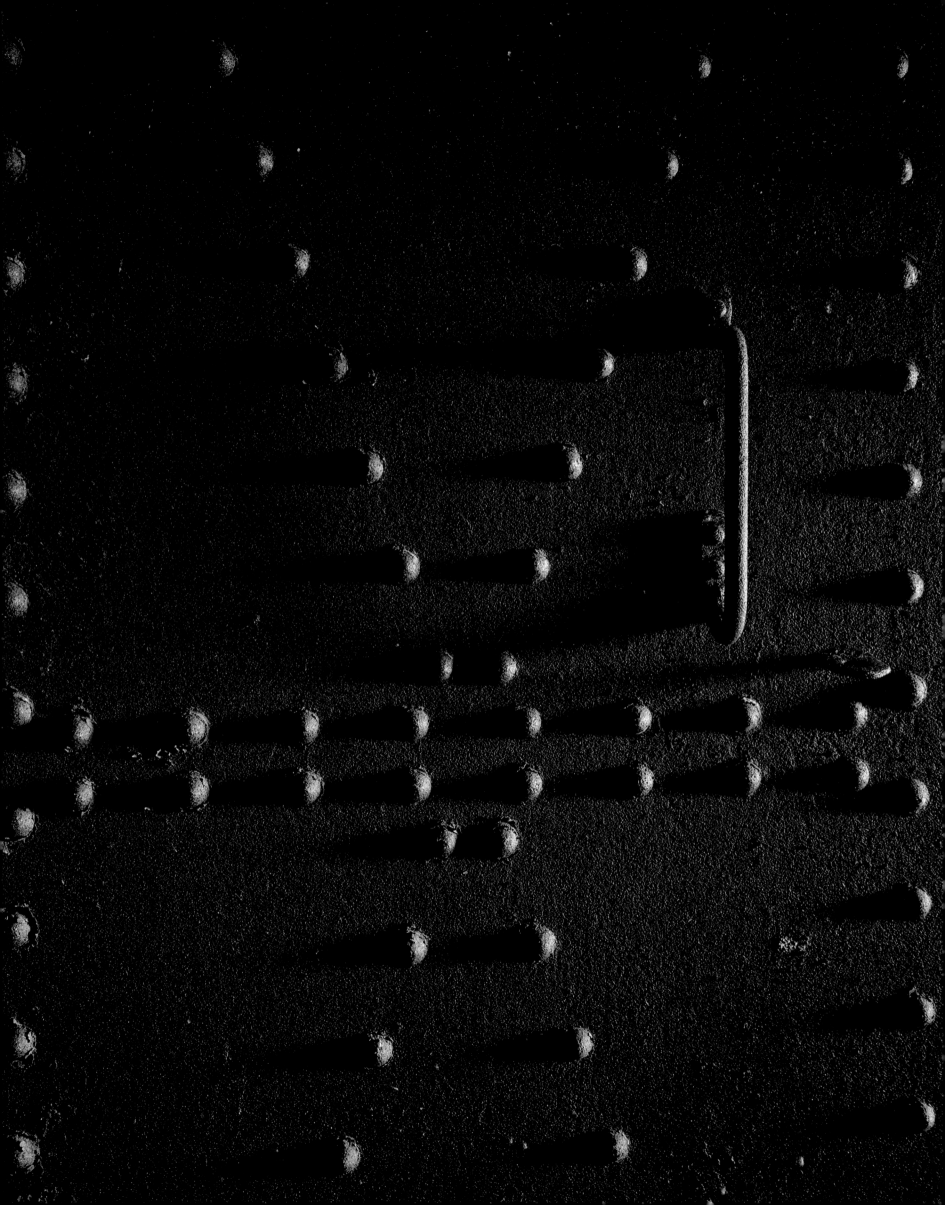

PRECEDING PAGES: Linen room and powerhouse, door studies

ABOVE: White tile study, operating room

OPPOSITE PAGE: Measles ward, brick study

OPPOSITE PAGE: Measles ward, hallway study with plant life

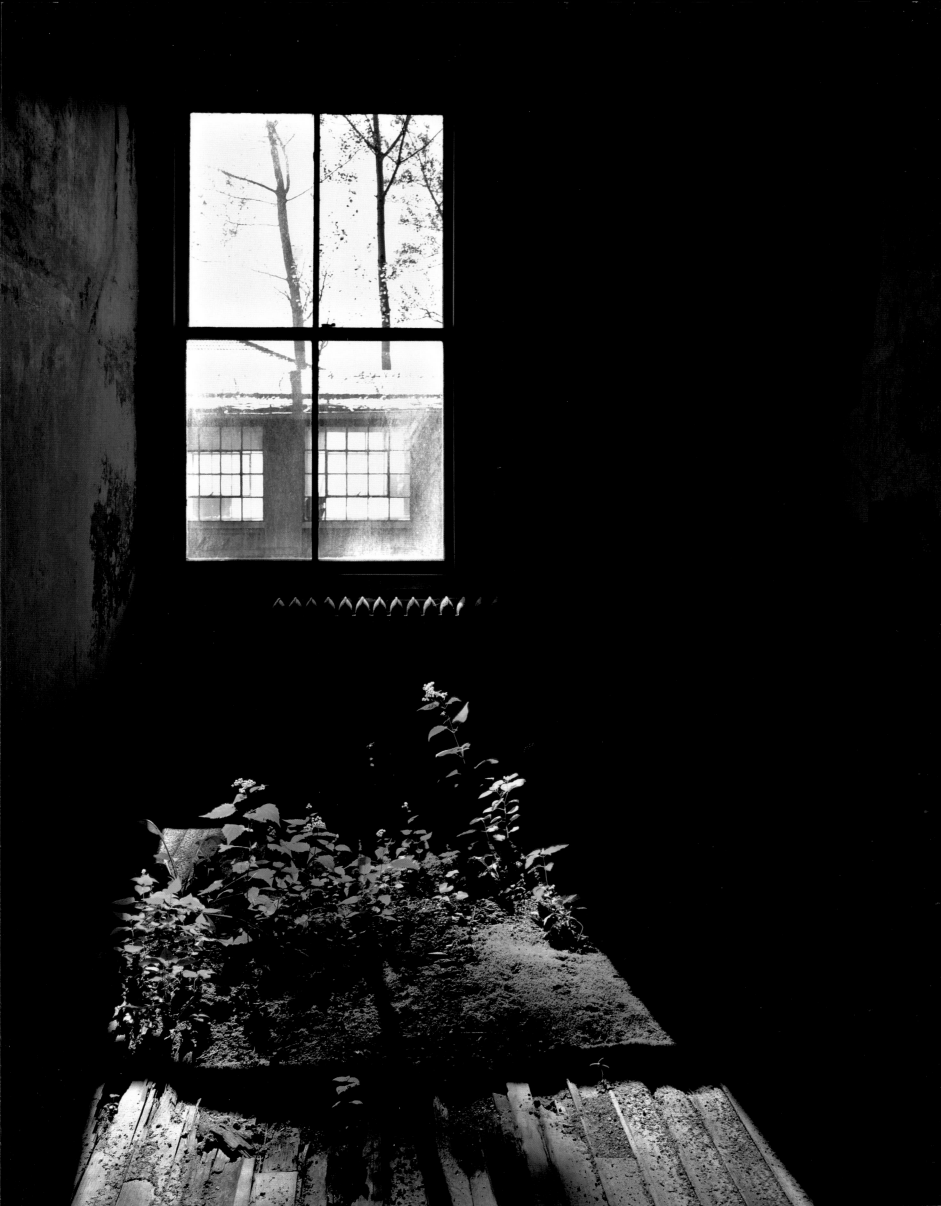

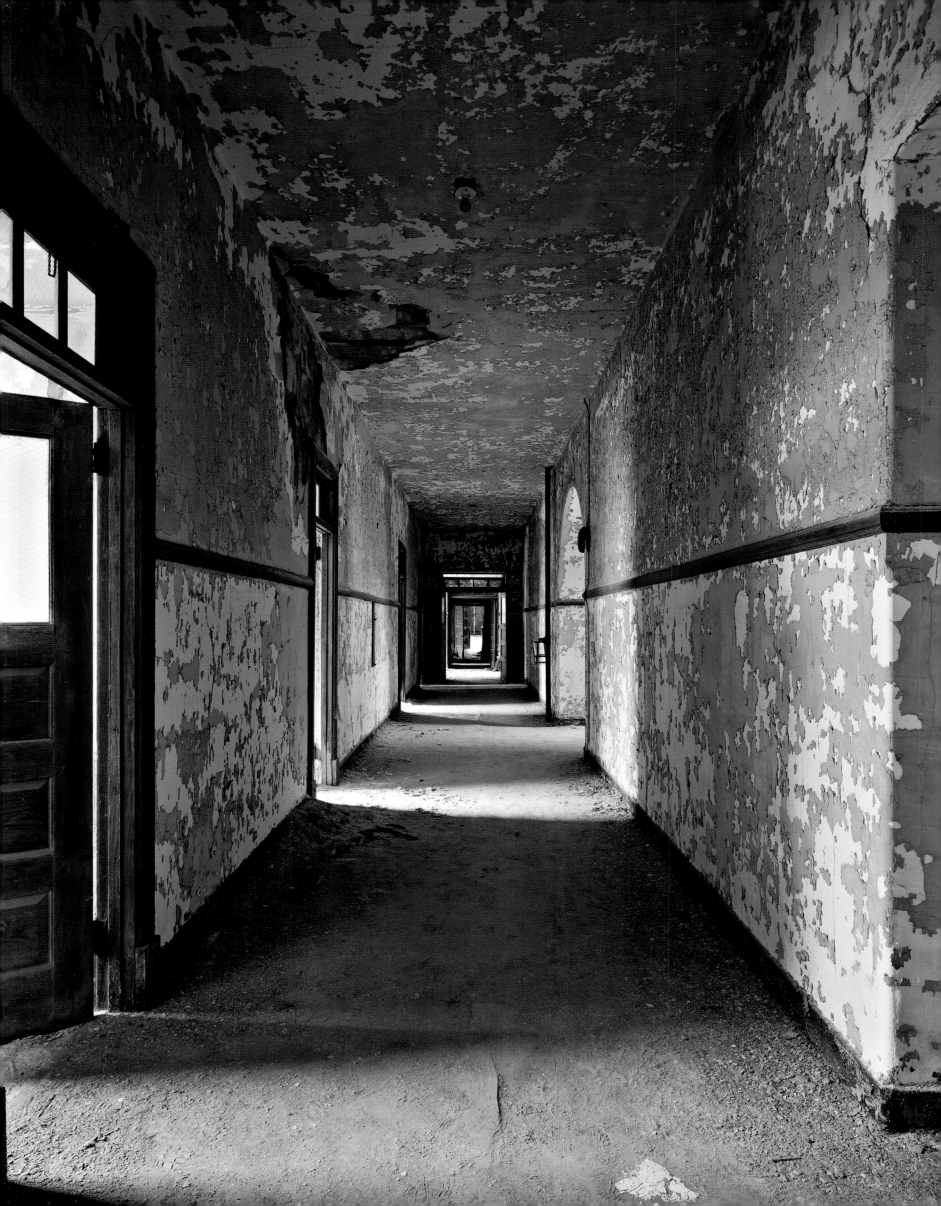

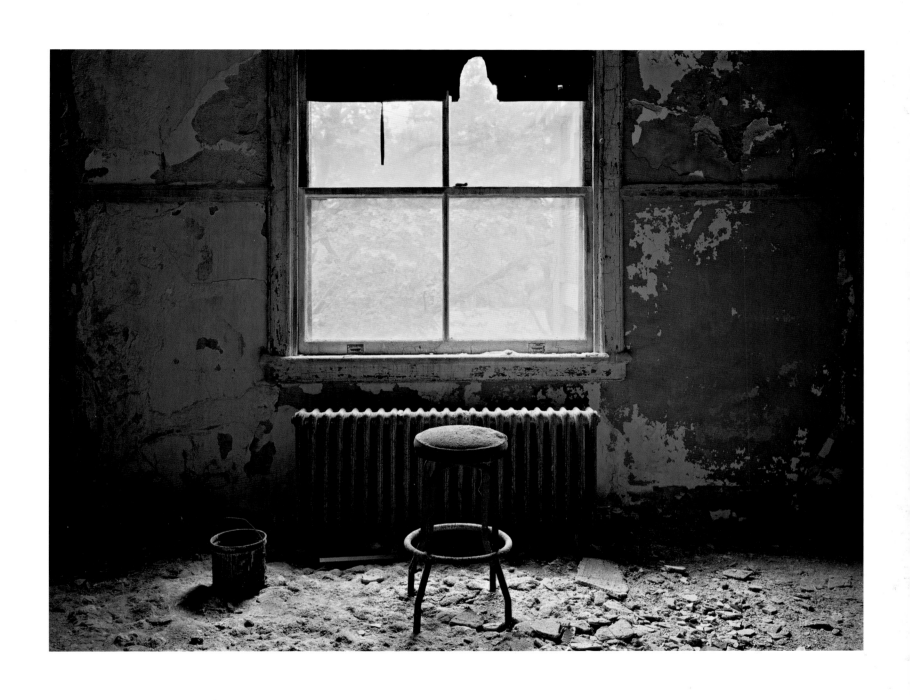

ABOVE: Hospital extension, bar stool
OPPOSITE: Psychiatric hospital, green hallway

OPPOSITE PAGE: Ceiling light fixture (detail)

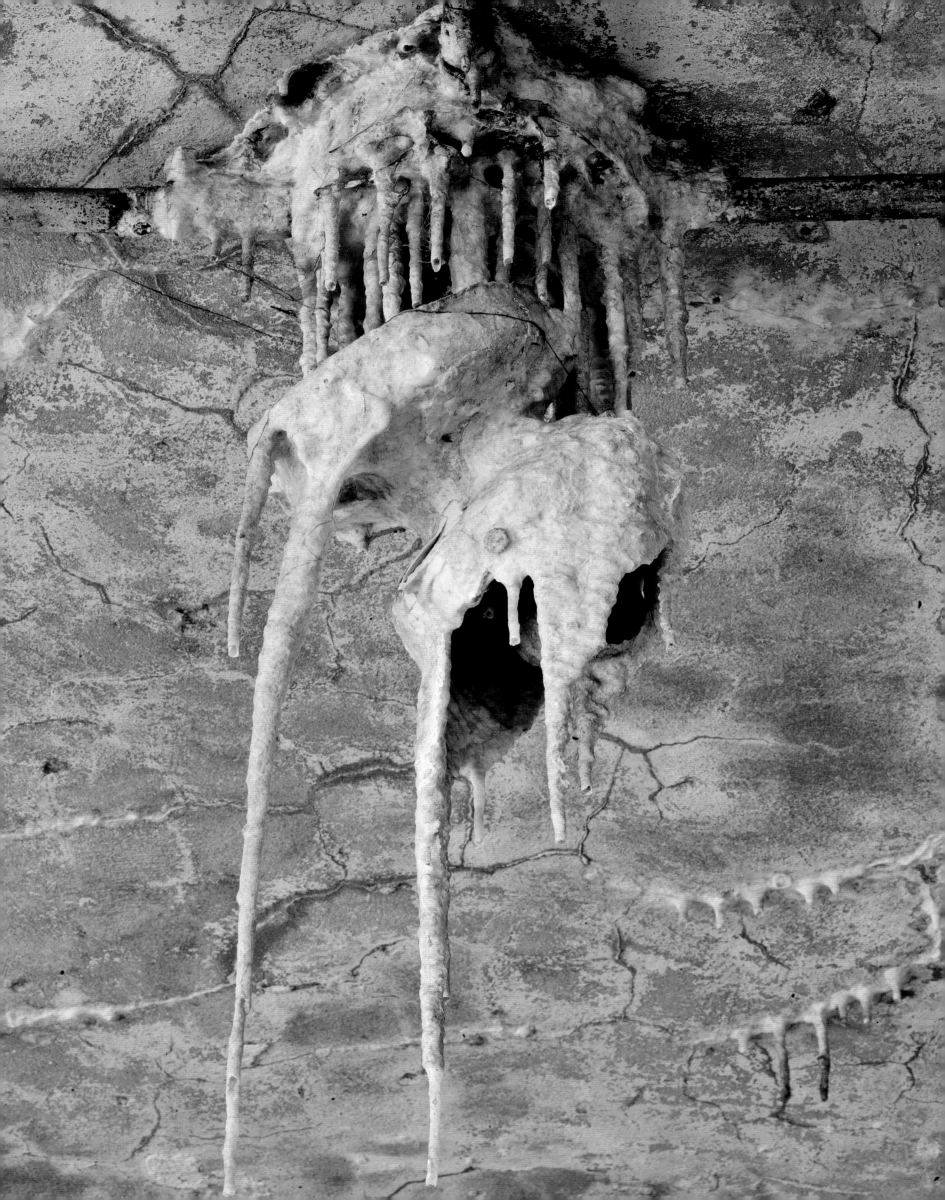

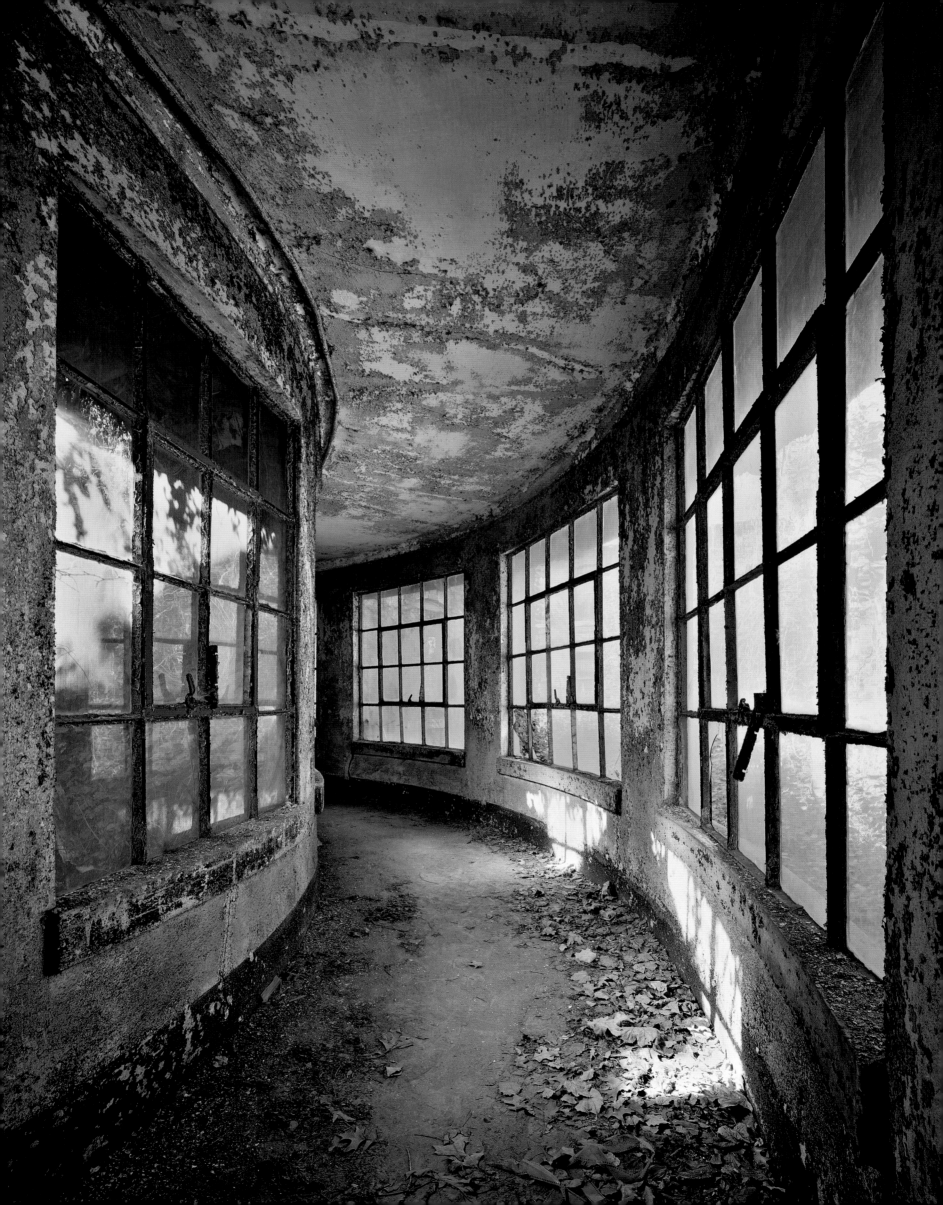

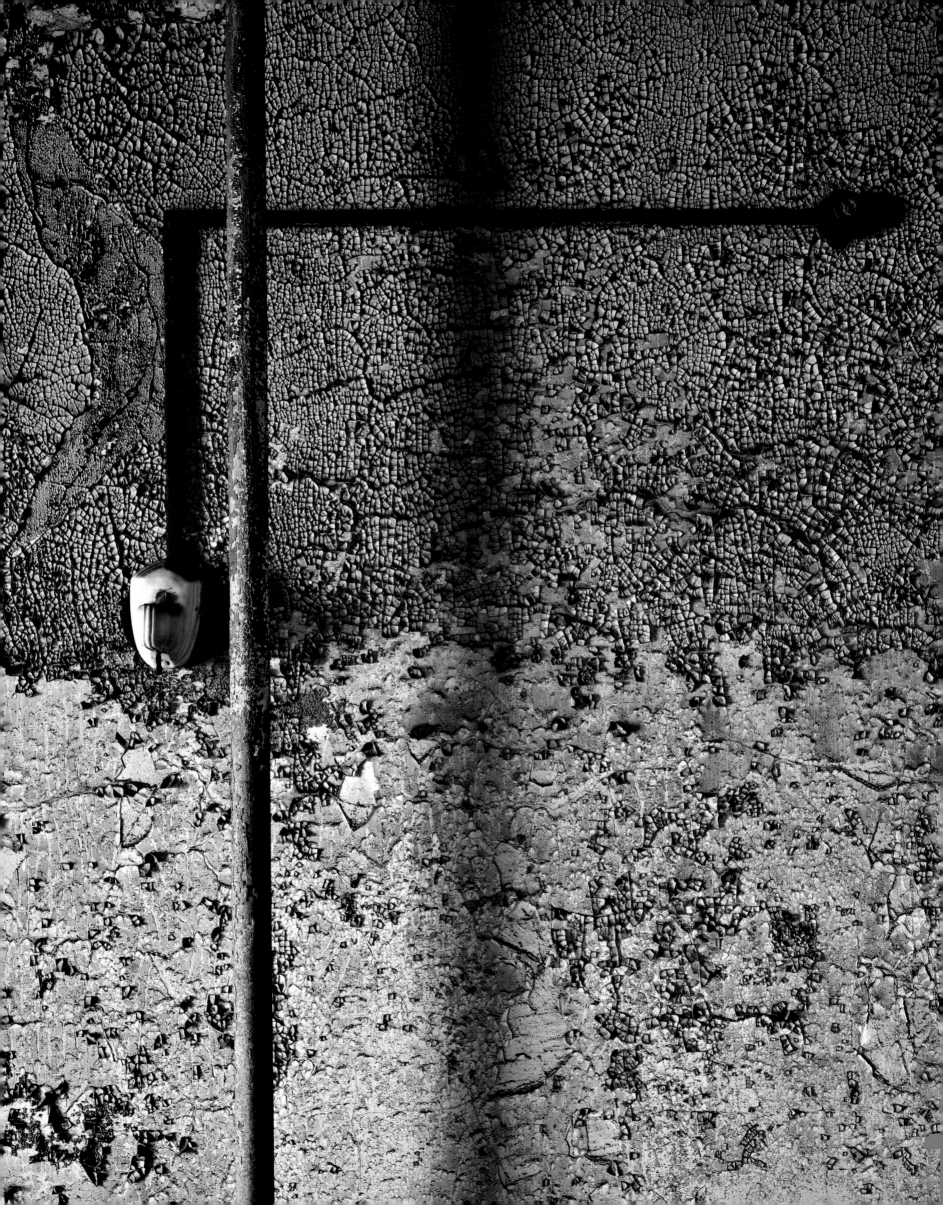

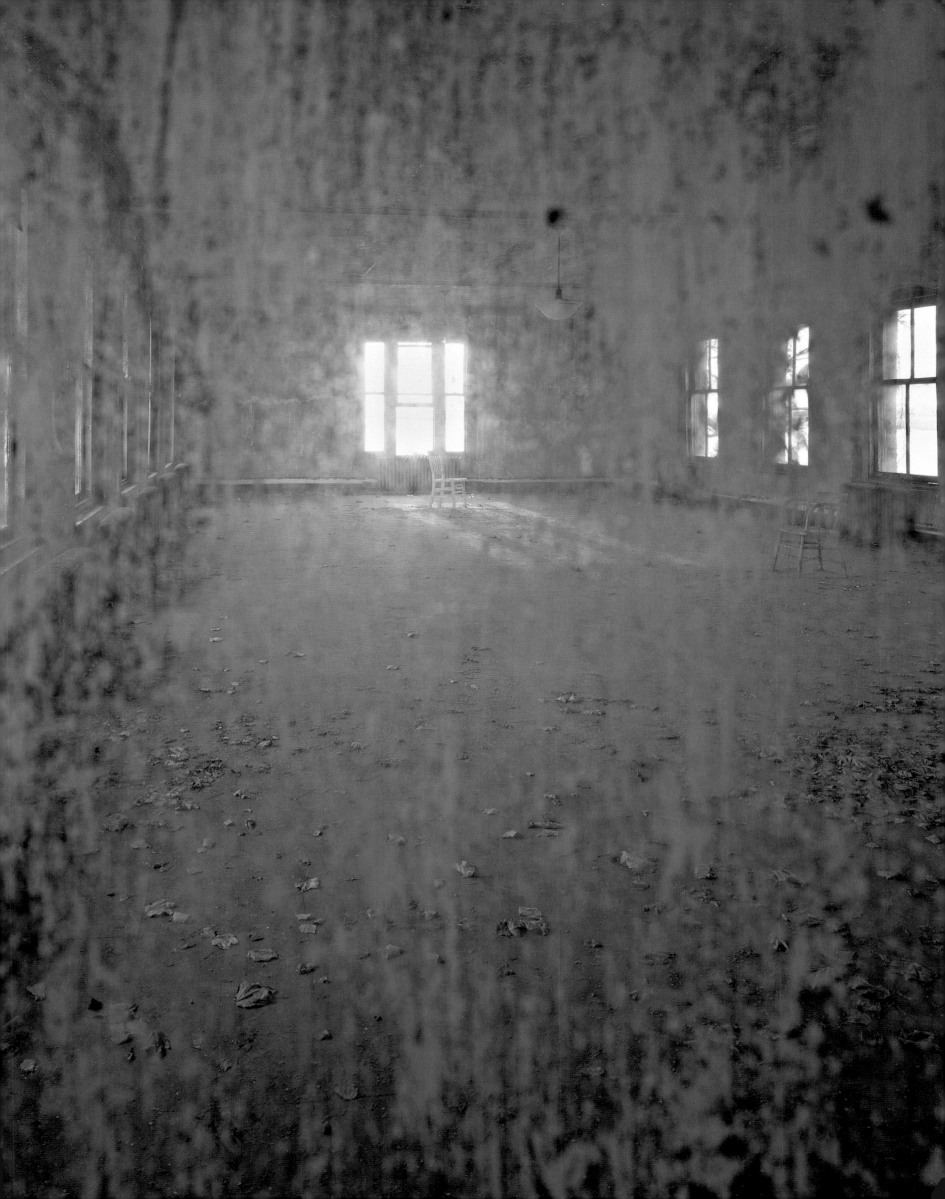

NOBODY SAID
A WORD TO ME
FOR TWENTY-
THREE DAYS.

NOBODY SAID
A WORD TO ME
FOR TWENTY-
THREE DAYS.

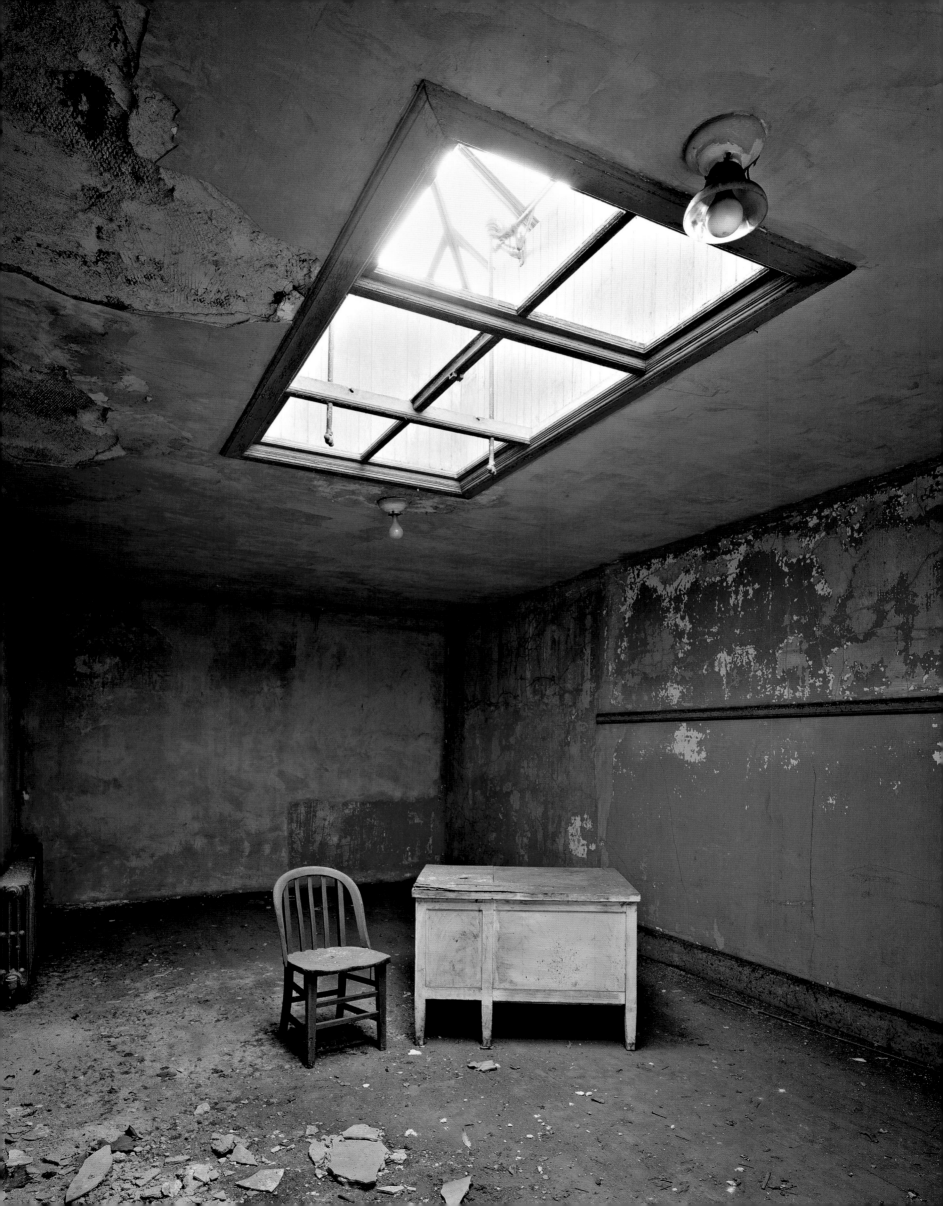

PRECEDING PAGE: Psychiatric hospital, green room
THIS PAGE: Measles ward, puddle of snow

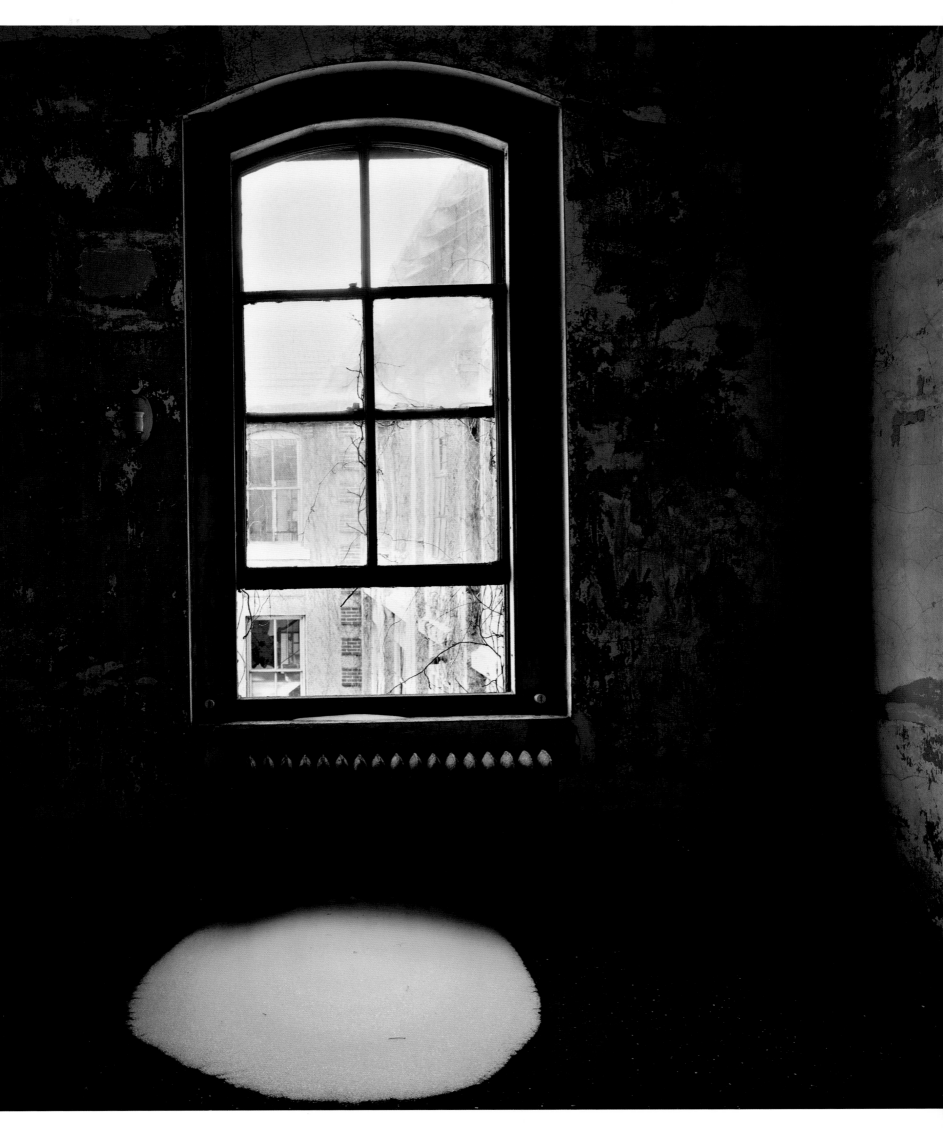

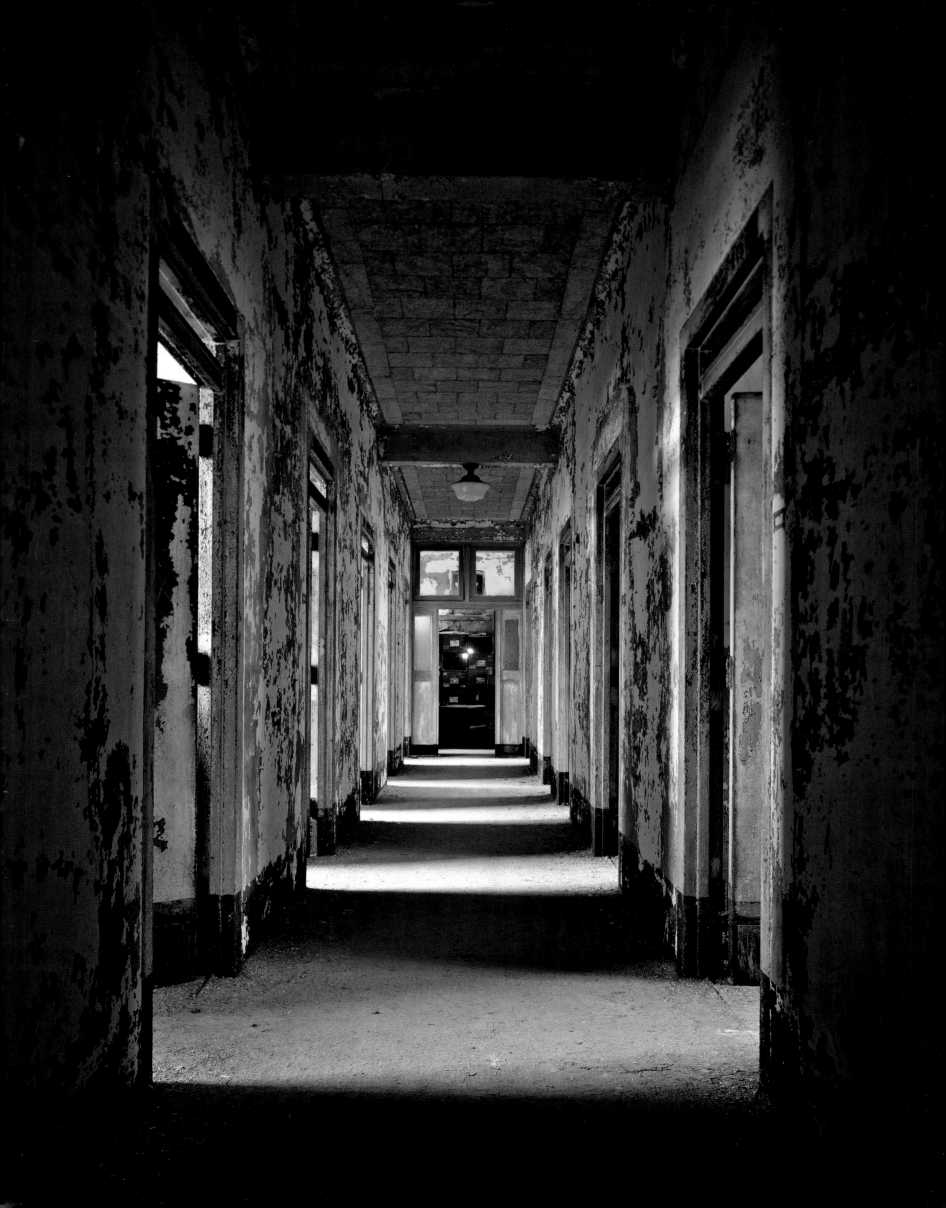

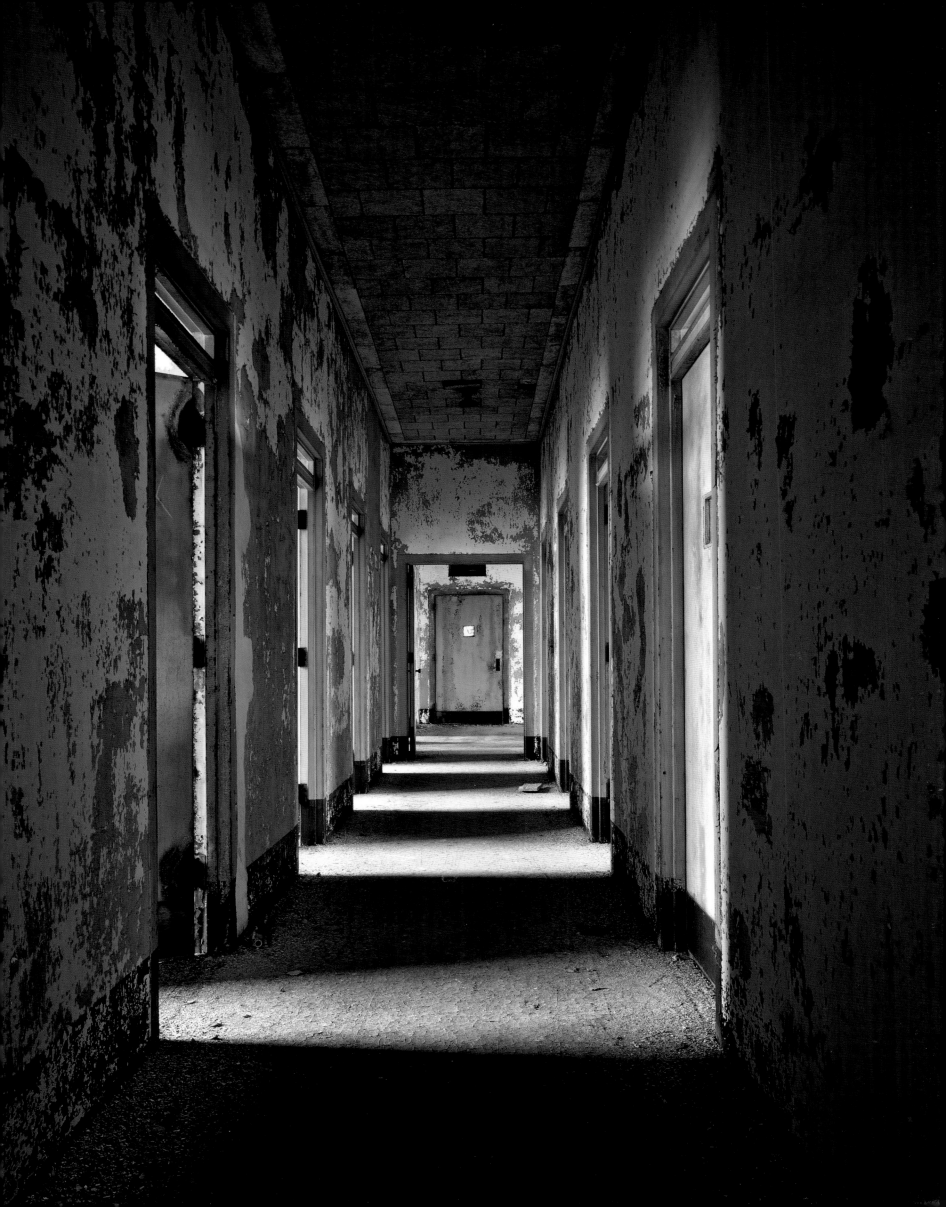

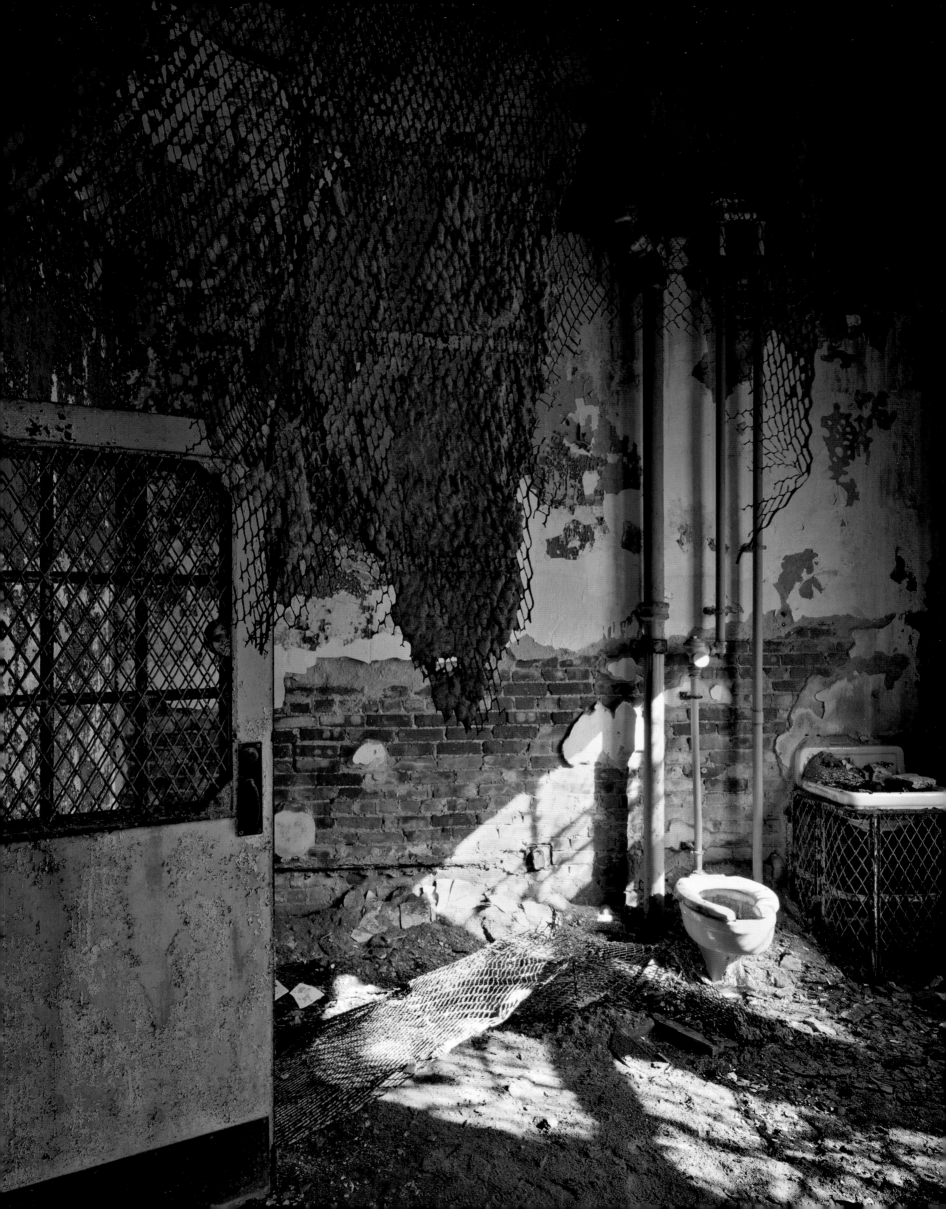

I RECALL ONE FELLOW
WHO WOULD STAND
IN A CORNER ALL DAY
LOOKING AT THE WALL.

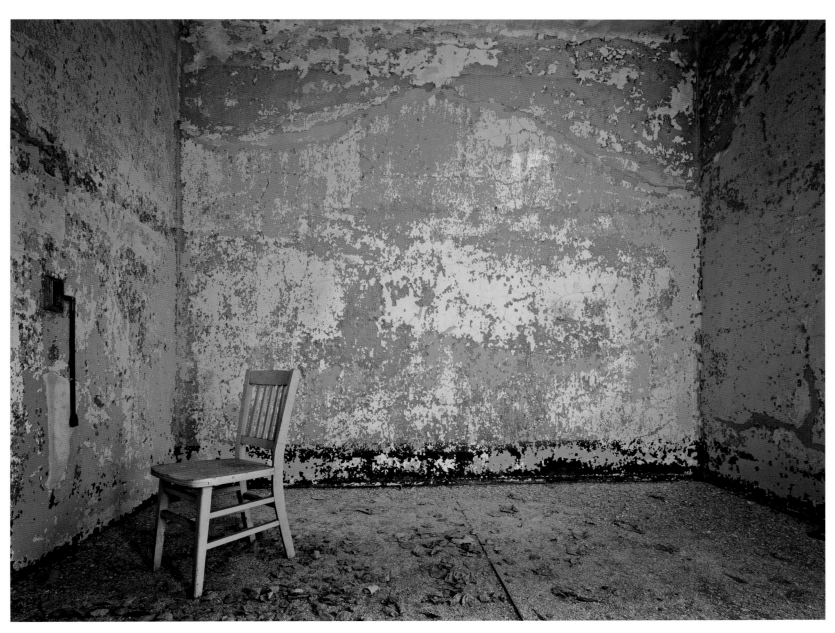

Isolation ward with white chair

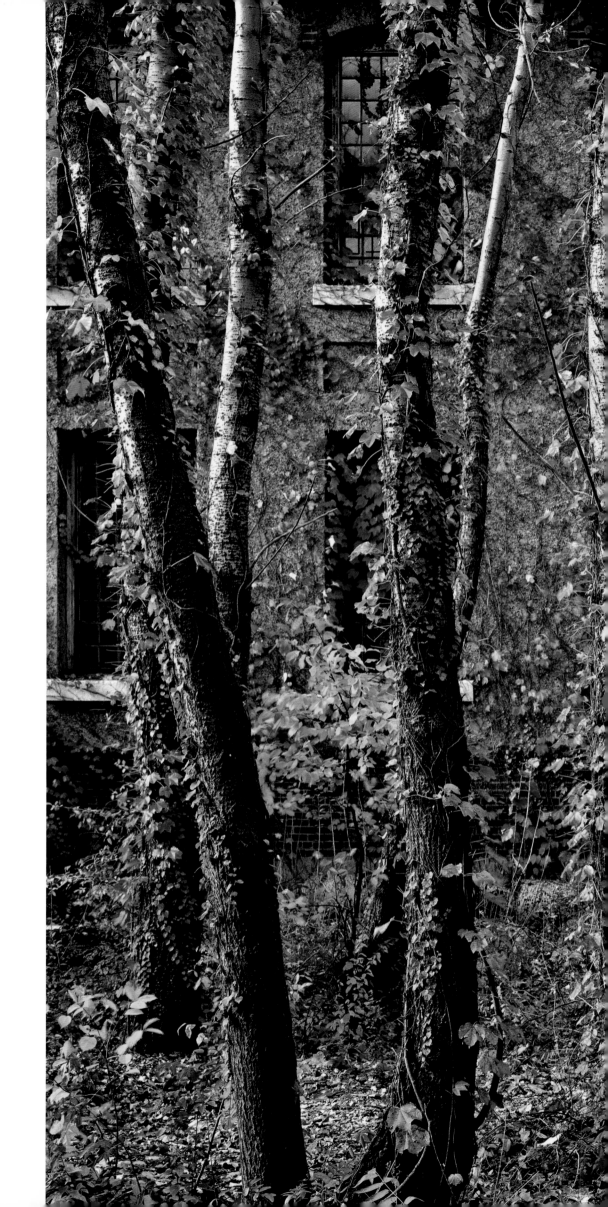

Courtyard, fall study

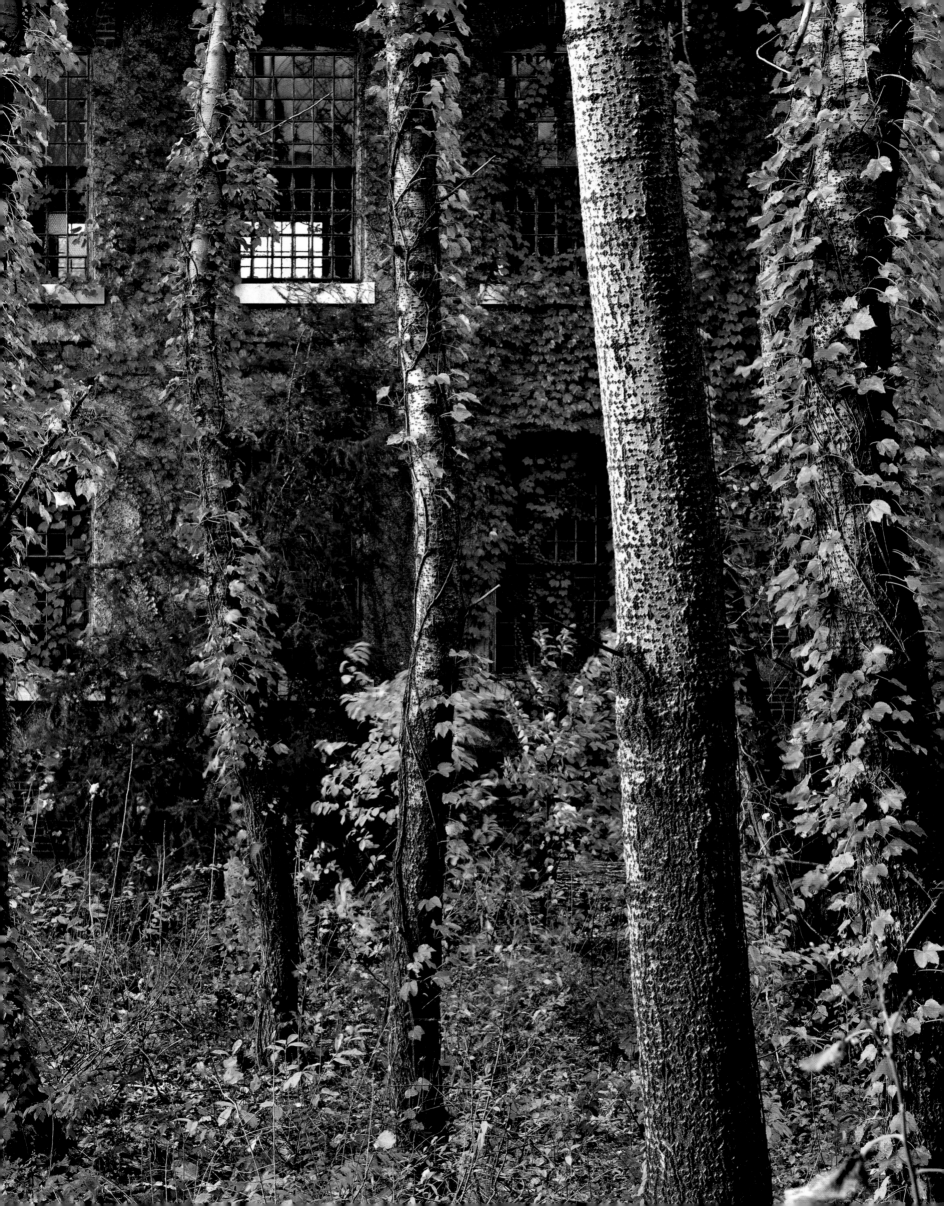

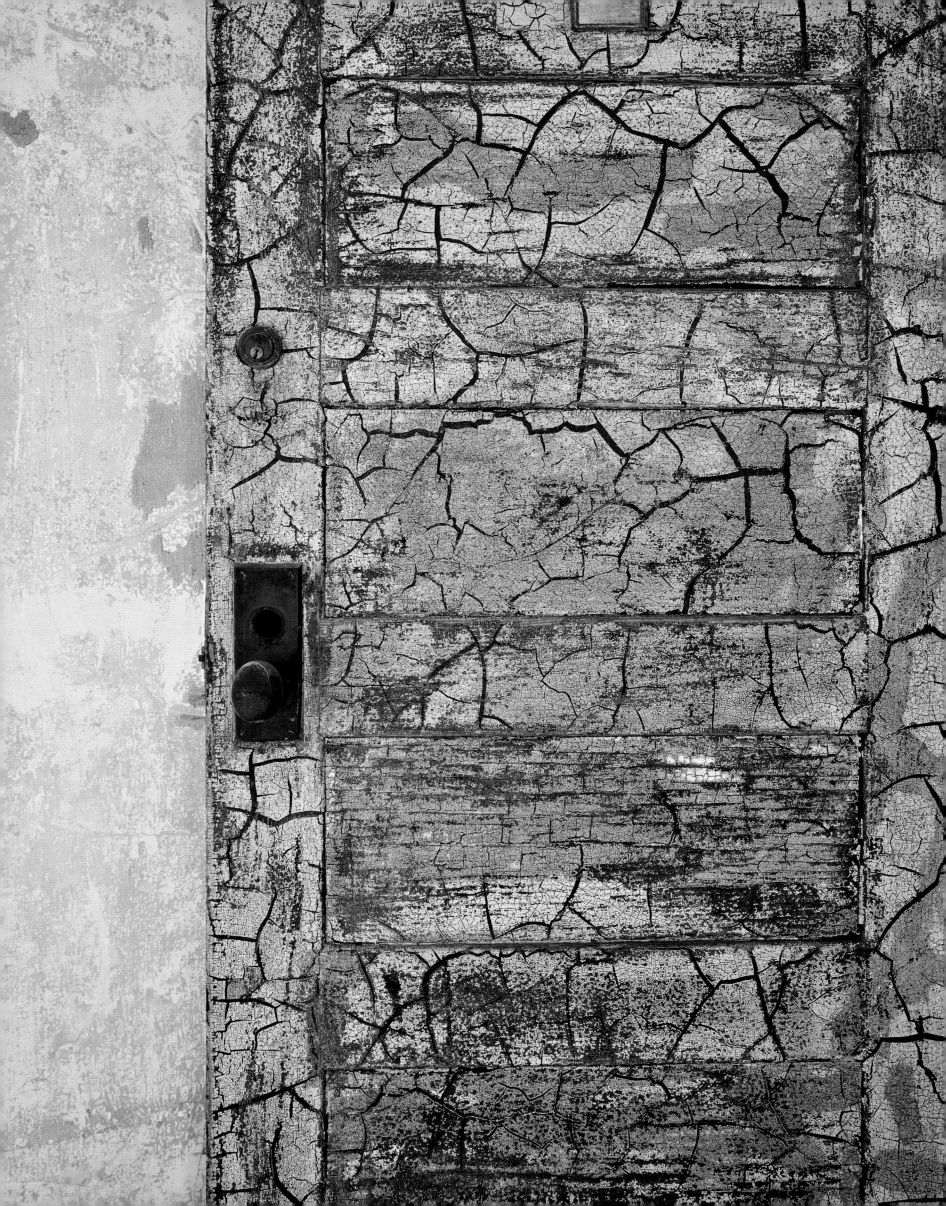

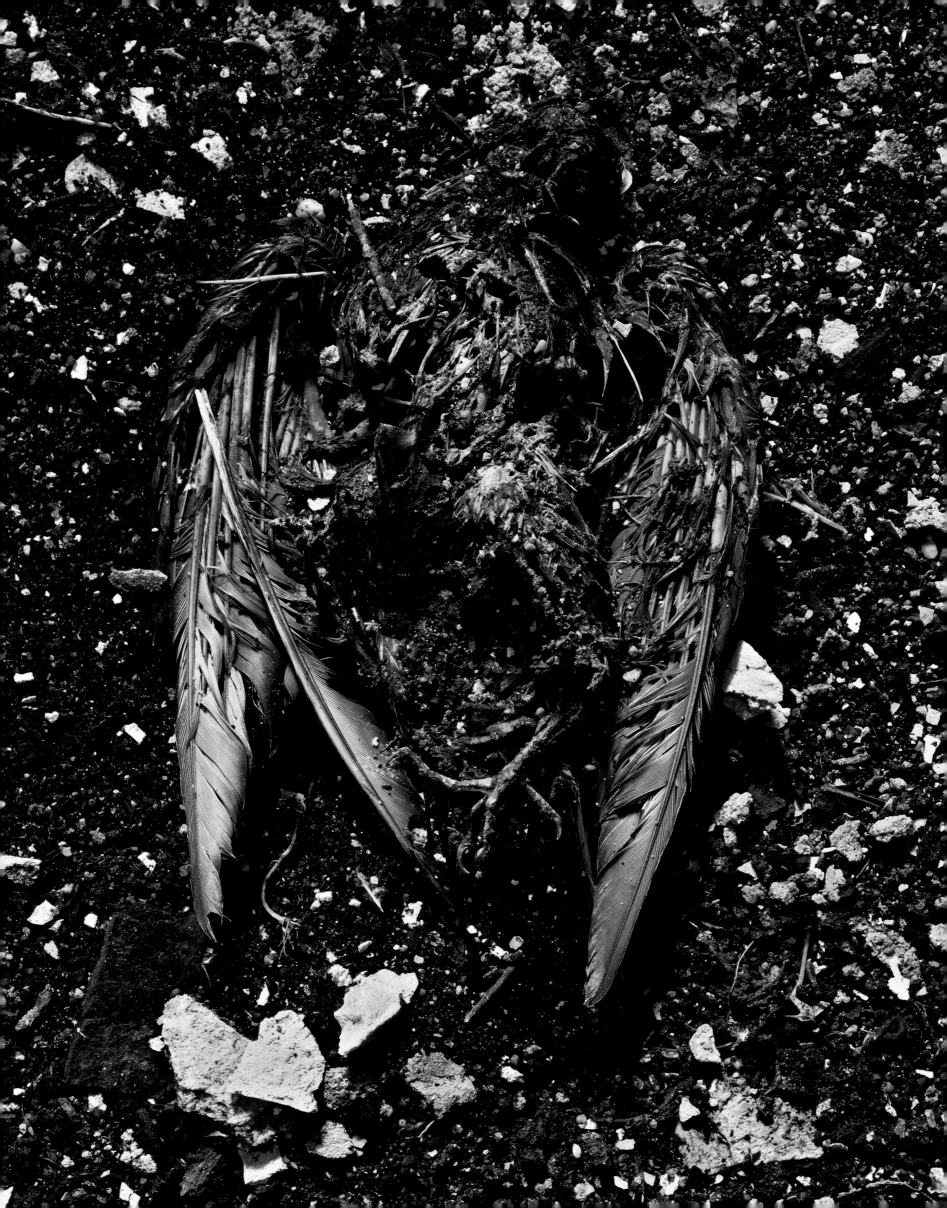

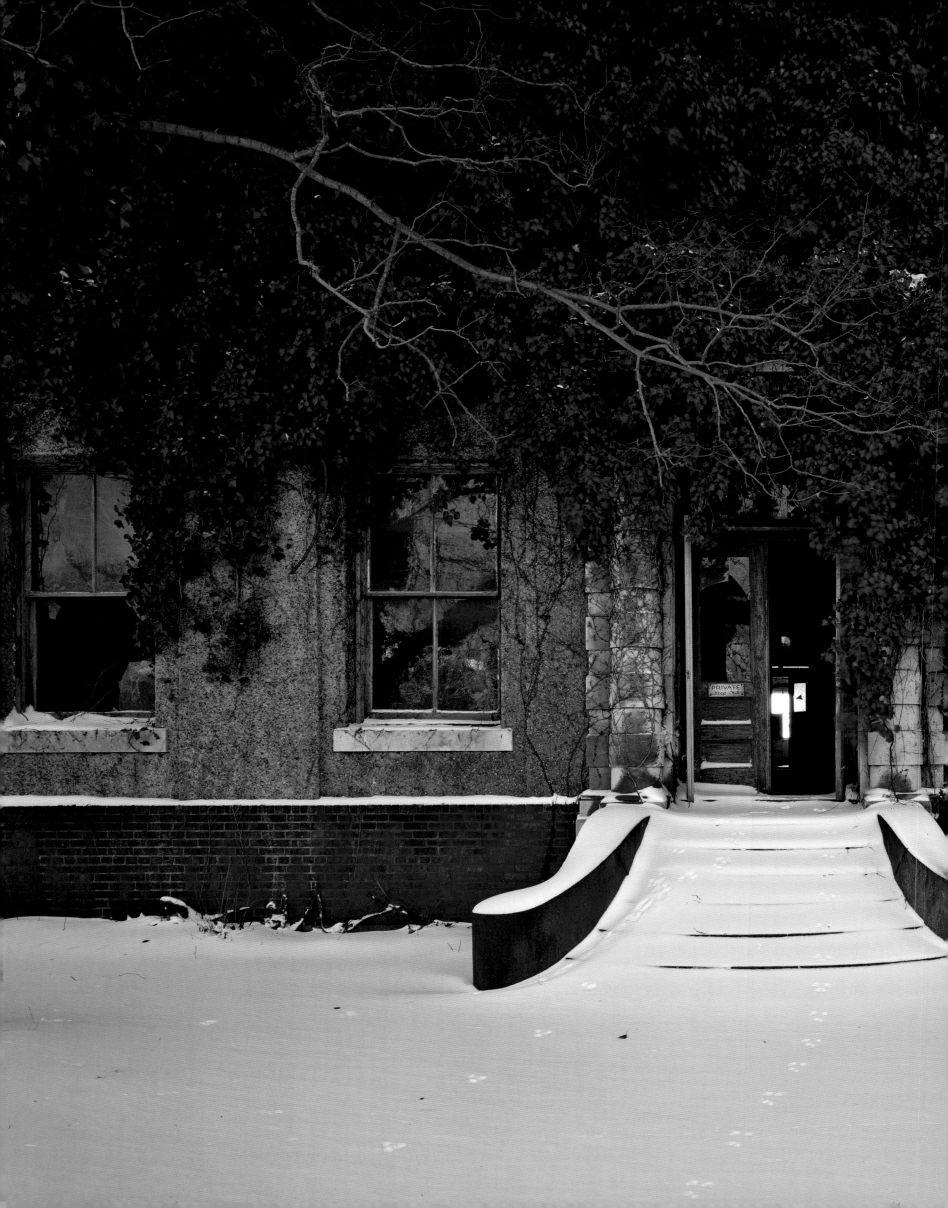

PRECEDING PAGES: LEFT: Measles ward,
shattered door study
RIGHT: Hospital extension, operating room, pigeon study
THIS PAGE: Administration building, snow-covered entrance

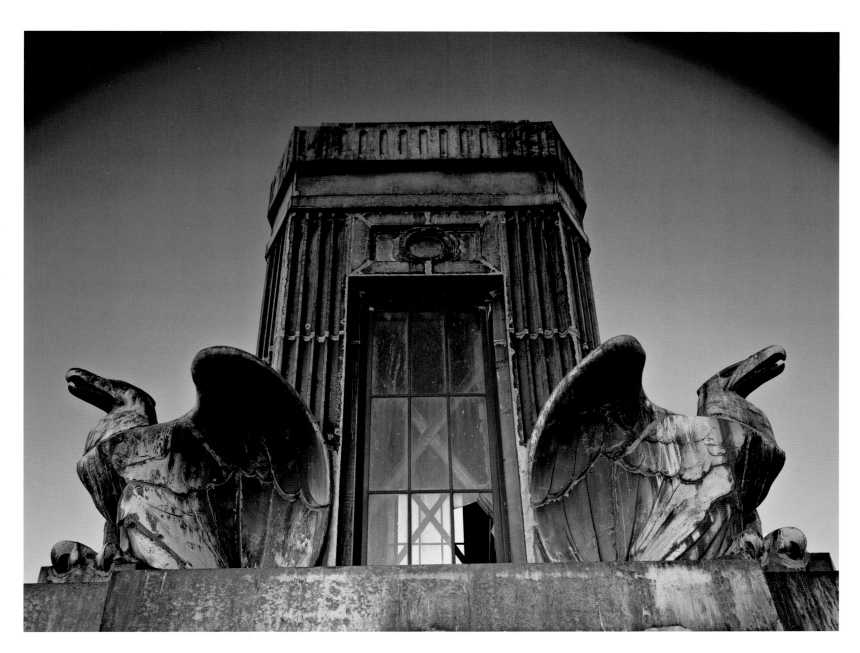

Ferry building, roof study with eagles

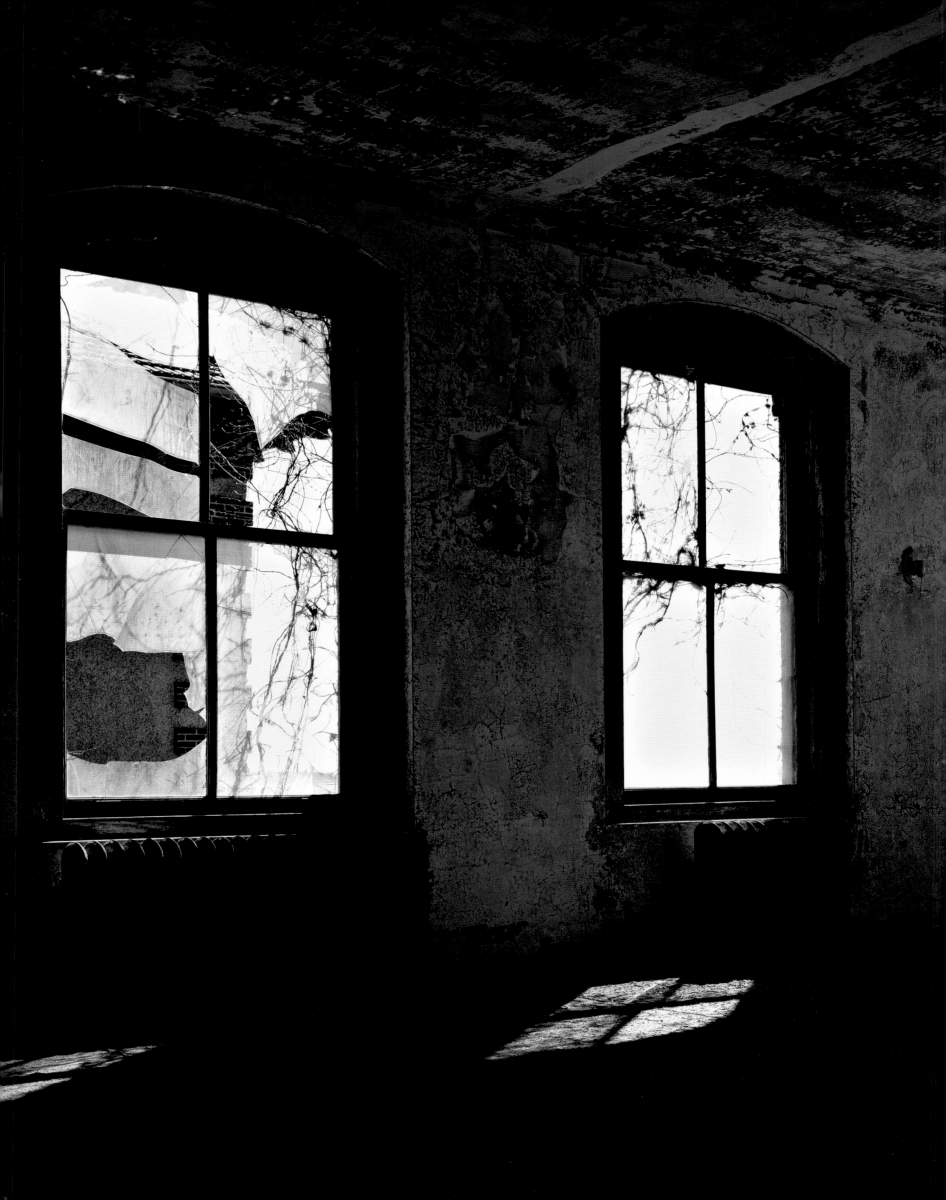

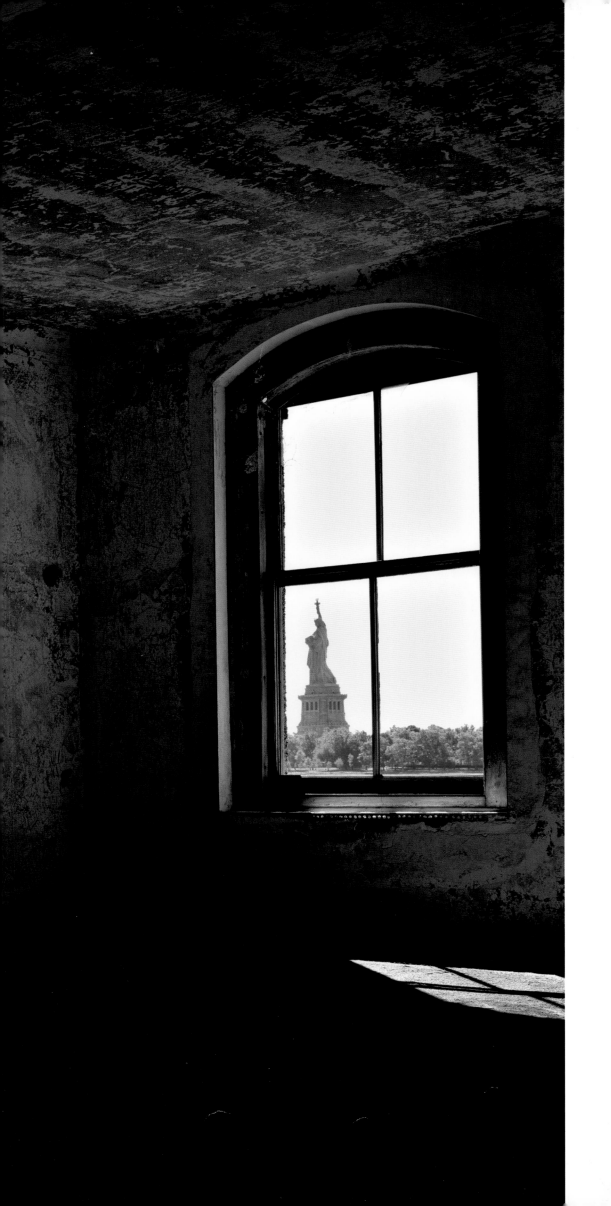

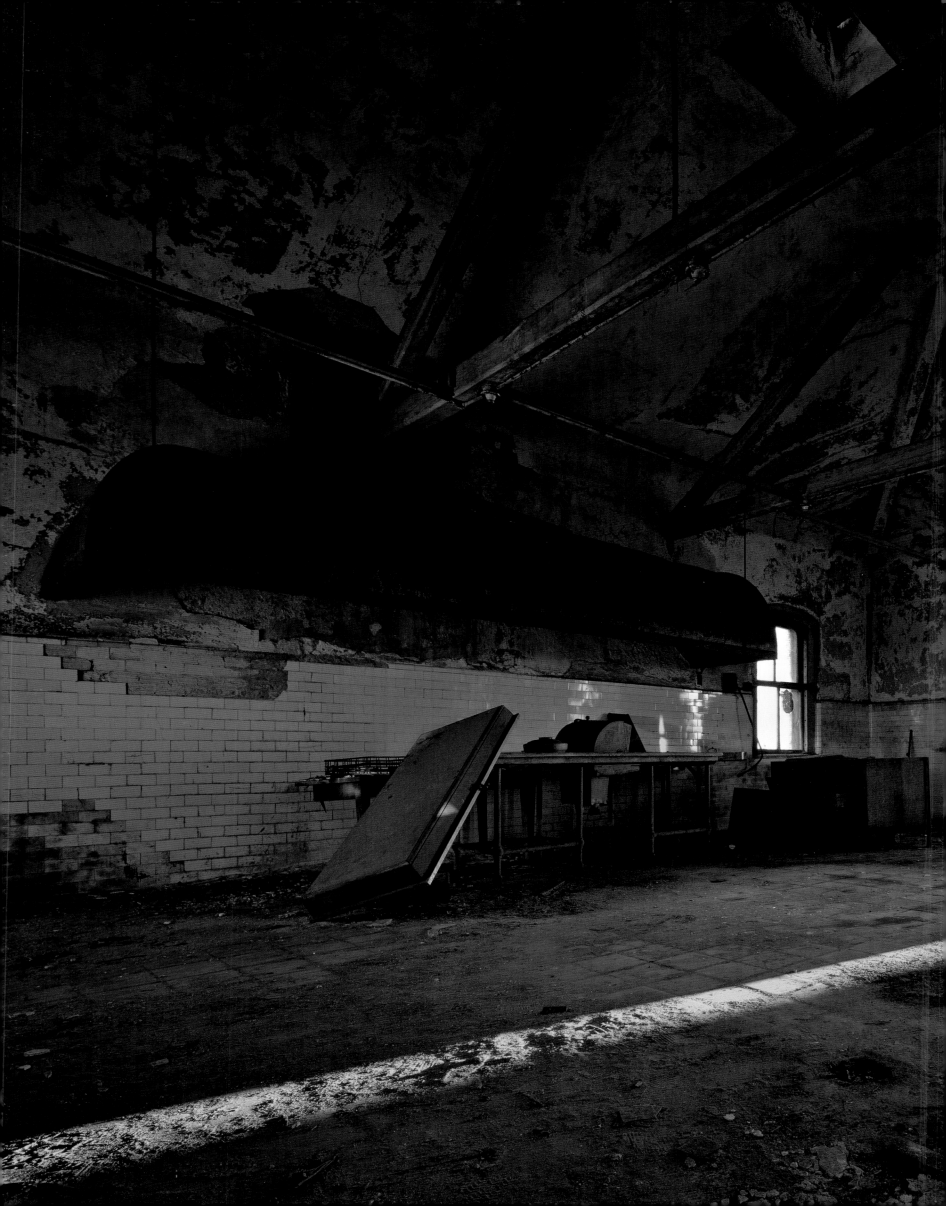

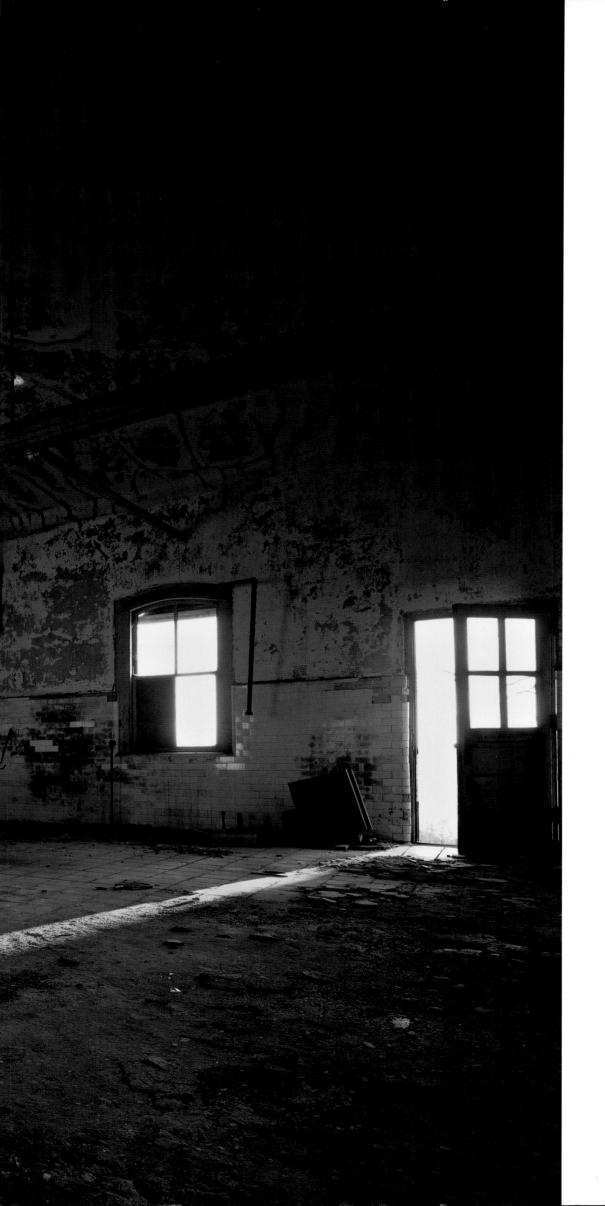

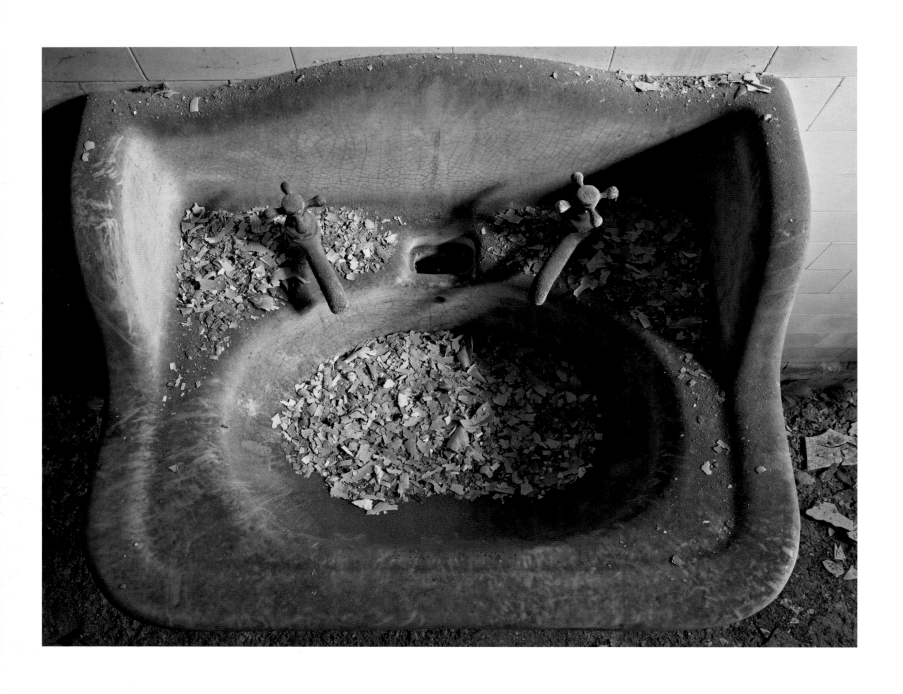

ABOVE: Psychiatric hospital, brig, sink study

OPPOSITE PAGE: Administration building, shattered bathroom study

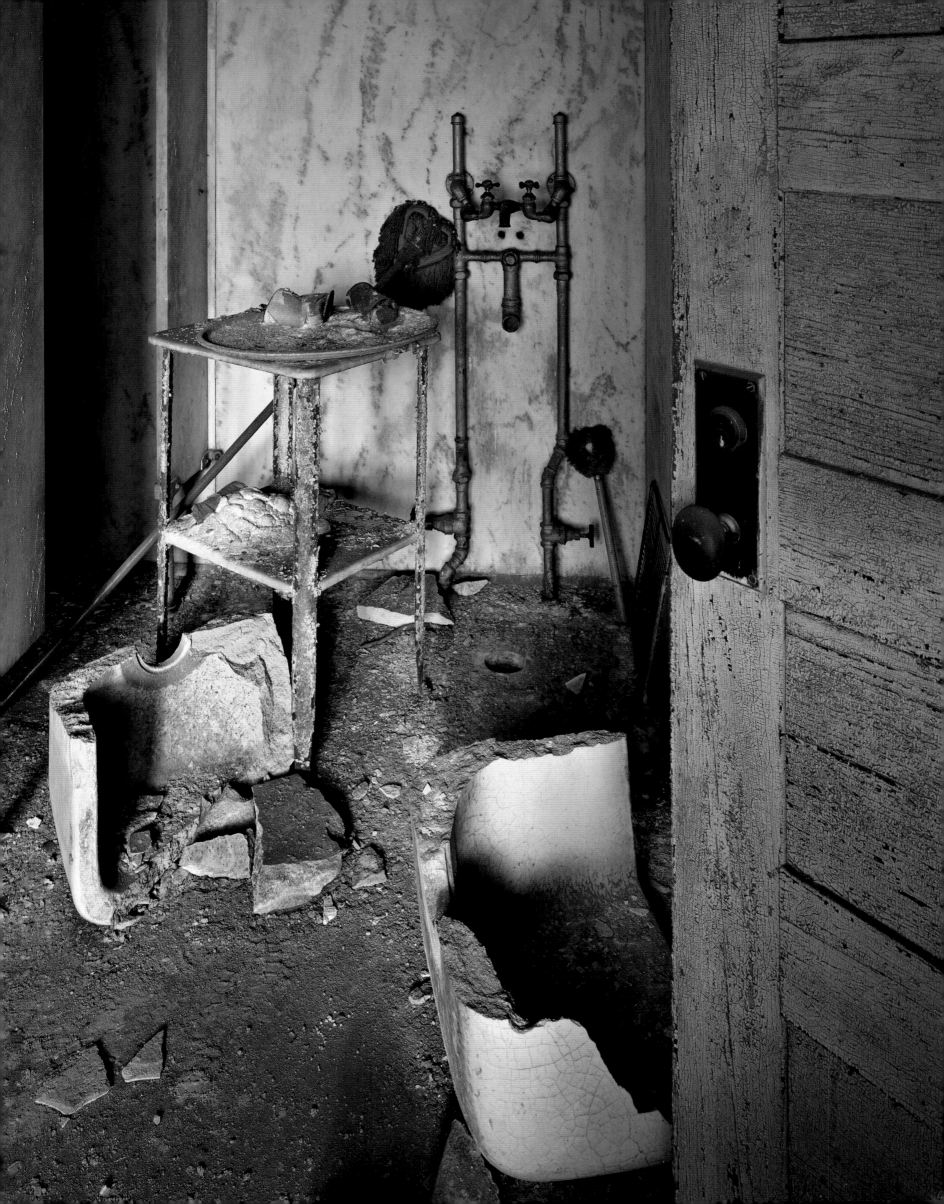

THE FIRST DOCTOR CALLED OVER
THE OTHER DOCTOR.

THEY SPOKE FAST.

THEY LOOKED AT MY SCALP....

THE FIRST DOCTOR PUT A CHALK
MARK ON MY SHOULDER AND
POINTED ME IN THE DIRECTION
OF A CAGE HOLDING DETAINEES.

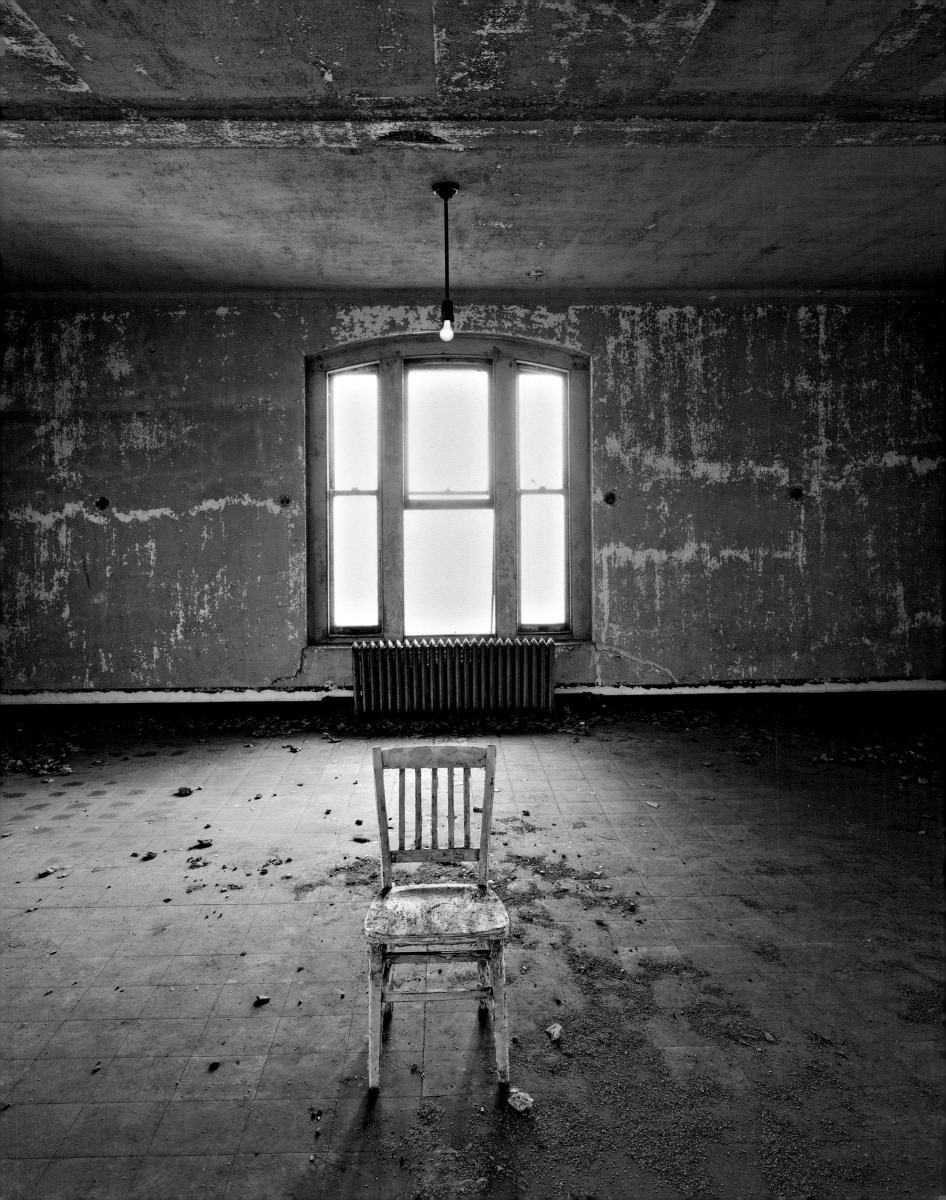

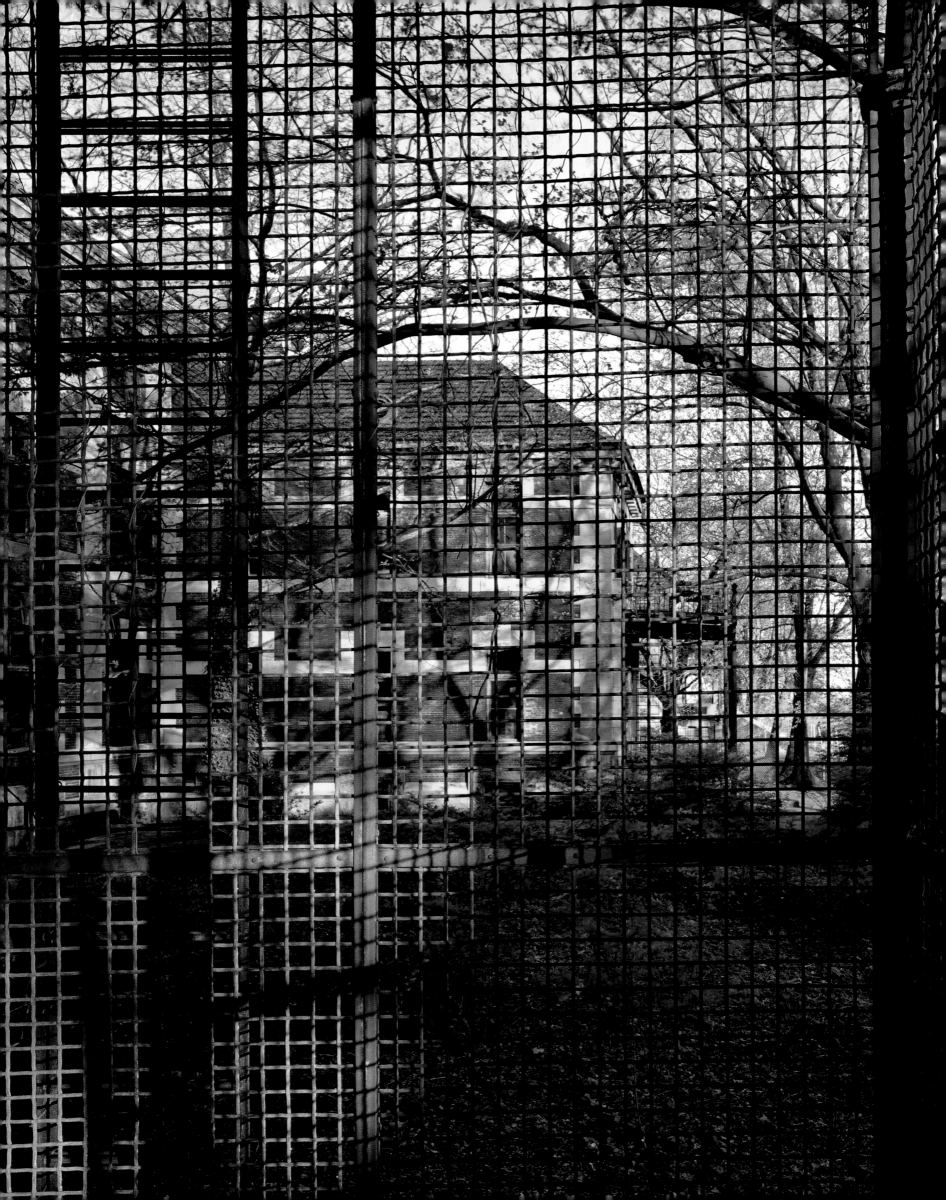

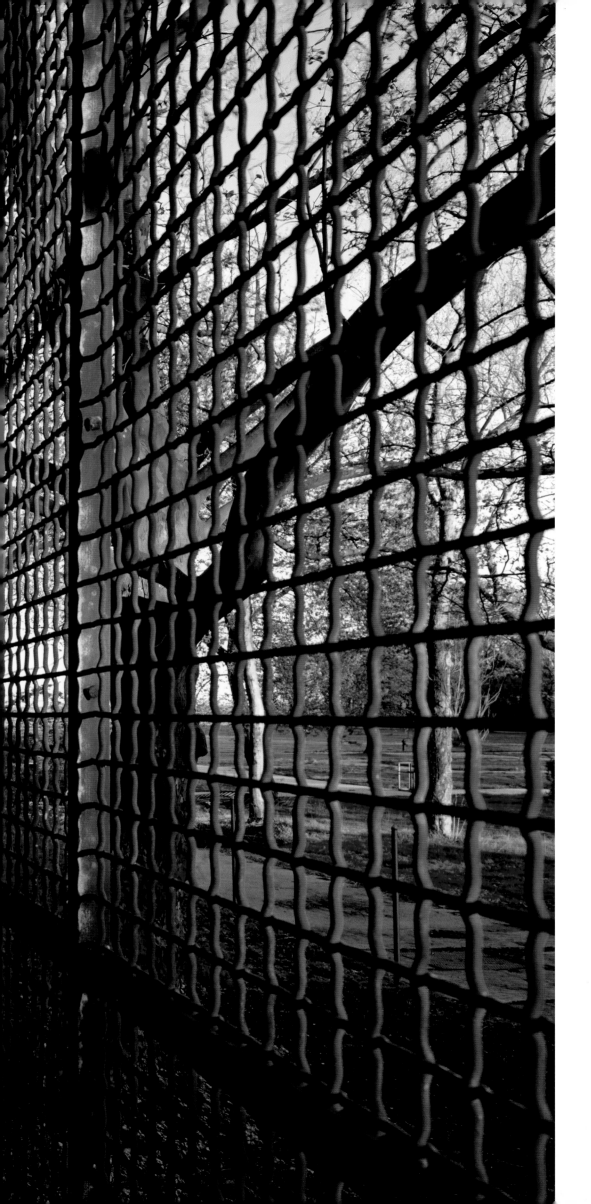

ON PAGE 95: Measles ward, lone chair and window
THIS PAGE: Psychiatric hospital, detention cage 97

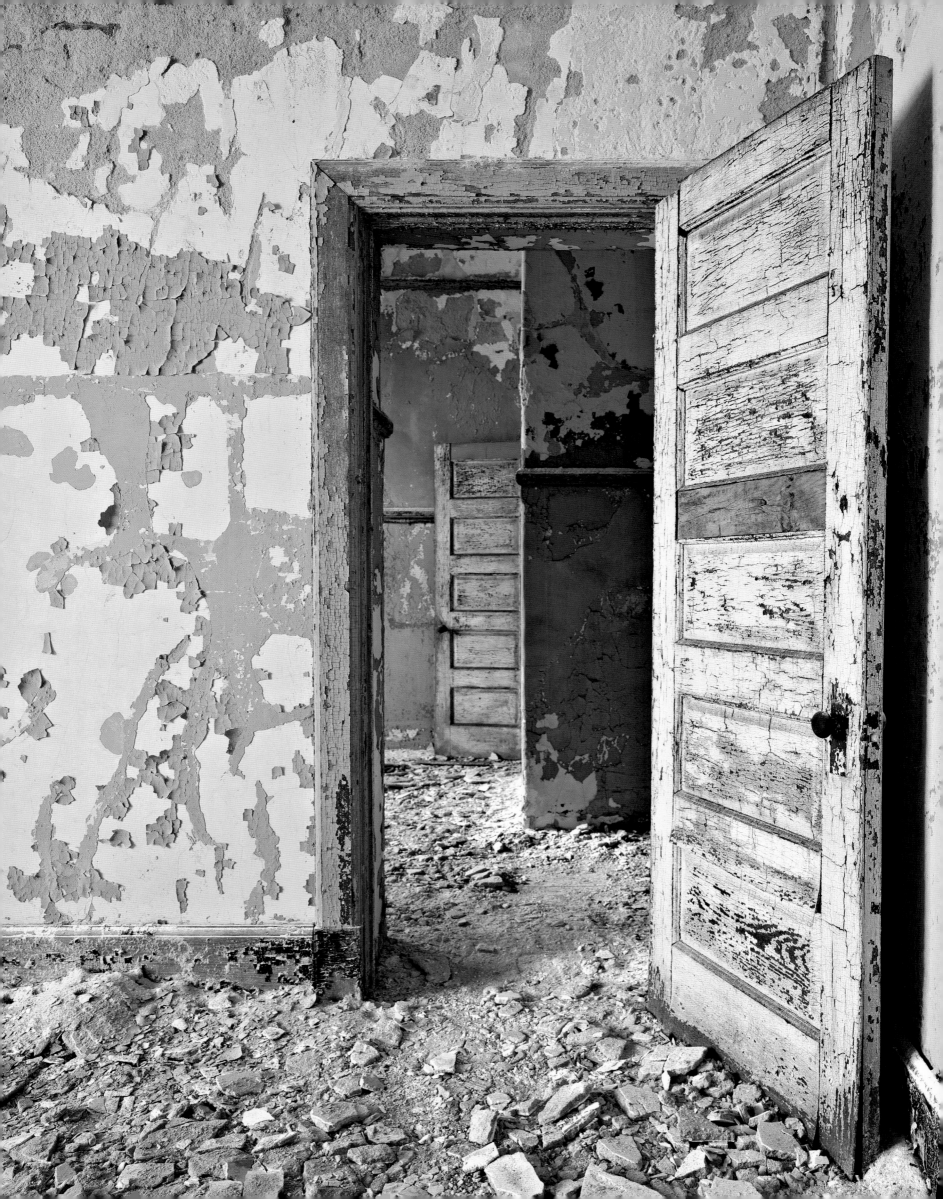

OPPOSTIE PAGE: Psychiatric hospital, "electric chair"

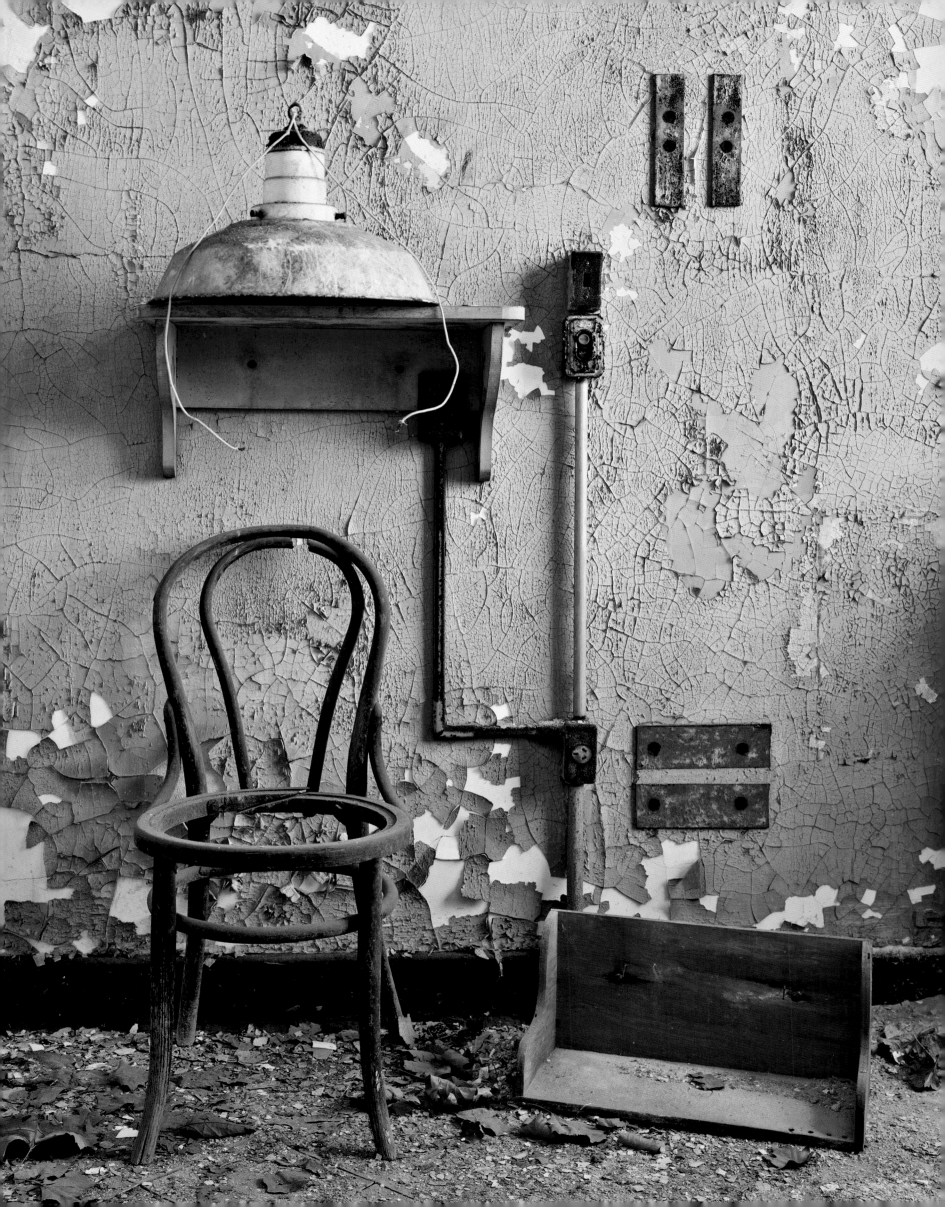

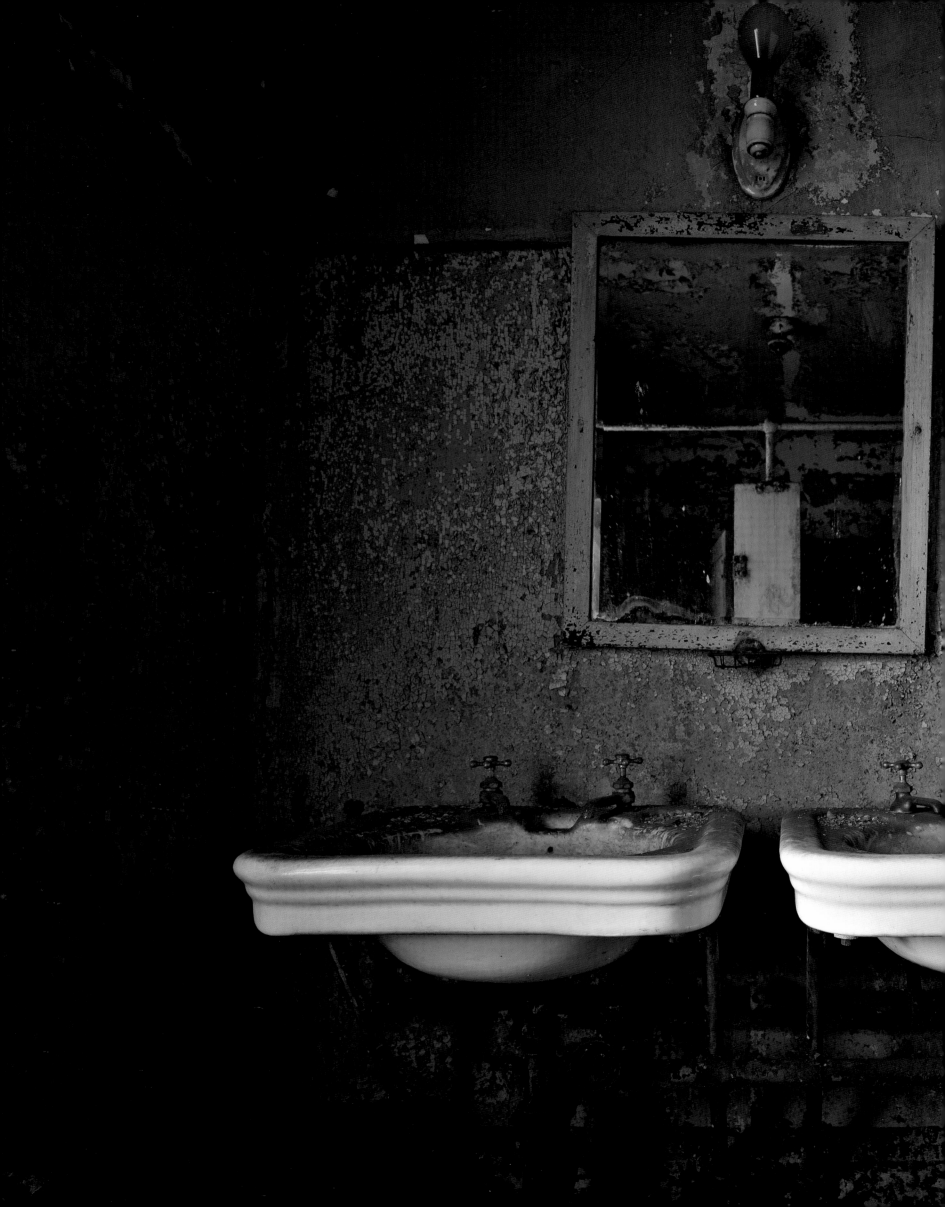

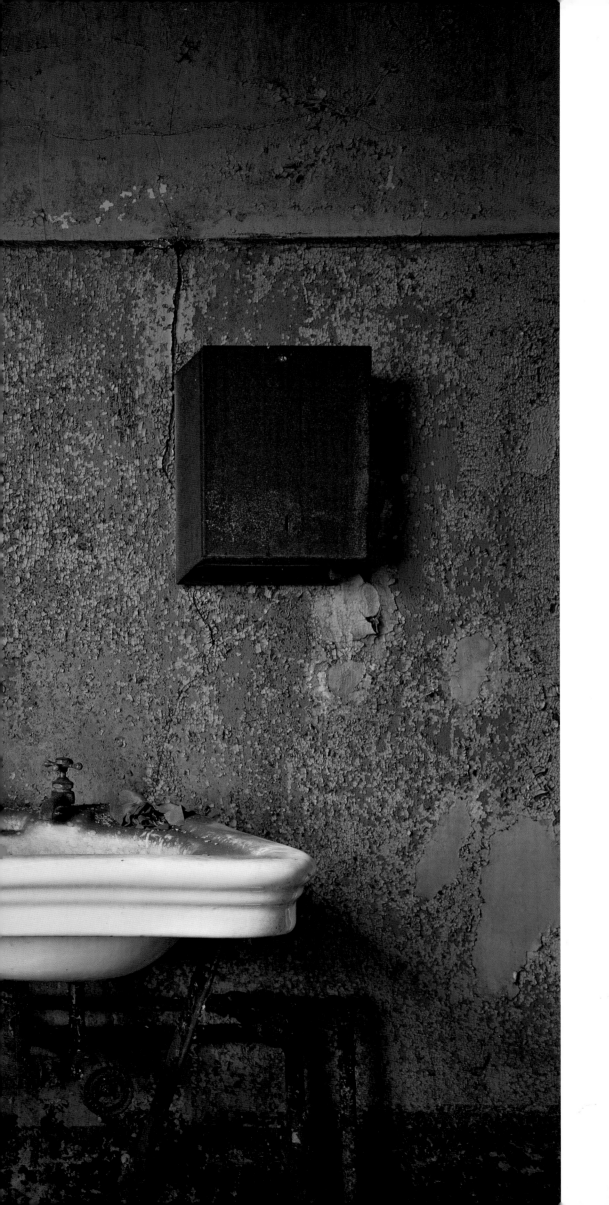

Nurses' quarters, twin sink (study) 103

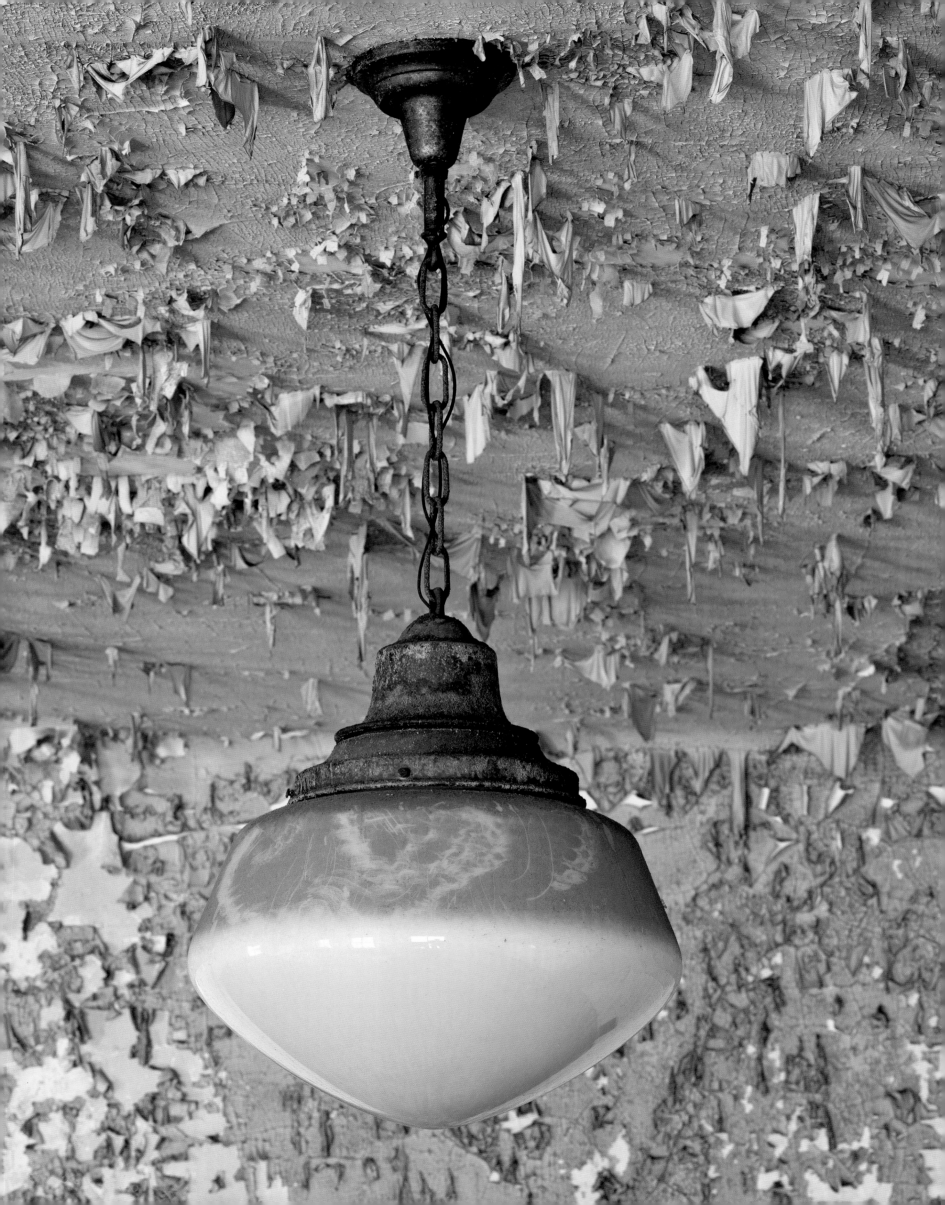

Isolation ward, ceiling fixture (detail) 105

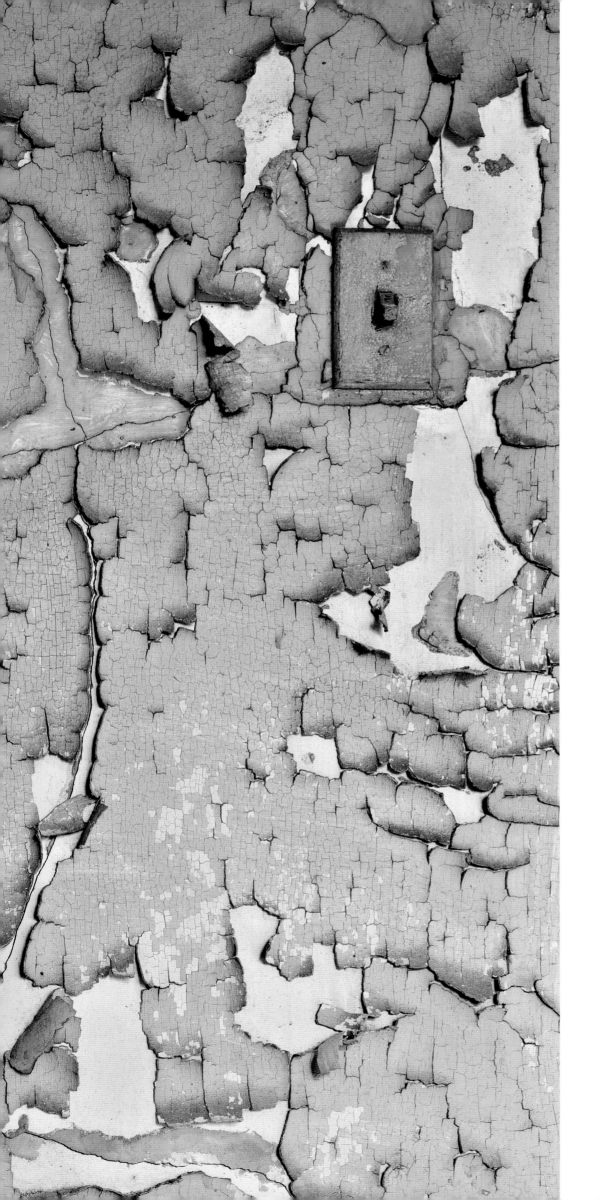

Psychiatric hospital, wall study with light switch 107

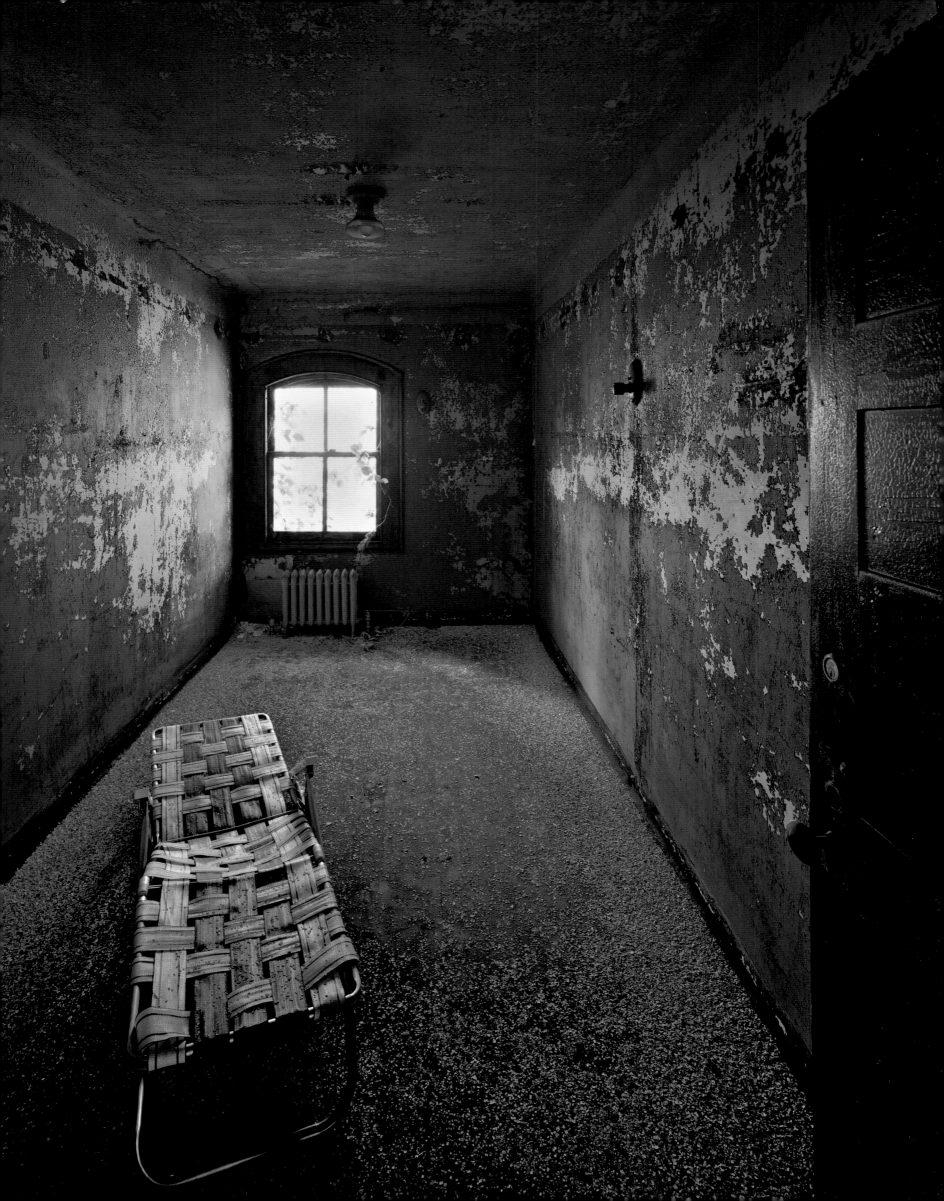

THE LEAVES CHANGE
COLOR JUST AS THEY
DO IN BERDICHEV.
GEESE FLY OVERHEAD
HONKING, FORMING
AND REFORMING IN
THE BLUE SKY ABOVE
MISS LIBERTY.

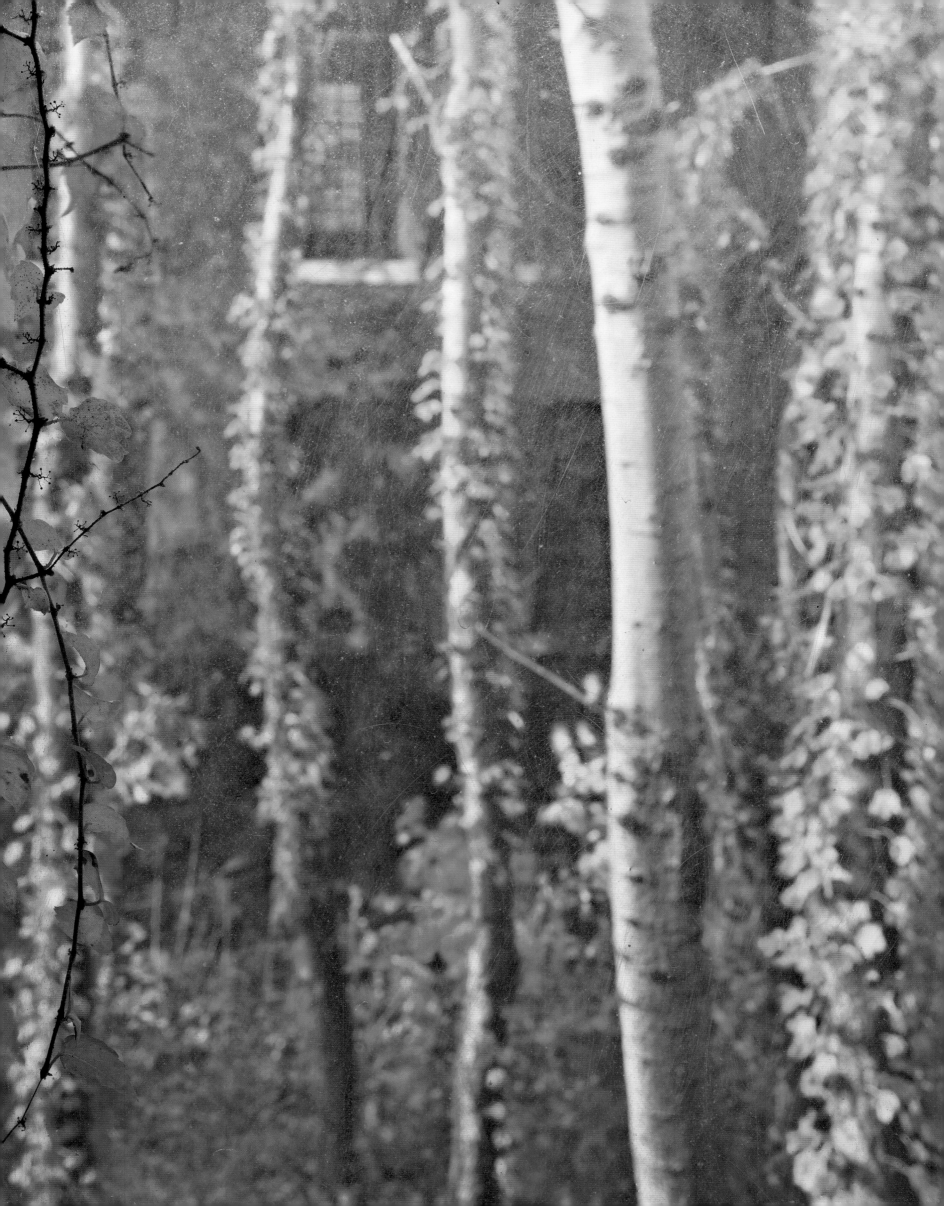

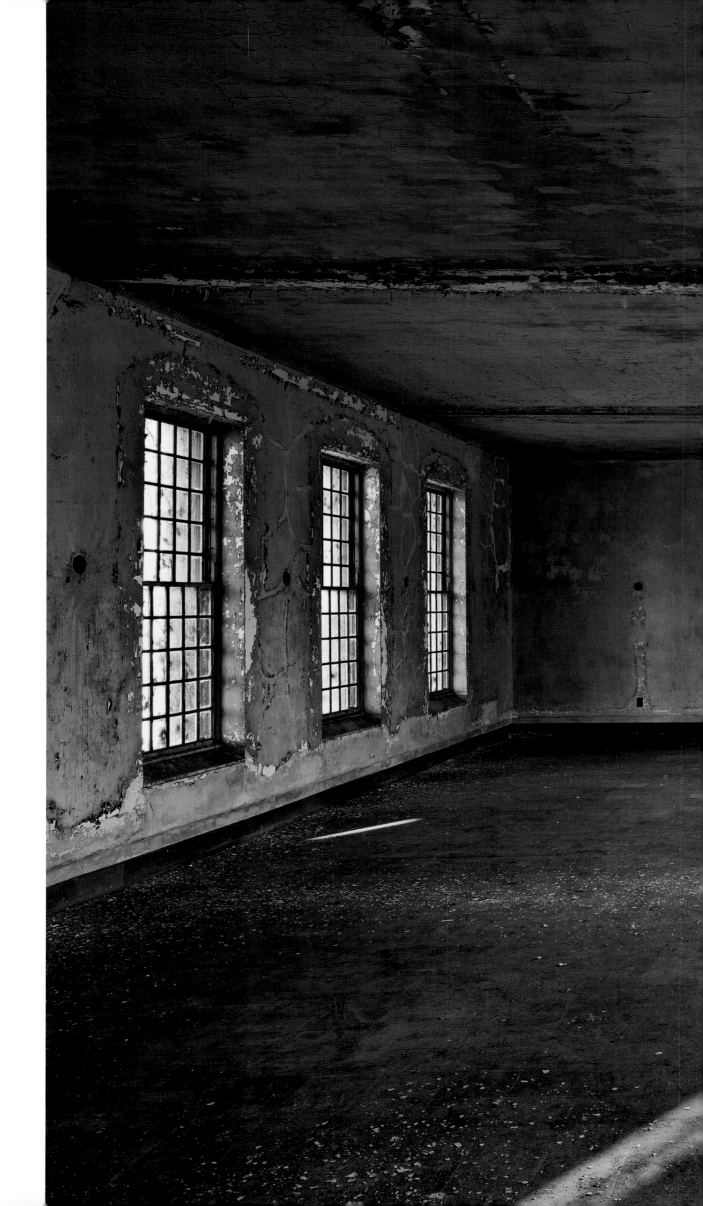

Measles ward, two chairs

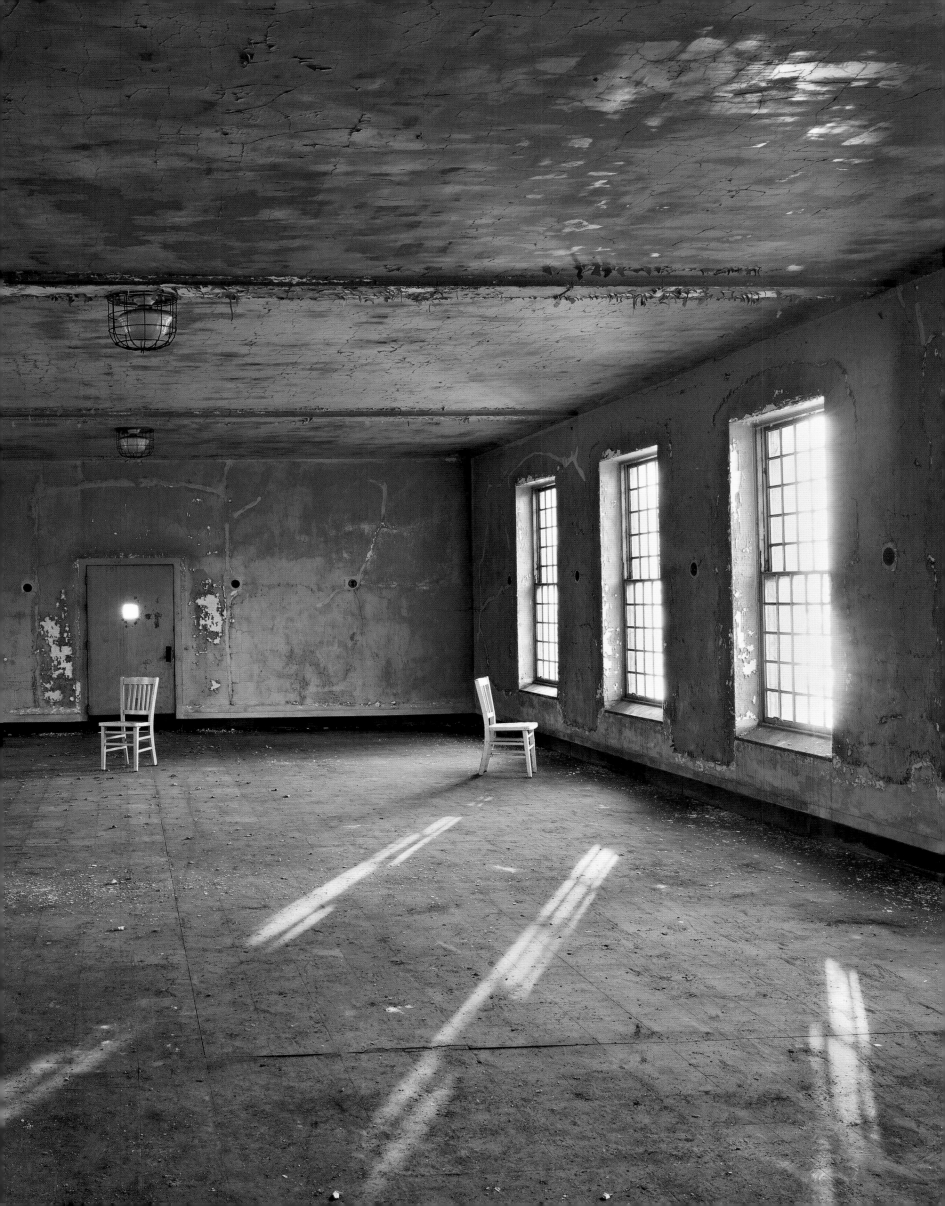

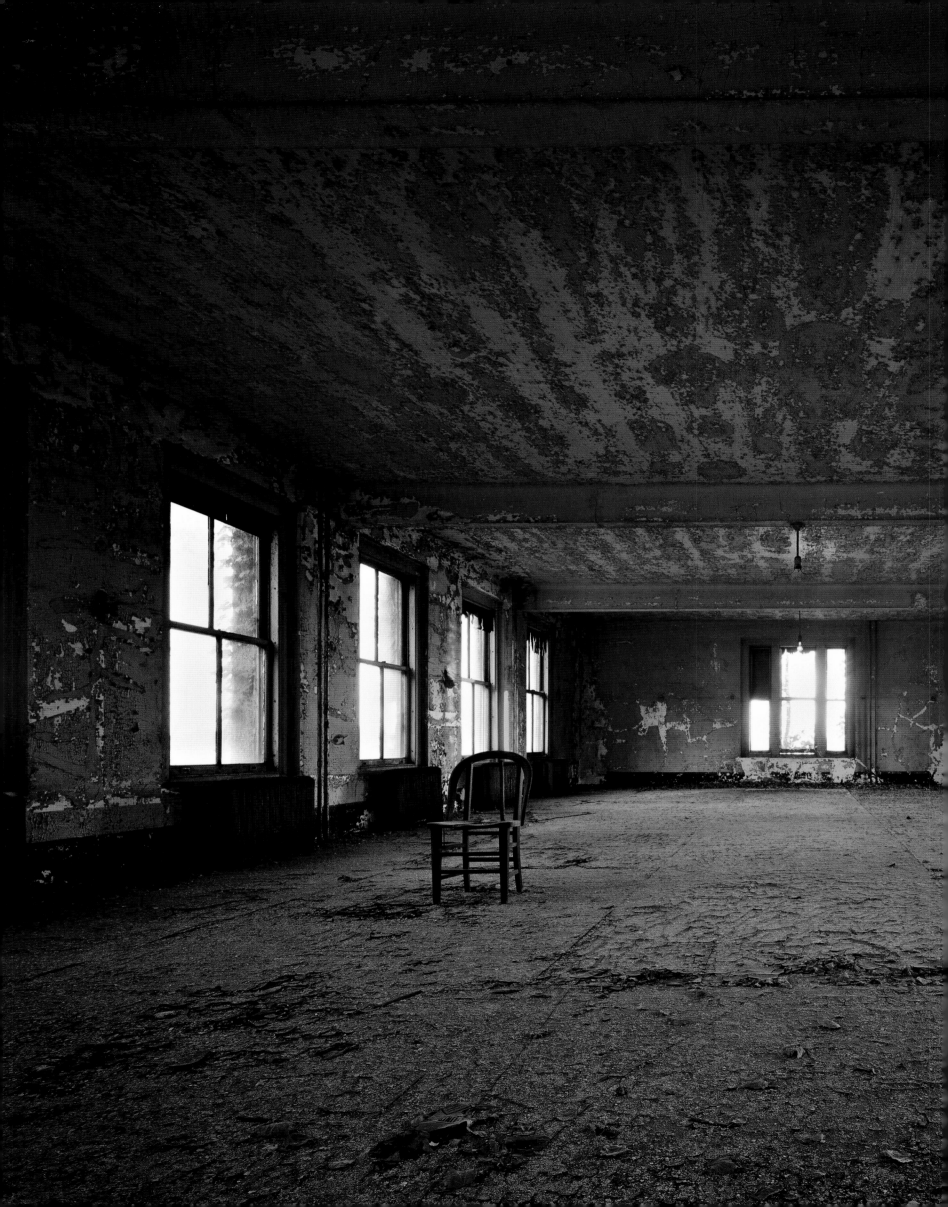

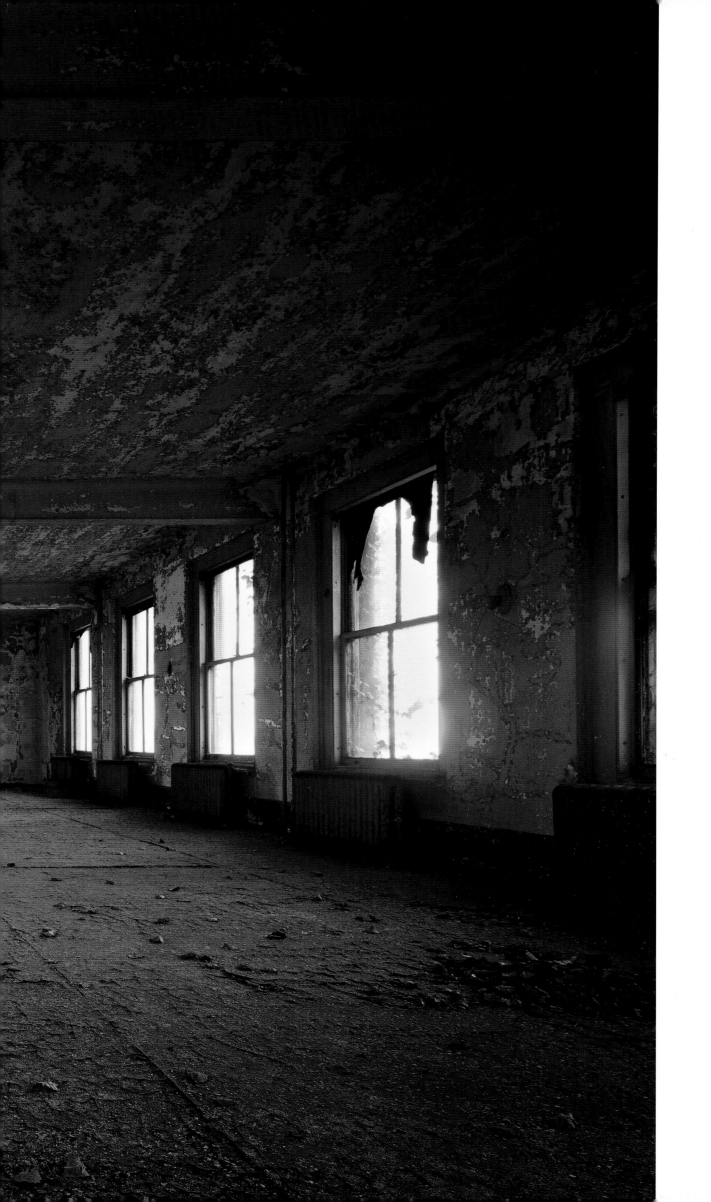

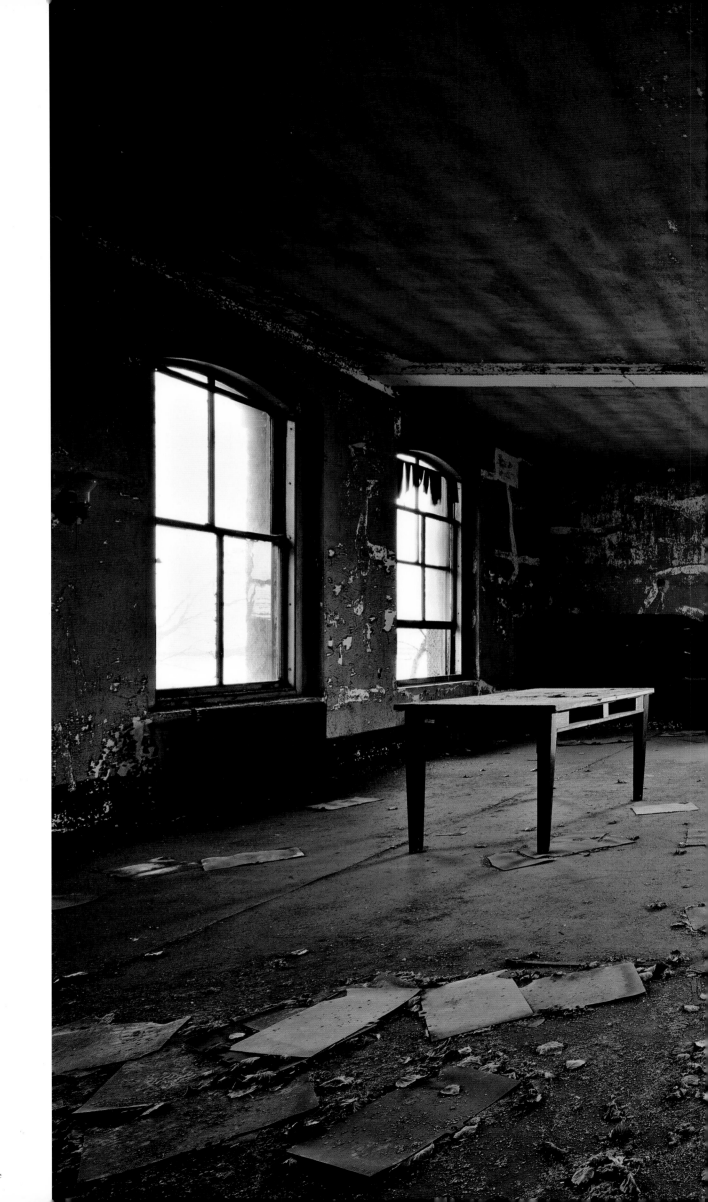

Patient ward with light on table

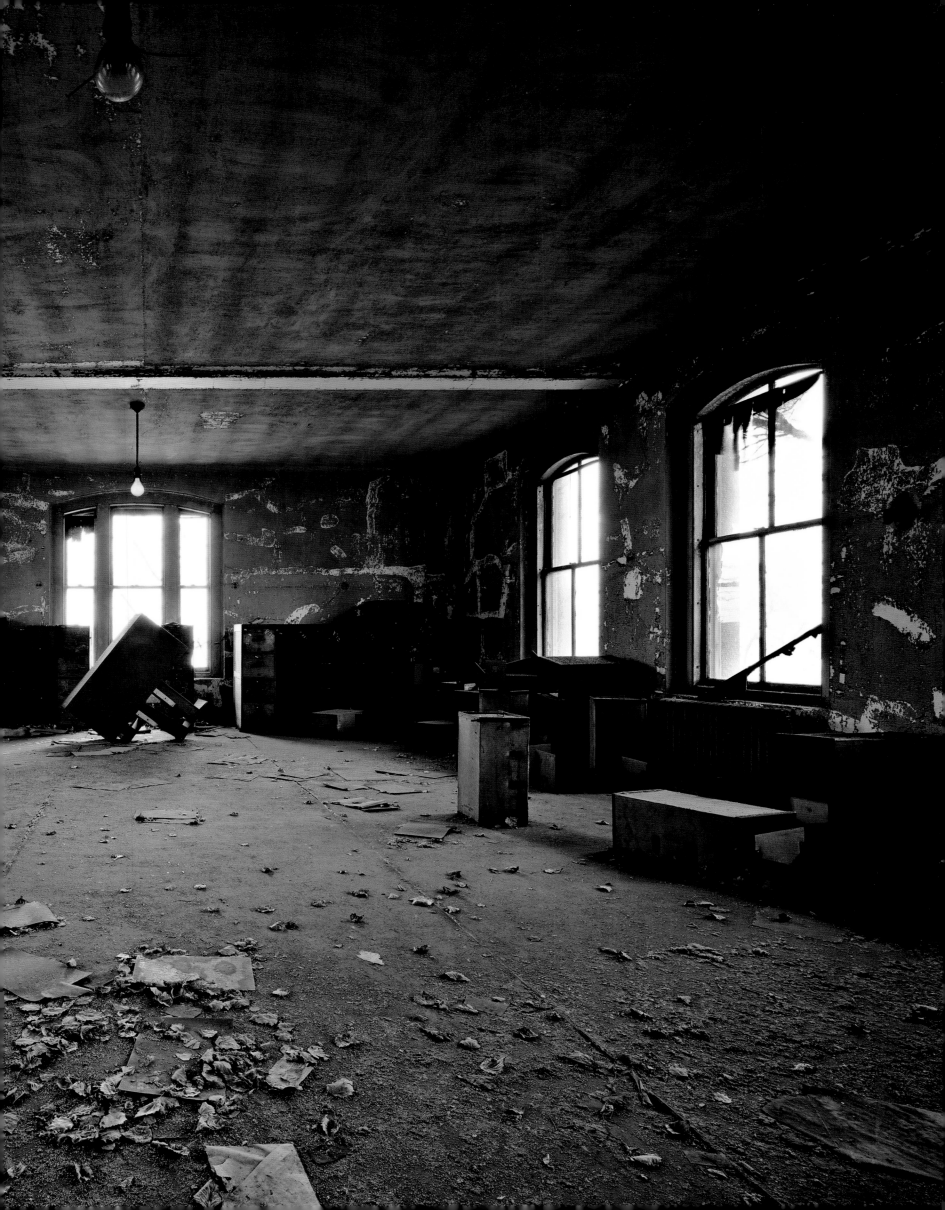

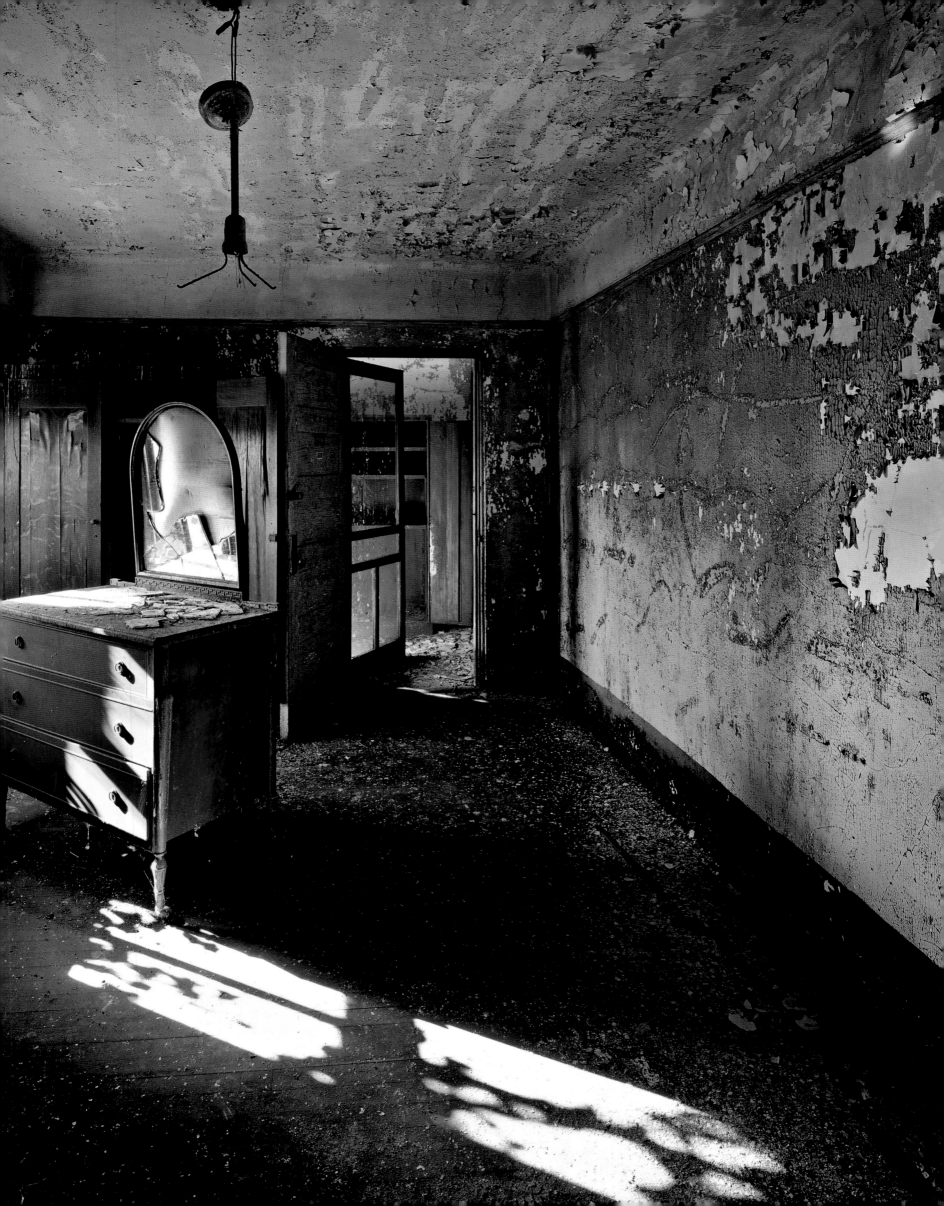

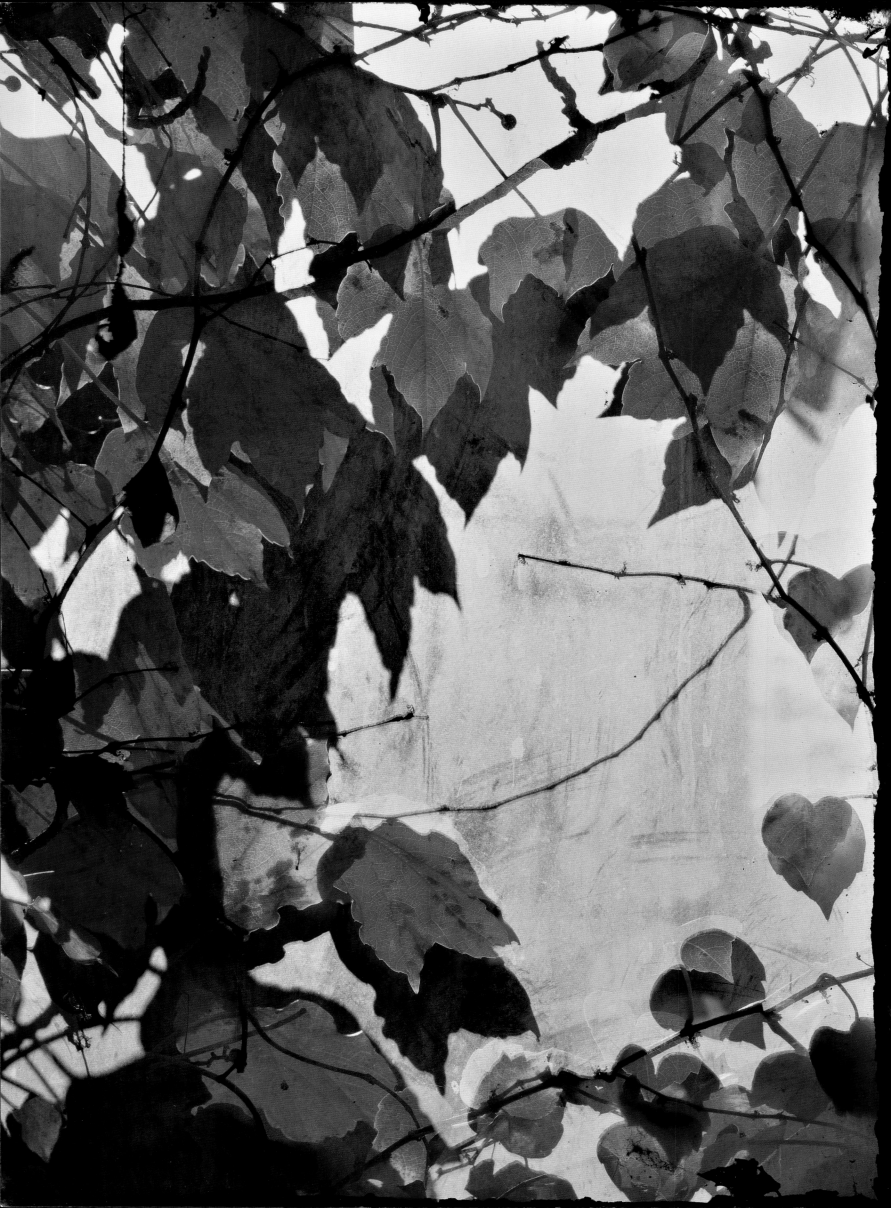

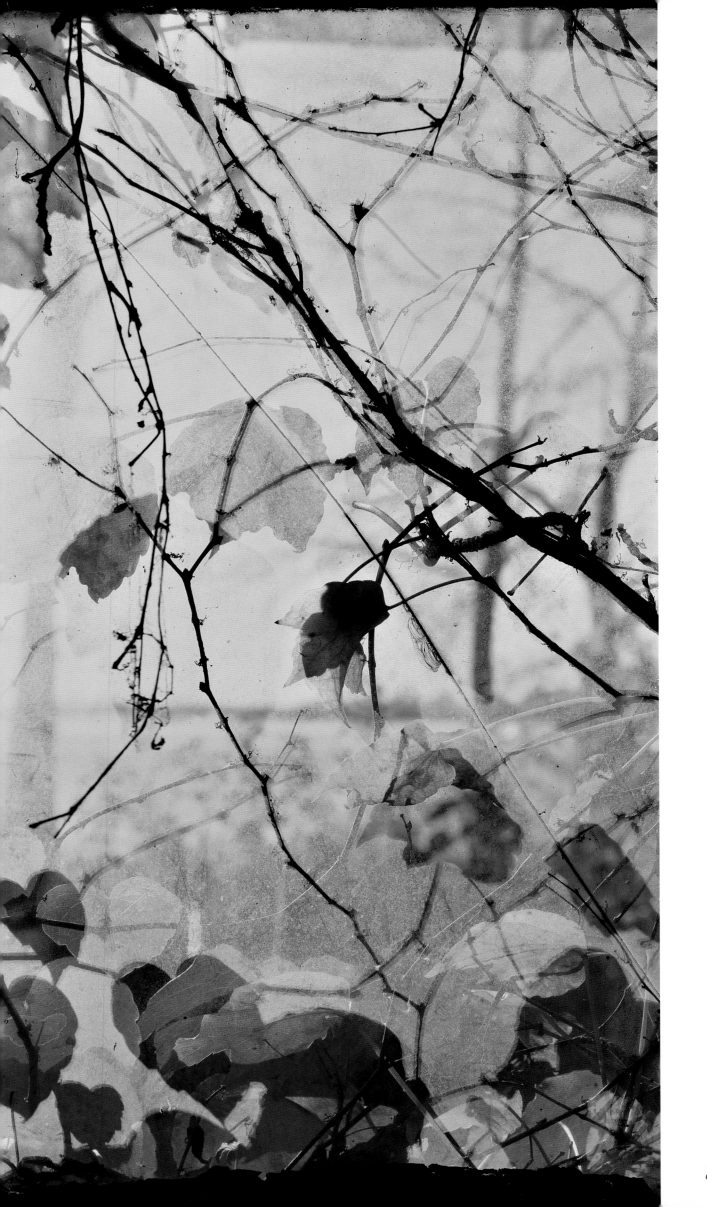

Corridor 9, fall study through window

Isolation ward, recreation room, window (study)

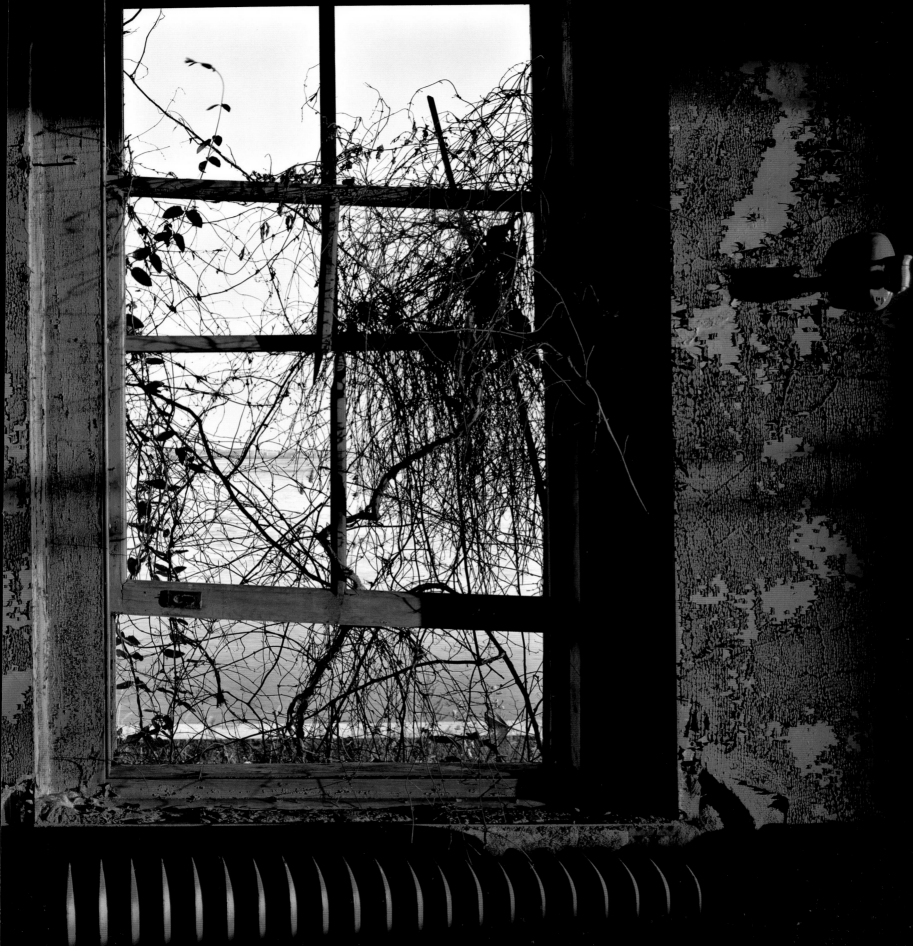

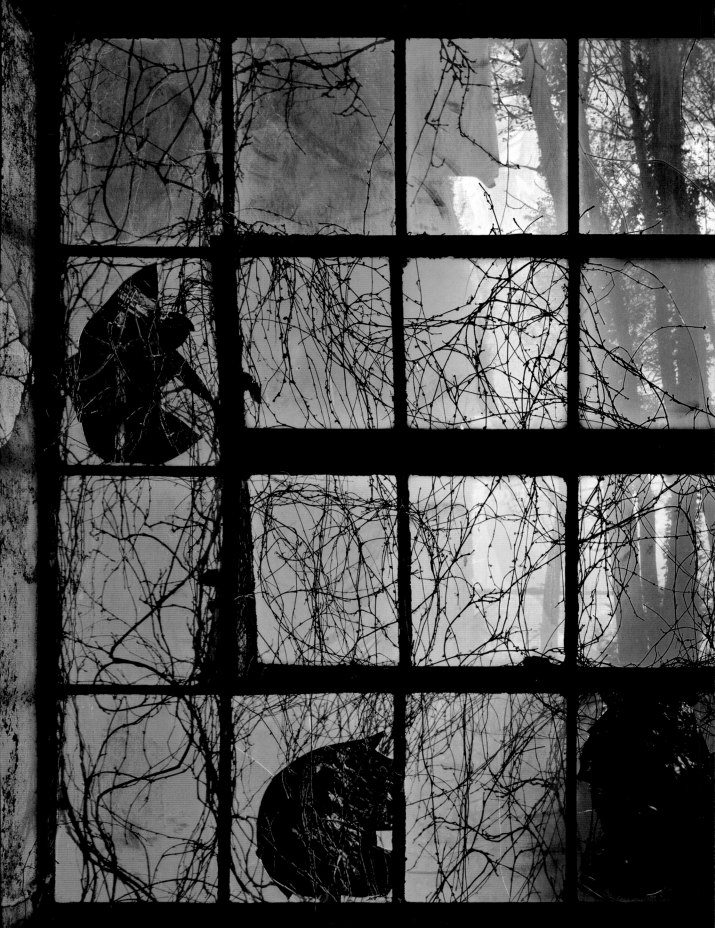

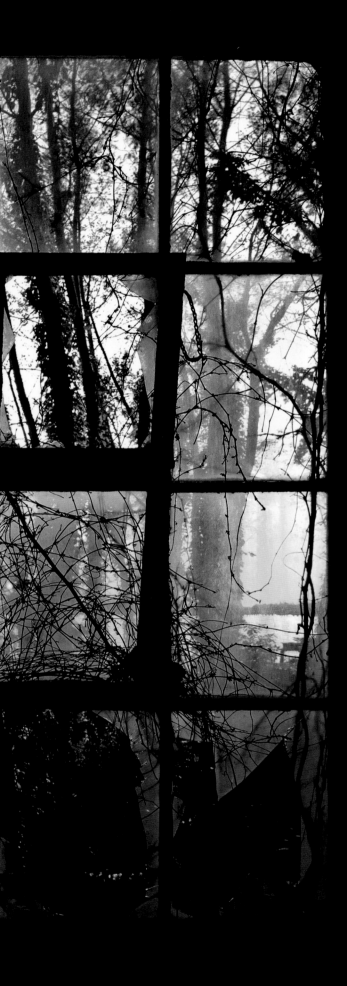

ELLIS ISLAND IS A LINE
SEPARATING MY FUTURE
FROM MY PAST.

UNTIL I CROSS THAT LINE,
I AM STILL HOMELESS,
STILL AN IMMIGRANT.

ELLIS ISLAND IS A LINE
SEPARATING MY FUTURE
FROM MY PAST.

UNTIL I CROSS THAT LINE,
I AM STILL HOMELESS,
STILL AN IMMIGRANT.

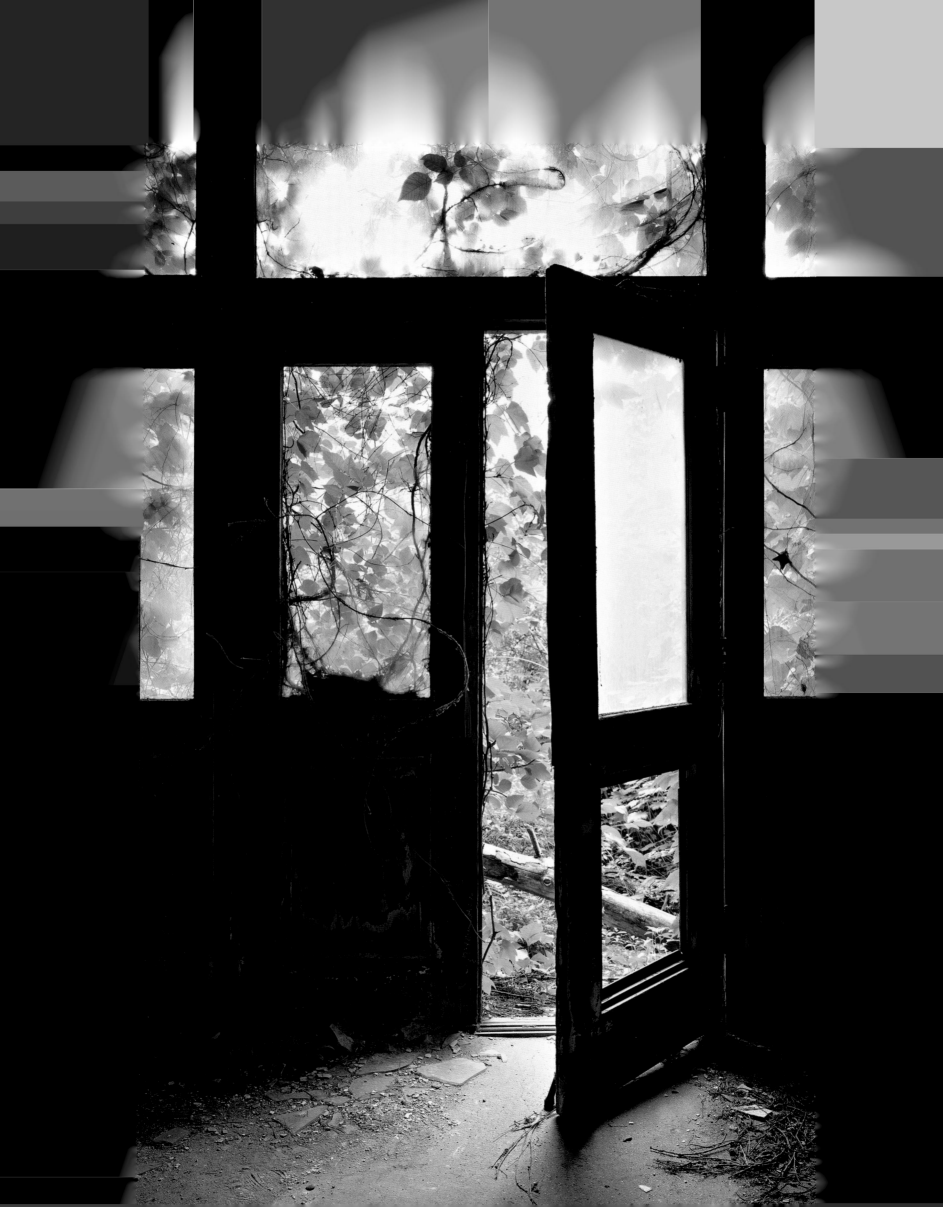

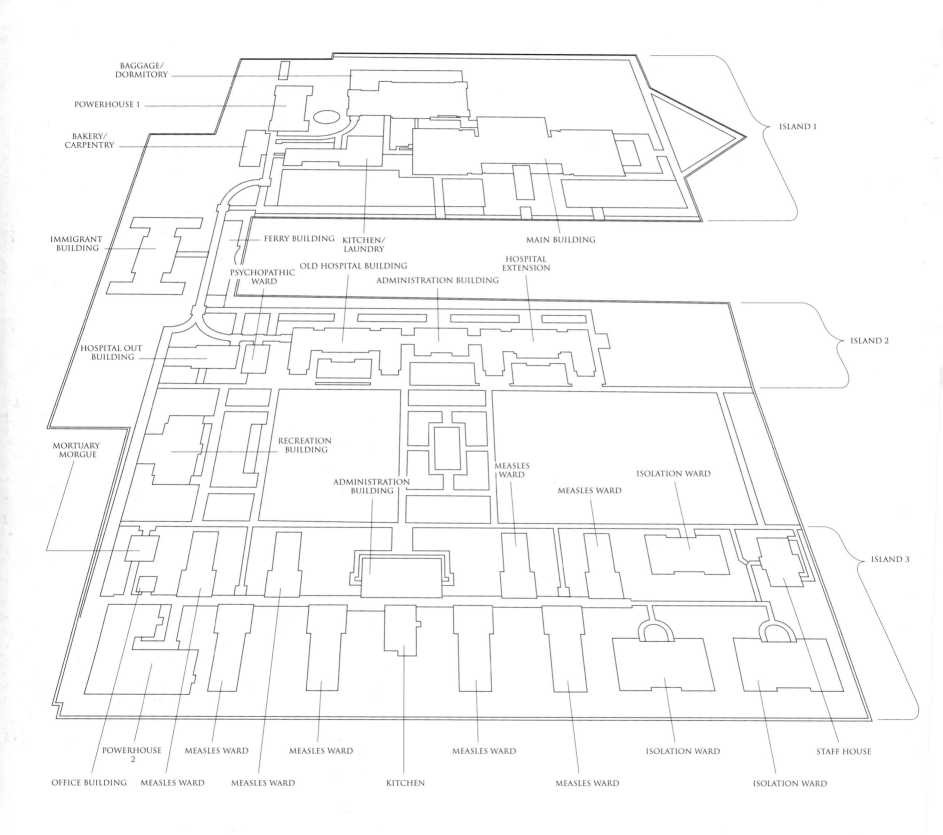

BAGGAGE/
DORMITORY

POWERHOUSE 1

BAKERY/
CARPENTRY

IMMIGRANT
BUILDING

FERRY BUILDING KITCHEN/
LAUNDRY

MAIN BUILDING

ISLAND 1

PSYCHOPATHIC
WARD

OLD HOSPITAL BUILDING

HOSPITAL
EXTENSION

ADMINISTRATION BUILDING

HOSPITAL OUT
BUILDING

ISLAND 2

MORTUARY
MORGUE

RECREATION
BUILDING

ADMINISTRATION
BUILDING

MEASLES
WARD

MEASLES WARD

ISOLATION WARD

ISLAND 3

POWERHOUSE
2

MEASLES WARD

MEASLES WARD

MEASLES WARD

ISOLATION WARD

STAFF HOUSE

OFFICE BUILDING MEASLES WARD MEASLES WARD KITCHEN MEASLES WARD ISOLATION WARD

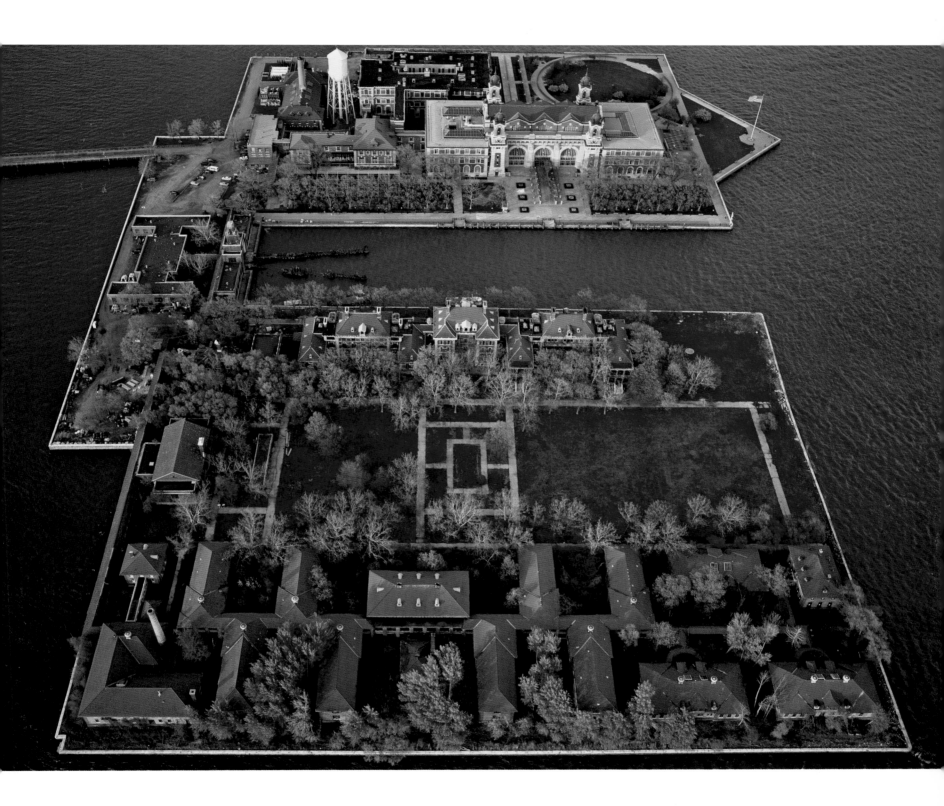

AERIAL VIEW OF ELLIS ISLAND (ISLANDS 1, 2, AND 3)

This aerial view of Ellis Island was photographed just above Island 3 looking northeast. The surrounding body of water is the upper New York Bay at the mouth of the Hudson River. In this image, Islands 1, 2, and 3 are clearly discernable. Island 1 is the original, "natural" island in the upper portion of the photograph. The large building on Island 1 is the Great Hall. Islands 2 and 3, created by landfill and joined by causeways, are seen in the foreground and middle-ground of the photograph. Together they comprise the south side.

HUDSON RIVER,
WATER STUDY

I began my journey by boat, try-
ing to understand the emotions
our ancestors felt as they looked
out toward the waves of the
Hudson, imagining that New
York would slowly emerge and
with it their prayers for freedom.

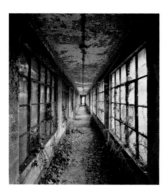

P.7: CORRIDOR 9, ISLAND 3

There was a palpable sense of
collaboration with an unknown
force when I made this photo-
graph. Red afternoon sunlight
created an aura at the end of the
corridor unlike any light I have
ever seen. I returned several
times, but this light never reap-
peared. It was eerie to realize
everything in shadow on the left
side was green, thriving and
alive, while everything on the
other side, glowing with white
light, was dead. This photograph
is an apt metaphor for the life
and death that passed through
this hospital so long ago.
Corridor 9 was in fact the spinal
cord of the south side.

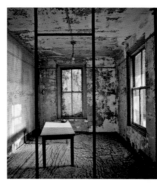

P.8: ADMINISTRATION OFFICE,
SINGLE SHOE, ISLAND 3

I walked into the room as
sunlight streamed onto a table
where a single shoe had been
left in the 1940s. After repeated
visits, I discovered that the room
never received direct sunlight
except at a single moment each
day: 3:15 p.m.—the precise
moment I happened upon the
scene and photographed it.

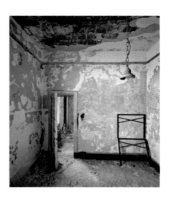

P.9: MAIN HOSPITAL,
BLUE ROOM WITH BED
FRAME, ISLAND 2

Here, in the ruins of the psychi-
atric hospital, I thought of van
Gogh. The lead paint of some
long-forgotten painters had
ruined into a deep violet. In the
falling of the plaster, the floor
became indistinguishable from
the walls.

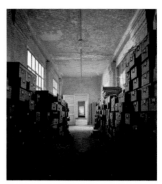

P.11: MEASLES WARD, OAK
FILE CABINETS, ISLAND 3

They are the records of those
who passed through the hospital,
a ziggurat of file cabinets in
chaotic disarray. They reminded
me of children huddled in a
room. I waited in pitch black for
the light. When the sun came,
a radiant glow ignited the
corridor. In the foreground
was the past—the files—and in
the background, the present:
a void spiraling endlessly into
the distance.

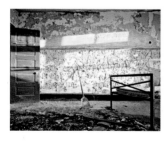

P.12: PSYCHIATRIC HOSPITAL,
BROOM STUDY, ISLAND 2

It's as though someone took a
coffee break fifty years ago and
never came back. The broom sits
propped dramatically, an eerie
expression of humanity. The
ravaged wall seems the product
of a blowtorch, the work of
water giving the impression that
intense heat somehow melted
the paint. I had the feeling that
nature was dissolving both floor
and wall and pushing in toward
the middle.

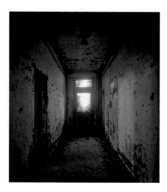

P.15: ADMINISTRATION
BUILDING, DARK HALLWAY,
ISLAND 3

In this corridor, as the eye moves
to the vanishing point, nature
battles furiously with architecture.
In the vines and plant life over-
taking glass and concrete, there is
a sense that only one will survive.

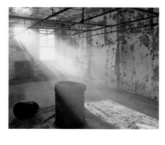

P.16: LINEN ROOM, ISLAND 3

I happened across this drama
of light in the remains of the
linen room. Godlike rays shaft
through the window and
envelop crucifixes—hangers for
the drying of linen.

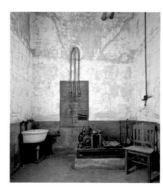

P.19: MORGUE, PREP ROOM,
ISLAND 3

Adjacent to the morgue are the
remains of a refrigeration unit
that kept bodies cold. The room
had a strong, menacing presence
and, movie-like, a wind began to
blow as I stood there. I remember
looking up and seeing a glass
lamp move in the wind. I ration-
alized that the wind was coming
from a crack in the window, but
I'm not sure.

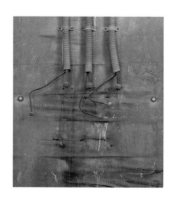

P.20: MORGUE REFRIGERATOR
DETAIL, ISLAND 3

In the morgue prep room, the
remains of the refrigeration unit
that was used to keep bodies
cool is still attached to the wall.

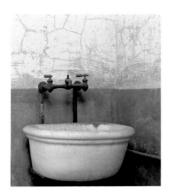

P.21: MORGUE PREP ROOM,
SINK STUDY, ISLAND 3

I was captivated by a double
patina: the cracking of the sink
meeting the cracking of the walls.

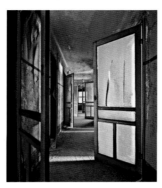

P.23: NURSES' QUARTERS,
ISLAND 3

I remember climbing a dark
staircase to discover the floor
where the nurses slept. Screen
doors were open at various
angles, creating an almost
mystical pattern in the space.
It was designed for airflow,
the chief weapon against tuber-
culosis and infectious diseases.

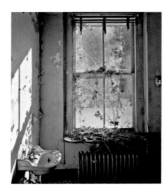

P.24: MEASLES WARD, SINK
WITH SNOW SCENE THROUGH
WINDOW, ISLAND 3

Something dying in the most
elegant, regal way. Vines changing
color and dying slowly, though
they should have been long dead
in the middle of winter. I waited
five years to capture snow on
the island. The interior scene
with vines and dappled light
felt warm and inviting, yet when
I looked through the window
a cold winter scene emerged.
The two distinct scenes create
a picture within a picture.

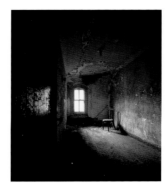

P.26: MEASLES WARD, LONE
CHAIR AND WINDOW,
ISLAND 3

I was captivated by the darkness
here, and the strong sense of
physical presence in this empty
room. The chair gave off a dis-
tinct impression that someone
was sitting in it.

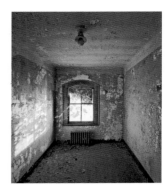

P.27: NURSES' QUARTERS,
BILLOWING SHADE
AT SUNSET, ISLAND 3

The subject of this picture had
a radiant energy. I was captivated
by the motion of the tattered
shade, blown by the wind gusting
through the window, giving it
an almost lyrical quality. The
undulating shade and dappled
shadows on the inner wall
created their own intriguing
narrative. The light was different
here. Energy emanated from
the outside in, rather than from
the inside out.

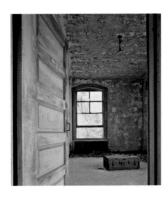

P.29: ISOLATION WARD,
SUITCASE, ISLAND 3

I can imagine an immigrant
standing here beside his suitcase
in the 1920s. Actually, I can feel
him. The suitcase sat there call-
ing to me, shattered like an egg,
as if something unknown had
emerged from it. Why is it there?
Few personal objects remained
on the island. Yet I walked into
this room and the suitcase was
waiting, so I photographed this
remnant of humanity exactly as
I had discovered it.

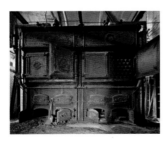

P.30: POWERHOUSE, BOILER,
ISLAND 3

It powered the entire hospital.
But as I waited ten minutes for
my eyes to adjust to the darkness,
and the patina and texture came
into view, the ancient furnace
felt more like a crematorium
than a boiler room.

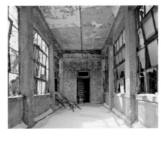

P.32: SNOW-COVERED
CORRIDOR, ISLAND 3

Finally, I got my snowstorm. I
had always wanted to photograph
this corridor, but something was
always missing. When the snow
sifted through, the element was
provided. I remember precisely
the wind blowing, the vines
moving, the sun fading in and
out. I remember how cold and
crisp it was in the purity of the
whiteness, and the dramatic
interplay between the snow and
the lichen-covered walls, walls
bursting with so much green life.

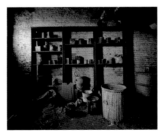

P.34: PAINT ROOM, ISLAND 3

I was entranced by the chaotic
sculpture of paint cans in this
room beside the morgue. The
labels are still attached to the
cans, a living record within the
cool light of history, awaiting the
archaeology of a camera lens.

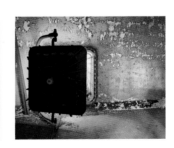

P.36: THE AUTOCLAVE,
ISLAND 3

In the scorching heat of the
autoclave, tuberculosis-infected
mattresses were sterilized. The
six-foot-high steel door seemed
to emerge from the ruins of the
Titanic, and the exterior back
wall had collapsed, allowing in
sunlight. The moment I arrived,
the autoclave exploded with the
light of the setting sun, which
reanimated a decaying structure.
This was another moment when
it became clear that somehow,
in my journey through the ruins
of the south side, the place was
coming back to life for me.

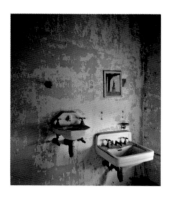

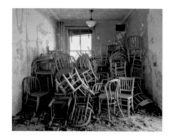

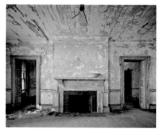

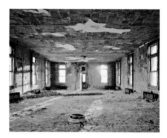

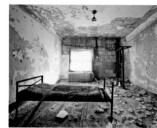

P.39: TUBERCULOSIS WARD. STATUE OF LIBERTY. ISLAND 3

I truly feel that it wasn't I who took a lot of these pictures. They were given to me. While studying the dead leaves on this floor, I brought my head up slowly and happened to look around. At a precise point, about 5 feet 2 inches off the ground, I saw the Statue of Liberty reflected in the mirror. I suddenly imagined a petite Eastern European woman rising out of her bed every morning. Seeing that reflection would be the closest she would ever come to freedom.

P.40: ADMINISTRATIVE QUARTERS. STAFF HOUSE. ISLAND 3

It is a photograph of the seen and the unseen. The fireplace is a black void pulling you toward the center of the photograph, while the doorways on either side present alternative routes. The colors of the room, yellows bleeding into the blue, merged with the fireplace offer warmth. Yet there a sense of a completely different kind of energy behind. It is an entry and an exit into two different worlds.

P.42: MEASLES WARD. HUDDLED CHAIRS. ISLAND 3

Ellis Island was home to "the huddled masses" yearning to breathe free. Those masses find their perfect metaphor in this extraordinary array of chairs gathered randomly from the wards and huddled in this room. They remind me of survivors. The unique gesture of each chair is a reminder that there never were any "masses"—but just a number of individual stories, some played out in this hospital so near and yet so far from paradise.

P.44: HOSPITAL EXTENSION. WOMEN'S WARD. ISLAND 2

It felt like a room unearthing itself. The pulverized plaster from the ceiling gave this room, where children with head lice and ringworm once slept, the character of a desert. Months later, I discovered an old photograph of this ward taken in 1917, shot from the identical vantage point as my photograph, at exactly the same angle. If you lay the "before" and "after" shots on top of each other they align perfectly. Except in one picture, children sit up in their beds while the head nurse stands with folded arms; in the other, they are gone.

P.46: PSYCHIATRIC HOSPITAL. SUNKEN BED. ISLAND 2

I was struck by the impression of physical weight on a mattress someone had once lain on. It felt like the weight was still there, another invisible presence on the island at which the camera can only hint.

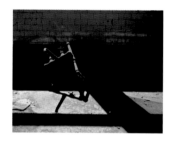

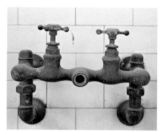

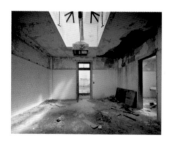

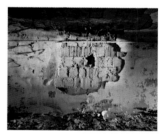

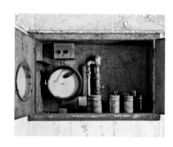

P.48: HOSPITAL EXTENSION. FAUCET STUDIES. ISLAND 2

P.49: HOSPITAL EXTENSION. FAUCET STUDIES. ISLAND 2

I was captivated by the lyrical quality of two faucets, each breathing with its own life. One faucet was frontal in attitude, the other was shy. The shy faucet on the left emerged in a hesitant way, while the bold one on the right was a study in contrast: green lichen on a black steel pipe from a century ago.

P.50: HOSPITAL EXTENSION. OPERATING ROOM. ISLAND 2

This operating room was the only place on the island imbued with natural light, and it suffered some of the most severe damage. I could hear the wind blowing. I heard footsteps approaching. Three separate times I felt the presence of someone standing in the doorway, watching. After the third time, I was uneasy and asked my assistant if he had felt someone's presence. Three times, he said.

P.52: ADMINISTRATION BUILDING. ROOM WITH VINES. ISLAND 3

It is the third floor, yet there are vines growing on the floor. As foliage pushes down from the roof, there is a weightlessness. Clumps of plaster have survived some great implosion. It's as if something is trying to dig itself out.

P.54: ISOLATION WARD. EVEREADY BATTERIES. ISLAND 3

It's an ancient Eveready battery wired to a meter. What could it have measured? Some suggest it was used for electroshock therapy. The first shock treatments ever administered on U.S. shores took place on Ellis Island. Perhaps it was an antique form of hydrotherapy. Green vines blocked the light here, casting a green glow. I went back three times. The final picture was taken in autumn, when the vines had turned yellow, and the Eveready was bathed in a warm glow.

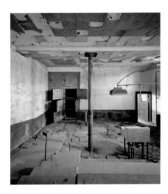

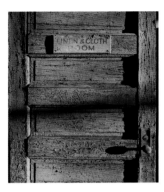

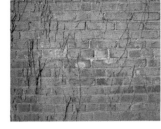

P.55: MAIN HOSPITAL.
MORGUE. ISLAND 3

It was the coldest room on the Island. The light always seemed blue, no matter what time of day. After patients died, some were brought to the morgue for autopsy. It also served as an observation room for medical students and for doctors studying infectious diseases. The week I made this photograph, I revisited the area several times. I noticed that the doors of the compartments that housed dead bodies, varied from day to day, from being open to shut. It was as if someone were playing some sort of child's game.

P.56: LINEN ROOM AND
POWERHOUSE. DOOR
STUDIES. ISLAND 3

It happened repeatedly: the sun would stream in through one particular crack in a room at only one particular moment each day, and there I found myself with my camera at that precise moment. I was struck by the weight and the craftsmanship, and the soft north light making changing patterns upon a canvas of pitted rust.

P.57: LINEN ROOM AND
POWERHOUSE. DOOR
STUDIES. ISLAND 3

P.58: WHITE TILE STUDY.
OPERATING ROOM. ISLAND 2

P.59: MEASLES WARD.
BRICK STUDY. ISLAND 3

Two ordinary brick walls, yet two extraordinary visual experiments. One exterior, one interior. Both are flat surfaces with a fascinating sequence of layers. I was captivated by the patina of history and nature on terracotta, the strange growth of vines, the Rorschach test: it is red, then green, then red again. Every brick has a different history.

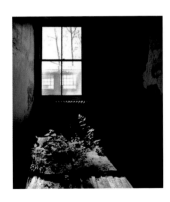

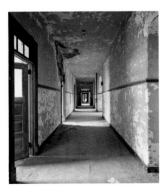

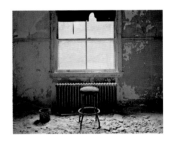

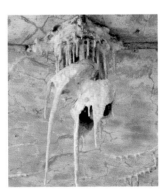

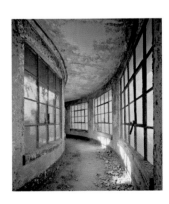

P.61: MEASLES WARD.
HALLWAY STUDY WITH
PLANT LIFE. ISLAND 3

Suddenly, life has been seeded into the floor. Water and degradation have turned the oak flooring in a hallway into a deciduous forest. This is one of the later photographs, taken after the restoration of the island had begun, yet life is continuing to stake its claim to architecture. Sunlight streams in, a triangulation of light appears on the floor, and a ghostly image of Corridor 9 haunts the window.

P.62: PSYCHIATRIC
HOSPITAL. GREEN HALLWAY.
ISLAND 2

This is pure space that goes on and on, doorways to deeper spaces, very layered. There is no place to land. It is like a submarine with various doors and compartments to flee into in case one area is flooded. The ceilings and floor were almost gone. This was perhaps the most hazardous area of the hospital to photograph. But something in the depth and patina of the walls compelled me to document it, along with the eerie green paint.

P.63: HOSPITAL
EXTENSION. BAR STOOL.
ISLAND 2

The paint and the plaster had been crashing down, and they were pulverized to a beautiful powder and patina on the floor. It felt like a sandy beach, created for the enjoyment of a stool and a paint bucket. The room took on the self-contained weight of a terrarium, which I looked through toward the window and the stirrings of life beyond, cloudy and mysterious, in the shapes of trees.

P.65: CEILING LIGHT
FIXTURE. DETAIL. ISLAND 3

A strange beauty is born from the disintegration of a building, and stalactites are spun from the transformation of plaster and concrete. As the structure is eaten away, the water drips and drips. Minerals come swirling down around this light fixture, and a new organic form is created. But the original light bulb remains.

P.67: ISOLATION WARD.
CURVED CORRIDOR. ISLAND 3

This corridor meanders from the hospital to the measles ward. When I photographed it on an autumn day, light dappled through the windows and gave the impression I was viewing something under water. Behind each wall of glass, it seemed, was water instead of air. An odd gravity rules the corridor. It is curved to impede the march of bacteria. But what is the top and what is the bottom? There is confusion, and an eeriness of blue.

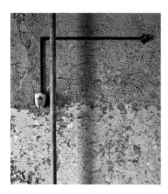

P.68: ISOLATION WARD, WALL STUDY WITH PIPES, ISLAND 3

Even the minutest object on the island was charged with power. I studied this wall detail as if it were a Mondrian composed of shadow, metal conduit and pipe. A north light washed down the wall, accentuating its skin-like texture. The lead paint had decayed with such a weight and density that when it peeled and fractured, it shattered into mosaic. I stared at this wall, beautiful in its decay, and remembered those in the isolation ward who stared at it when the walls were new.

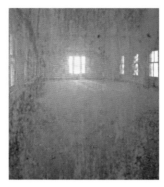

P.69: MEASLES WARD THROUGH WINDOW, ISLAND 3

We see life "through a glass darkly." So says the Bible. This is the ward through a glass darkly. The power of the room is enhanced by viewing it through a surface of ancient painted glass. The chair was illuminated the particular moment I came through, and it seemed to carry a strong human spirit. It was a presence we all felt as we peered through glass at the glow—a haunting glow of life enhanced, not diminished, by the scattering of dead leaves.

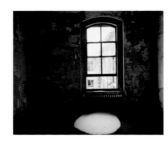
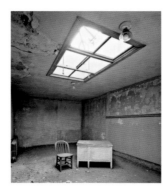

P.71: PSYCHIATRIC HOSPITAL, GREEN ROOM, ISLAND 2

It was an overwhelming tension: the power of color merged with the human energy of history. The arresting depth of color pulled me in like a black hole. Meanwhile, the chair and table emitted an odd energy, as if one was interrogating the other; the authority of the desk, or doctor, was an intimidating force over the chair.

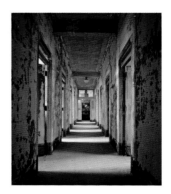

P.72: MEASLES WARD, PUDDLE OF SNOW, ISLAND 3

It is like a dot in an imaginary exclamation point. A soft, tender circle of snow drifting in though an open window, laid gently on the decaying floor of an ancient room.

P.74: ADMINISTRATION BUILDING, HALLWAY, ISLAND 3

They are two hallways, identical in structure yet dramatically different in feeling. In this administrative hallway, there is darkness and a simple vista of strange file cabinets dominating the view.

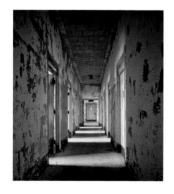

P.75: PSYCHIATRIC WARD, HALLWAY, ISLAND 3

In the ward for psychiatric patients, the energy is different. Miniature ceiling lights and windows are reminders of the patients who were prevented from hurting themselves or others. Something happened on this floor, unknown, which didn't happen on the administrative floor below. It is palpable.

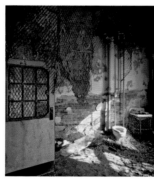

P.77: PSYCHIATRIC HOSPITAL, BRIG, ISLAND 2

Maybe they were violent, or insane, or just frustrated by a strange language; maybe they were victims of pain and exile from home and family. This was the brig that housed the mentally ill. Coincidentally, it is the only room in the entire south side where the metal lath crashed down in this manner, like a metal curtain descending, a second level of imprisonment in metaphoric form.

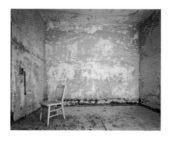

P.79: ISOLATION WARD WITH WHITE CHAIR, ISLAND 3

The light was changing as I set up camera, so I stayed, and as I stayed it got better and better, as if I was being rewarded. At four o'clock, a pattern of sunlight overtook the wall, bursting with a random, chaotic energy. The extraordinary peeling wall of orange and yellow became alive with the sunlight, a Franz Kline-like display of bold strokes. The craziness of the patina and color became a metaphor for what went on here in the psychiatric ward—deepened by the chair, which emitted a strong sense of humanity.

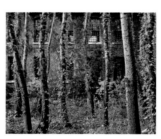

P.80: COURTYARD, FALL STUDY, ISLAND 3

I always admired this stand of trees growing in the courtyard. Each seemed imbued with a human spirit and an individual identity, and I decided to capture them in the fall, as they changed. They had gone about their lives with a magical spirit and harmony, ignoring the human world. But they overtook the foundation, so when the renovations began they were clear-cut in order to save the structure. They don't exist anymore. A small victory for man against nature, which saddened me.

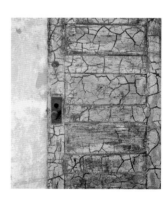

P.82: MEASLES WARD, SHATTERED DOOR STUDY, ISLAND 3

It is as if a photograph were printed on glass and then cracked. The fractured patina that overtook this physical structure created a metaphor for the lives shattered by this place. Everything is connected in a capillary system of decay.

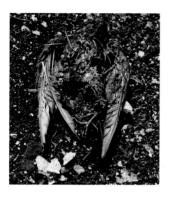 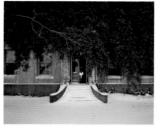 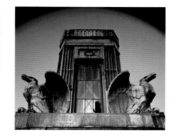 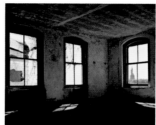 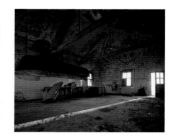

P.83: HOSPITAL EXTENSION. OPERATING ROOM. PIGEON STUDY. ISLAND 2

The bird had disappeared. Only the bones and feathers remained. It seemed a religious relic lying in the crisp light of the operating room, where the skylight once provided doctors with natural lighting for their procedures. The pigeon is gone, and an angelic duality remains. It is solid yet transparent. It is life and it is dirt at the same time.

P.84: ADMINISTRATION BUILDING. SNOW-COVERED ENTRANCE. ISLAND 3

It was an entrance to nowhere. Of all the exteriors on the island, it was the most eerie. It could have been the entrance to an Ivy League college, except you felt that if you entered you would never return. In the strangulation of architecture by vines, something is happening. Nature has tipped the balance. I felt that there was a closure coming, coming very quickly. The entrance to nowhere was about to disappear forever.

P.87: FERRY BUILDING. ROOF STUDY WITH EAGLES. ISLAND 2

Where were the rats and the rodents? Why was nothing living in the wrack and ruin of the island? It defied logic. I found my answer. It lay in bones scattered on the roof of the ferry building. A white barn owl inhabited the deco skylight of the roof, a bold, efficient and relentless predator. He ravaged his prey among the lead eagles here who themselves watched over the comings and goings of Ellis Island.

P.88: ISOLATION WARD. STATUE OF LIBERTY. ISLAND 3

Once patients spent their time in this recreation room, reading, sitting and staring out at the Statue of Liberty, the icon of freedom a stone's throw from this hospital where their dreams were put on hold.

P.90: IMMIGRANT HOSPITAL COMPLEX. MAIN KITCHEN. ISLAND 3

Where did it all go? A vast institutional kitchen is now a cavernous void, suffused with a warm glow. A streak of sunlight violently bisected the floor when I arrived, drawing the eye across the room and encouraging the question. This is another image in which light became the "narrative" part of the moment.

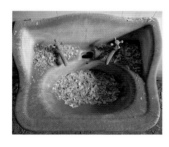 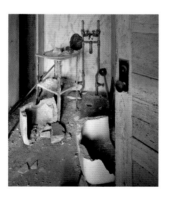 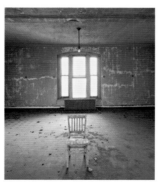 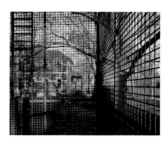 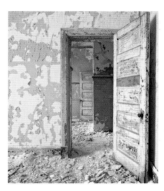

P.92: PSYCHIATRIC HOSPITAL. BRIG. SINK STUDY. ISLAND 2

A simple visual study. I was captivated by the contrast between the sink and the paint collected in it: the brown dirt of an abandoned sink against the lightness of the fallen paint.

P.93: ADMINISTRATION BUILDING. SHATTERED BATHROOM STUDY. ISLAND 3

A sculpture of chaos, and one of the darkest and most bizarre and violent scenes I encountered. A random collage of brooms, shattered toilet bowl and medical table sit beneath a residue of white powder. All the while, a beautiful marble wall lurks behind.

P.95: MEASLES WARD. LONE CHAIR AND WINDOW. ISLAND 3

It was a room viewed through a glass darkly. Then I came back a few years later and pushed open the door. I felt the humanity in the room greeting me; it was like a parent who had been waiting up for a child. I turned to my assistant and asked, "Did you feel that energy?" I've never felt so emotionally moved to revisit a picture.

P.96: PSYCHIATRIC HOSPITAL. DETENTION CAGE. ISLAND 2

To stare at freedom through a steel cage. This was a place of detention, a double imprisonment for those so near yet still so far from America. I wanted to experience this cage from the perspective of those who stood here. They were those with behavioral problems, the mentally ill, or simply those who spoke an unrecognizable language.

P.99: PSYCHIATRIC HOSPITAL. BLUE ROOM. ISLAND 2

It wasn't the energy of the room that captivated me. It was the blue. The blue that grew lighter in the foreground and deeper in the distance. That, and the mysteries of the geometry of this room. What is through those doors? And why were the rooms of the psychiatric hospital painted this color?

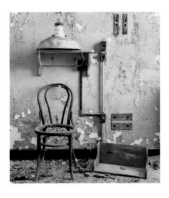

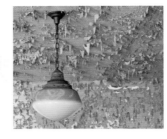

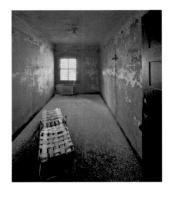

P.101: PSYCHIATRIC HOSPITAL. "ELECTRIC CHAIR." ISLAND 2

It's an old lamp on a shelf. It's a rotten chair with no place left to sit. It's an ancient electrical box. But I saw an electric chair. I saw the lamp as an apparatus being lowered onto someone's head. I saw a confluence of random inanimate objects emanating their own presence and gestures and forming a pattern suddenly—an electric chair, after which you can't see anything else.

P.102: NURSES' QUARTERS. TWIN SINK STUDY. ISLAND 3

It is like a ship disintegrating at sea, and only the sails remain. These two sinks live on in their purity of whiteness, in their original pristine glow, surrounded by a theater of decay. I felt like a voyeur looking into the cockeyed mirror of a bathroom where nurses looked at themselves a century ago. I liked looking into the mirror and seeing it as a window to something, though uncertain of what.

P.104: ISOLATION WARD. CEILING FIXTURE DETAIL. ISLAND 3

An amazing contrast of filth and cleanliness. The water that brought down an entire building left the bottom of this light fixture sparkling like new.

P.106: PSYCHIATRIC HOSPITAL. WALL STUDY WITH LIGHT SWITCH. ISLAND 2

Patina becomes a metaphor. The extraordinary peelings of the periwinkle blue become a topographic map, a kind of ancient chart of the sea in which the explorers who studied it all found themselves at Ellis Island. I was mesmerized by the levels of white beneath the blue and the undertones of gold and yellow. At the moment of photography, light struck from over my shoulder, and the various shades of blue are actually elements of light. You lose yourself in the map, and then, suddenly, you come upon the light switch.

P.109: NURSES' QUARTERS. LAWN CHAIR. ISLAND 3

I was awestruck when I opened a door in the nurses' quarters and found a nylon lounge chair. It is a mystery, the only modern piece of furniture on the island. Clearly, someone lay down in it here, and, like many chairs I discovered, it exuded a powerful human presence. I've heard about people who came here on their own and wandered through the forgotten side of Ellis Island; by the evidence of this chair, some came prepared.

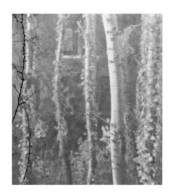

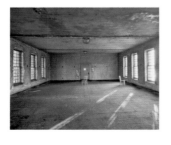

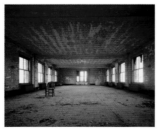

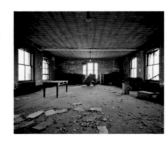

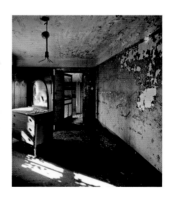

P.111: ISOLATION WARD. FALL COURTYARD THROUGH WINDOW. ISLAND 3

I looked out onto the courtyard and was captivated by two perspectives: the soft trees outside, and the vines growing on the outer edge of the window. Sunlight was backlighting and sidelighting the trees, and they became what they were so long ago for the patients staring idly out the window: a lyrical daydream of trees in autumn.

P.112: MEASLES WARD. TWO CHAIRS. ISLAND 3

In this psychiatric ward, the chairs have a human presence. They are like a married couple no longer talking, and the tension is heightened by the amazing streaks of light on the floor. The sunlight reanimates the room and heightens the tension between these chairs in need of counseling.

P.114: MEASLES WARD. RED SUNSET. ISLAND 3

This is a study of red light. A wide, expansive ward taking a warm magenta bath in the late afternoon sun. The reddish warmth of the light transforms the emotional atmosphere so that even the lone chair appears confident rather than desolate. The power of the ceiling pulls you through the room, the vertical lines all heading for the vanishing point, and the window with the tiny remains of a shade.

P.116: PATIENT WARD WITH LIGHT ON TABLE. ISLAND 3

The room is dark and monochromatic, and then there's a shaft of light. A single beam illuminates the desk, a message from somewhere of a human presence still remaining long after life has fled the island. It couldn't be luck. With this picture, I came to recognize that I was being handed things. The swaths of paint falling to leave hieroglyphics on the wall offer a fascinating study. But it is that ray of light, falling in a single beam upon the desk the instant I showed up—this is the message of the photograph, perhaps of this book.

P.119: ADMINISTRATION BUILDING. DRESSER AND MIRROR. ISLAND 3

I walked into this room only to be hit with an energy so intense, so negative, that I couldn't take a picture. I had to walk away. The dresser didn't feel like a dresser. It felt like an old man sitting on a stool, crouched over. I returned a month later and the energy had totally changed. The room felt neutral and I photographed it without inhibition. Of course, the dresser with its shattered mirror is what makes the picture. It is the element of humanity that, when captured, opens a link to the human spirit.

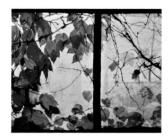 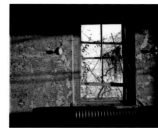 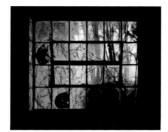 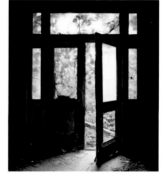

P.120: CORRIDOR 9.
FALL STUDY THROUGH
WINDOW. ISLAND 3

So many things had to come
together in one instant to turn
these ruins into a romance of
sheer beauty. It is a filthy window.
The vines may be on their way
to shattering the glass. They may
even be poison ivy. In any other
light, the story would be different.
But in a perfect balance between
inside and outside, a unique slant
of light, it is suddenly beautiful.
It is stained glass. There are even
leaves in the shape of hearts.

P.122: ISOLATION WARD.
RECREATION ROOM.
WINDOW STUDY. ISLAND 3

The last thirty seconds of sunlight
transform the structure. Walls
are painted a potent orange. The
radiator explodes into a dazzling
pattern. Calm, soft water appears
through the window, an amazing
contrast to the red-lit room.
Vines punch through the
window. They seem to push the
window upward yet hold it in
place at the same time. Outside
and inside connect in some
strange way.

P.124: CORRIDOR 9.
WINDOW STUDY.
SUNSET. ISLAND 3

I had seconds to work. The sun
was setting in autumn, half the
picture was cool and half was
warm, and I captured on film
that fleeting moment between
day and night. So many parts, so
many shapes, each individual
windowpane its own universe.
In the dying light of autumn, I
captured the passage of time.

P.127: CORRIDOR 9.
DOORWAY. ISLAND 3

It is a doorway to a jungle. And
it is the end of the story. Of all
the images I captured here on
Ellis island, none so epitomizes
nature's triumph. I felt that had
I walked through this door, I
might never have been heard
from again. Is nature being
invited in here, or are we being
invited out? The fact is, nature is
wild and heavy and thick and
mystical, and with the renovation
it will never look this way again.
This is a magical moment to
which I bore witness, and in my
mind the room will always
remain this way.

TECHNICAL INFORMATION

All the pictures in this book were photographed using a 4 × 5 inch view camera. I used no artificial light or digital
enhancement. In tribute to all the great photographers who journeyed to Ellis Island before me, I used only the tools
they did: a camera, lenses, film . . . and light.

ACKNOWLEDGMENTS

Many people accompanied me on my journey through Ellis Island. I'll always be grateful for their contributions to this project of a lifetime.

Bob Ciano, who through an editorial assignment brought Ellis Island into my life.

Mark Weber, New York Landmark Conservancy, who gave me the opportunity to develop this project, and record history.

Kathy Ryan, director of photography, *The New York Times Magazine*, for recognizing the importance of this work early on.

Richard Wells, National Park Service, whose expertise of the south side proved to be invaluable.

Cynthia Garrett, National Park Service, for all her support.

Les Meyers and David Kelly, my assistants, who shared the joys and the challenges of photographing on the Island.

Judy Mcalpin, Janice Callela, and Dorthy Hartman, Save Ellis Island Foundation. Thank you for your support.

Janet Levine, oral historian, Ellis Island.

Dr. Fred Regan, former head of the psychiatric hospital on Ellis Island. Thank you for being my living historian.

Richard Jackson, my color printer, for your friendship and the mastery of your craft. You've helped me bring this work to life.

Paul Wolfe, for your friendship and your poetic way of spinning my words into gold.

Greg Samata, for your friendship and genius. Your design has created the book of my dreams.

Beth May, for your patience and hard work in helping design this book.

Morgen Van Vorst, my editor at W. W. Norton, whose impeccable taste and instinct were invaluable. Thank you for all your support and your willingness to go the extra yard.

John Campbell, my friend and literary agent, for believing in this project and making it a reality. You have been my guiding light along this journey.

Howard Bernstein, my agent, for always having a unique pulse and insight into my work.

Sid and Michelle Monroe at The Monroe Gallery for their constant support and intensive work on my behalf.

David Barenholtz of Apex Fine Art Gallery for his creativity and belief in my work.

My parents and family for instilling in me the importance of history, especially my mother who immigrated from Vienna, and whose own journey has always been my inspiration.

All my friends, colleagues, and assistants, who supported my enthusiasm and creative passion throughout this project.

My wife, Bette, for her love and support. You are my toughest critic, greatest ally, and best friend. I love you for always bringing out the best in me.

"Fear gripped me . . .": Eftafi Kotsaqis, author interview.

"I was alone . . .": Eftafi Kotsaqis, author interview.

"The nurses were there . . .": Elizabeth Martin, immigrated in 1920. Quoted in Martin W. Sandler, *Island of Hope: The Story of Ellis Island and the Journey to America* (New York: Scholastic Nonfiction, 2004).

"I didn't do anything . . .": Edward Cholakian, emigrated from Armenia in 1920, aged thirteen (trachoma). Oral History Library, Ellis Island.

"This was not the America . . .": Thomas Allen, emigrated from Scotland in 1927, aged nine (chicken pox). Oral History Library, Ellis Island.

"Nobody said a word . . .": Angelina Palmiero, emigrated from Sicily in 1923, aged ten (throat problems). Quoted in Peter M. Coan, *Ellis Island Interviews: In Their Own Words*.

"I recall one fellow . . .": Dr. John Thrill, doctor on Ellis Island 1924–25. Oral History Library, Ellis Island.

"The first doctor called over . . .": Karen Hesse, *Letters from Rifka* (New York: Henry Holt & Company, 1992).

"The leaves change color . . .": Karen Hesse, *Letters from Rifka*.

"Ellis Island is a line . . .": Karen Hesse, *Letters from Rifka*.

Apex Fine Art
Mr. David Barenholtz, Director
152 N. LaBrea Avenue
Los Angeles, CA 90036
Tel. 323.634.7887
Fax. 323.634.7885

apexart@pacbell.net
www.apexfineart.com

Monroe Gallery
Mr. Sid Monroe, Director
112 Don Gaspar
Sante Fe, NM 87501
Tel. 505.992.0800
Fax. 505.992.0810

info@monroegallery.com
www.monroegallery.com

EXHIBITIONS

2000
America in Detail, Chicago, New York, San Francisco, Los Angeles

2001
Ellis Island, Soho Triad Fine Arts, New York, New York

2003
Ellis Island Apex Fine Art, Los Angeles, California
New Works, Soho Triad Fine Arts, New York, New York

2004
Bethlehem Steel, Apex Fine Art, Los Angeles, California
Ellis Island, Monroe Gallery of Photography, Santa Fe, New Mexico

2005
Bethlehem Steel, Monroe Gallery of Photography, Santa Fe, New Mexico

2006
Ellis Island Revisited, Monroe Gallery of Photography, Santa Fe, New Mexico
Ellis Island Revisited, Apex Fine Art, Los Angeles, California

The hospital buildings on Ellis Island's south side, untouched since the island facility closed in 1954, will come to life again in the coming years, completing Ellis Island's story as a major gateway to America, and as a place where ill and infirm immigrants were examined and treated in the largest U.S. Public Health Service hospital in the country.

Save Ellis Island, Inc. is a partner to the National Park Service for not-for-profit fundraising and programming to preserve and reuse the remaining thirty buildings on Ellis Island. The now stabilized hospital buildings were hidden and enshrouded in vegetation only a few years ago. In his photographs, Stephen Wilkes has brilliantly captured the plight of these structures prior to restoration. Stabilization has stopped further deterioration while the buildings await restoration efforts.

We welcome your support in the restoration of historically important buildings for this and future generations, and we welcome you to become a member of Save Ellis Island by visiting our Web site at www.saveellisisland.org or contacting us at:

Save Ellis Island, Inc.
268 Main St.
P.O. Box 571
Gladstone, NJ 07934
908-781-9900

Borkhardt, Henry
Harris, Barney
Hennig, August
Holway, Charles
Asquith, Harold
Lyon, James
Maisel, Louis
Maisel, Sophia
Pickford, Helen
Pitzel, Samuel
Luiz, Rufino
Schonthal, Lee
Schonthal, Irma
Vic, Charles
Banzhaff, Albert
Byrnes, Edward
Carr, Susan
Goadby, William
Goadby, Elsie
Eaton, Francis
Eaton, Harriett
Gibson, Ora
Hunt, William
Johnson, Aymar
Markham, Maud
Roth, Mary
Serrao, Amerigo
Devitt, James M
Devitt, Bridget
Cuun, Mary M
Laughlin, Philip M
Laughlin, Mary
Doherty, Joseph
Sheils, Mary
Laughlin, Rose Ann
Laughlin, Sarah
Laughlin, Annie
Laughlin, Pat'k
Houton, Michael
Ferry, Charles
Sieyes, Bridget
Johnston, Fannie
Caul, Francis M
Robb, Joseph
Conway, Wm
Havin, Patrick
Hart, Honor
Kelly, Hugh
Mc Carthy, Alexander
Mc Quade, Annie
Faulkner, Charles
Moody, Arthur J.
Moody, Eliza
Carrigan, Annie
Giblin, John
Smyth, Patrick
Rodway, Sophia
Rodway, Ralph
Rodway, Marie
Doyle, Teresa
Higgins, Michael
Woodward, Chas.
Smith, Frank
Smith, Mary Ann
Smith, Mary
Gragg, Stewart
Smith, Harold
Evans, Louis
Evans, Polly
Evans, George
Dougherty, Marg't
Dougherty, Jennie
Jones, Evan
Jones, Harriet Celia
Jones, Sallie
Henaghan, Michael
Baldwin, Harry
Baldwin, Samuel John
Crawford, Thomas
Crawford, William
Robert
Brady, Mary
Hayes, Robert
Nolan, James
Billgren, Katherina
Brennan, Patrick
Reilly, John
Hollywood, Peter
Wilkes, Albert Edward
Judge, Edward
Cussane, Michael
Dolan, Patrick
Rogers, Margaret
Hunt, Walter
Flanagan, Paddie
McNally, Michael
Shecter, Jessie
Rostron, James
McKeown, Rebecca
McKeown, Vincent
Zaltzman, Brandel
Zaltzman, Scheindel
Zaltzman, Simon
Zucker, Elka
Zucker, Sloima
Zucker, Sura
Zucker, Alter
Spring, Hersch
Spring, Basha
Spring, Clara
Spring, Elka
Spring, Sloma
Goldstein, Blima
Goldstein, Yetta
Goldstein, Baile
Goldstein, Mary
Goldstein, Morris
Goldstein, Kiwe
Goldstein, Rivika
Uhrmacher, Laja
Uhrmacher, Hinde
Uhrmacher, Chiel
Silver, Sara
Silver, Herzil
Silver, Nuta

Feldbrill, Nathan
Spigel, Chaja
Jablonsky, Golda
Nazario, Scanzano
Damico, Nicola
Damico, Michele
Bertolotti, Giuseppe
Monti, Rafaelle
Valente, Domenico
Pascale, Giovanni
Rocca, Antonio
Rotella, Giuseppe
Gassat, Felix
Grall, Luillansue
Yoffe, Eisik
Le Lams, Jean
Metzler, Nikolaus
Antoniak, Michele
Kenzink, Adam
Kosik, Jean
Raghide, Giuseppe
Fossa, Giambatisto
Muller, Louis
Kohler, Joseph
Frederick, Albert
Cerny, Franz
Ortelli, Gerolamo
Conodaks, Antoni
Marics, Ysioko
Palfi, Rudolf
Papp, Yanos
Gaal, Istran
Erlik, Ferencz
Villares, Guilherme
Villares, Maria L.
Lopes, Adelio
Lopes, Mary S.
Campbell, John Reid
Campbell, Helen
Campbell, Jean
McKnight
Cirne, John J.
Fernandez, Victor
Fernandez, Inocencia
Fernandez, Matilde
Fernandez, Noemia
Fernandez, Ermelindo
Creed, Frank O.
Diaz Gomez, Angel
Moreira, Thiers V.
Menezes, Rodrigo
Vaz, Paulo R.
Scalabrini, Lino
Casasanta, Donato
Presutto, Antonio
Petrillo, Vincenzo
Gizi, Vincenzo
Leombrumo, Luigi
Pronuto, Costanzo
Prizzo, Pietro
Curto, Saverio
Totera, Rosina
Barbetta, Nicola
Gallo, Santo
Gallo, Carmine
Pane, Gaetano
Tallarico, Giovanni
Coppola, Domenico
Aliberti, Michele
Mancino, Salvatore
Giugliano, Aristide
Longobardi, Casello
Tortora, Aniello
Berardi, Gaetano
Muccilla, Sabatino
Imbrogno, Pasquale
Chirico, Francesco
Testa, Ferdinando
d'Angela, Guiseppe
Bentivegna, Vincenzo
Spagnoli, Antonio
Spagnoli, Giustino
Buenasorti, Gennaro
Argentieri, Francesco
Plant, Eugene
Shields, William
Earley, Roy
Lipton, Thomas
Young, Louis
Stephenson, Milton
O'Malley, John
Knudsen, David
Byrne, Thomas
Schofield, James
Roberts, Walter
Ingham, Frederick
Russell, John
Blackman, Thomas
Clarke, Arthur
Sheppard, Stanley
Kennedy, David
McCourt, James
Jones, Sydney
Cash, Frederick
Sanquist, Robert
Oliver, Joseph
Rice, Jack
Magliola, Salvatore
Frick, Louis
Walham, Ernest
Fendler, George
Kaliris, John
Karadimitris, Kleanthis
Loidis, Kosntantinos
Naoumis, Stefanos
Koutsoubelis, Georgios
Eleftheriou, Eragelos
Nikolaou, Hristos
Konstantinou, Ilias
Larolas, Nikolaos
Kaskaralas, Dimitrios
Matsikas, Mihail
Giantjos, Panagiotis
Liberis, Anastasios
Filitsis, Vasilios
Silver, Sara
Silver, Herzil
Silver, Nuta

Liakis, George
Molalis, Dimitrios
Saralakis, Efstratios
Keravas, Panagiotis
Athanasiou, Manolis
Daout, Boutros
Michael, Ibrahim
Lamari, Salim
Esapar, Mitri
Saghir, Giorgi
Saghir, Ibrahim
Hannout, Hanna
Olson, Martin
Bjorklund, Johannes
Johnson, Otto
Birsus, H.J.
Pedersen, H.
Larsen, Malen
Helland, Ingeborg
Osgud, K.H.
Osgud, G.
Ilsan, Bertha
Bjorklund, Ellen
Berhlsen, Martin
Berhlsen, Karen
Berhlsen, Chs. J.
Ludvigsen, S.L.
Olsen, Emilia
Olsen, Ch. O.
Olsen, Ch. A.
Helland, S.
Helland, Krisi
Helland, Edward
Helland, Mikal
Helland, Karine
Helland, S.
Helland, Josefine
Helland, Lina
Olsen, Jens
Fenson, T.
Hangen, B.
Hangen, Eli
Hangen, Al...t
Gosling, H.
Ogola, Frans M.
Kason, A.
Sikta, Mikael
Svensk, Samuel
Ylikokka, Yakks
Makki, Isak
Nikkola, Frans
Kalega, Ida
Gasse, Joh
Anderson, Kaisa
Long, Johannes
Fillpus, Johan
Sundell, Johan
Holmlund, Jakob
Nass, Johan M.
Hoglund, Matts
Kass, J.H.
Beck, Gustaf
Jakobson, Simon
Napnan, Anders M.
Blank, Karl J.
Drinker, Gysber
Dame, Gertrude
Dame, Jessie
den Rooyen, Johannes
Aarts, Peter M.
Spoelstra, Wintje
Spoelstra, Hilda
Spoelstra, Jan
Spoelstra, Jennie
Spoelstra, Martha
Spoelstra, Janna A.
Tahedl, Johanna
Koch, Anna
Koch, Rudolf
Stejskal, Christina
Legenstein, Josef
Legenstein, Franz
Kotrosits, Nikolaus
Honicka, Frantiska
Korinek, Katerina
Friedman, Elias
Belemer, Jakob J.
Judelewsky, Josel
Judelewsky, Sora
Sweers, Agnes
Herzer, Pauline
Brener, Kaethi
Parrott, L.
Parrott, Cl.
Parrott, Daisy
Barber, A.
Kelbel, F.
Morris, C.
Morris, Mrs.
Claudins, C.
Steiner, Jacob
Fich, Jacob
Miller, W.S.
Miller, Mrs.
Steinhardt, C.C.
Oliver, Joseph
Rice, Jack
Magliola, Salvatore
Frick, Louis
Walham, Ernest
Fendler, George
Kaliris, John
Kondziola, Anna
Kondziola, Karol
Kondziola, Max
Kondziola, Dominik
Kondziola, Valeria
Kondziola, Heinrich
Konkal, Miloslaw
Konkal, Yulie
Auchli, Alois
Yosefson, Leon
Yosefson, Liza
Yosefson, Lisela
Yosefson, Hermann
Yosefson, Yacques
Nachbur, Urs
Nachbur, Albertina
Nachbur, Bertha
Nachbur, Marie
Nachbur, Paul

Hasck, Emile
De Busscher, Leonie
De Busscher, Rene
Hrzyglud, Yosef
Yudowicz, Leie
Yudowicz, Leib
Czisla, Wladislawa
Balachowski, Reise
Balachowski, Putie
Rutkowska, Marianna
Jacob Landau
Sarah Landau
Raoul Landau
Sara Berson
Morris Wilks
Ruth Landau
Abraham Tarendash
Mayer Flasker
Betty Frauendienst
Samuel Weinfeld
Hannah Rykovetzsky
Rachel Smigelsky
Rose Schwadron
Allen, Louis
Baker, Adelbert
Borkhardt, Henry
Harris, Barney
Hennig, August
Holway, Charles
Jaquith, Harold
Lyon, James
Lyon, Elinor
Maisel, Louis
Maisel, Sophia
Pickford, Helen
Pitzel, Samuel
Ruiz, Rufino
Schonthal, Lee
Schonthal, Irma
Vic, Charles
Banzhaff, Albert
Byrnes, Edward
Carr, Susan
Goadby, William
Goadby, Elsie
Eaton, Francis
Eaton, Harriett
Gibson, Ora
Hunt, William
Johnson, Aymar
Markham, Maud
Roth, Mary
Serrao, Amerigo
Devitt, James M
Devitt, Bridget
Cuun, Mary M
Laughlin, Philip M
Laughlin, Mary
Doherty, Joseph
Sheils, Mary
Laughlin, Rose Ann
Laughlin, Sarah
Laughlin, Annie
Laughlin, Pat'k
Houton, Michael
Ferry, Charles
Sieyes, Bridget
Johnston, Fannie
Caul, Francis M
Robb, Joseph
Conway, Wm
Havin, Patrick
Hart, Honor
Kelly, Hugh
Mc Carthy, Alexander
Mc Quade, Annie
Faulkner, Charles
Moody, Arthur J.
Moody, Eliza
Carrigan, Annie
Giblin, John
Smyth, Patrick
Rodway, Sophia
Rodway, Ralph
Rodway, Marie
Doyle, Teresa
Higgins, Michael
Woodward, Chas.
Smith, Frank
Smith, Mary Ann
Smith, Mary
Gragg, Stewart
Smith, Harold
Evans, Louis
Evans, Polly
Evans, George
Dougherty, Marg't
Dougherty, Jennie
Jones, Evan
Jones, Harriet Celia
Jones, Sallie
Henaghan, Michael
Baldwin, Harry
Baldwin, Samuel John
Crawford, Thomas
Crawford, William
Robert
Brady, Mary
Hayes, Robert
Nolan, James
Billgren, Katherina
Brennan, Patrick
Reilly, John
Hollywood, Peter
Wilkes, Albert Edward
Judge, Edward
Cussane, Michael
Dolan, Patrick
Rogers, Margaret
Hunt, Walter
Flanagan, Paddie
McNally, Michael
Shecter, Jessie
Rostron, James
McKeown, Rebecca
McKeown, Vincent
Zaltzman, Brandel

Steinhardt, Mrs.
Hahn, Y.W.
Claudins, C.A.
Peschard, Ch.
Lautrec, Toulouse
Kondziola, Anna
Fendler, George
Kaliris, John
Karadimitris, Kleanthis
Loidis, Kosntantinos
Naoumis, Stefanos
Koutsoubelis, Georgios
Eleftheriou, Eragelos
Nikolaou, Hristos
Konstantinou, Ilias
Larolas, Nikolaos
Kaskaralas, Dimitrios
Matsikas, Mihail
Giantjos, Panagiotis
Liberis, Anastasios
Filitsis, Vasilios
Vlahopulos, Pantelis
Nicoloudakis, Vasilios
Mihailidis, Emanouil
Hatzialexiou, John
Liakis, George
Molalis, Dimitrios
Saralakis, Efstratios
Keravas, Panagiotis
Athanasiou, Manolis
Daout, Boutros
Michael, Ibrahim
Lamari, Salim
Esapar, Mitri
Saghir, Giorgi
Saghir, Ibrahim
Hannout, Hanna
Olson, Martin
Bjorklund, Johannes
Johnson, Otto
Birsus, H.J.
Pedersen, H.
Larsen, Malen
Helland, Ingeborg
Osgud, K.H.
Osgud, G.
Ilsan, Bertha
Bjorklund, Ellen
Berhlsen, Martin
Berhlsen, Karen
Berhlsen, Chs. J.
Ludvigsen, S.L.
Olsen, Emilia
Olsen, Ch. O.
Olsen, Ch. A.
Helland, S.
Helland, Krisi
Helland, Edward
Helland, Mikal
Helland, Karine
Helland, S.
Helland, Josefine
Helland, Lina
Olsen, Jens
Fenson, T.
Hangen, B.
Hangen, Eli
Hangen, Al...t
Gosling, H.
Ogola, Frans M.
Kason, A.
Sikta, Mikael
Svensk, Samuel
Ylikokka, Yakks
Makki, Isak
Nikkola, Frans
Kalega, Ida
Gasse, Joh
Anderson, Kaisa
Long, Johannes
Fillpus, Johan
Sundell, Johan
Holmlund, Jakob
Nass, Johan M.
Hoglund, Matts
Kass, J.H.
Beck, Gustaf
Jakobson, Simon
Napnan, Anders M.
Blank, Karl J.
Drinker, Gysber
Dame, Gertrude
Dame, Jessie
den Rooyen, Johannes
Aarts, Peter M.
Spoelstra, Wintje
Spoelstra, Hilda
Spoelstra, Jan
Spoelstra, Jennie
Spoelstra, Martha
Spoelstra, Janna A.
Tahedl, Johanna
Koch, Anna
Koch, Rudolf
Stejskal, Christina
Legenstein, Josef
Legenstein, Franz
Kotrosits, Nikolaus
Honicka, Frantiska
Korinek, Katerina
Friedman, Elias
Belemer, Jakob J.
Judelewsky, Josel
Judelewsky, Sora
Sweers, Agnes
Herzer, Pauline
Brener, Kaethi
Parrott, L.
Parrott, Cl.
Parrott, Daisy
Barber, A.
Kelbel, F.
Morris, C.
Morris, Mrs.
Claudins, C.
Steiner, Jacob
Fich, Jacob
Miller, W.S.

Crawford, William
Robert
Brady, Mary
Hayes, Robert
Nolan, James
Billgren, Katherina
Brennan, Patrick
Reilly, John
Hollywood, Peter
Wilkes, Albert Edward
Judge, Edward
Cussane, Michael
Dolan, Patrick
Rogers, Margaret
Hunt, Walter
Flanagan, Paddie
McNally, Michael
Shecter, Jessie
Rostron, James
McKeown, Rebecca
McKeown, Vincent
Zaltzman, Brandel
Zaltzman, Scheindel
Zaltzman, Simon
Zucker, Elka
Zucker, Sloima
Zucker, Sura
Zucker, Alter
Spring, Hersch
Spring, Basha
Spring, Clara
Spring, Elka
Spring, Sloma
Goldstein, Blima
Goldstein, Yetta
Goldstein, Baile
Goldstein, Mary
Goldstein, Morris
Goldstein, Kiwe
Goldstein, Rivika
Uhrmacher, Laja
Uhrmacher, Hinde
Uhrmacher, Chiel
Silver, Sara
Silver, Herzil
Silver, Nuta
Silver, Hena
Silver, Feige
Feldbrill, Nathan
Spigel, Chaja
Jablonsky, Golda
Nazario, Scanzano
Damico, Nicola
Damico, Michele
Bertolotti, Giuseppe
Monti, Rafaelle
Valente, Domenico
Pascale, Giovanni
Rocca, Antonio
Rotella, Giuseppe
Gassat, Felix
Grall, Luillansue
Yoffe, Eisik
Le Lams, Jean
Metzler, Nikolaus
Antoniak, Michele
Kenzink, Adam
Kosik, Jean
Raghide, Giuseppe
Fossa, Giambatisto
Muller, Louis
Kohler, Joseph
Frederick, Albert
Cerny, Franz
Ortelli, Gerolamo
Conodaks, Antoni
Marics, Ysioko
Palfi, Rudolf
Papp, Yanos
Gaal, Istran
Erlik, Ferencz
Villares, Guilherme
Villares, Maria L.
Lopes, Adelio
Lopes, Mary S.
Campbell, John Reid
Campbell, Helen
Campbell, Jean
McKnight
Cirne, John J.
Fernandez, Victor
Fernandez, Inocencia
Fernandez, Matilde
Fernandez, Noemia
Fernandez, Ermelindo
Creed, Frank O.
Diaz Gomez, Angel
Moreira, Thiers V.
Menezes, Rodrigo
Vaz, Paulo R.
Scalabrini, Lino
Casasanta, Donato
Presutto, Antonio
Petrillo, Vincenzo
Gizi, Vincenzo
Leombrumo, Luigi
Pronuto, Costanzo
Prizzo, Pietro
Curto, Saverio
Totera, Rosina
Barbetta, Nicola
Gallo, Santo
Gallo, Carmine
Pane, Gaetano
Tallarico, Giovanni
Coppola, Domenico
Aliberti, Michele
Mancino, Salvatore
Giugliano, Aristide
Longobardi, Casello
Tortora, Aniello
Berardi, Gaetano
Muccilla, Sabatino
Imbrogno, Pasquale
Chirico, Francesco
Testa, Ferdinando
d'Angela, Guiseppe

Spagnoli, Antonio
Robert
Brady, Mary
Hayes, Robert
Nolan, James
Billgren, Katherina
Brennan, Patrick
Reilly, John
Hollywood, Peter
Wilkes, Albert Edward
Judge, Edward
Cussane, Michael
Dolan, Patrick
Rogers, Margaret
Byrne, Thomas
Schofield, James
Roberts, Walter
Ingham, Frederick
Russell, John
Blackman, Thomas
Clarke, Arthur
Sheppard, Stanley
Kennedy, David
McCourt, James
Jones, Sydney
Cash, Frederick
Sanquist, Robert
Oliver, Joseph
Rice, Jack
Magliola, Salvatore
Frick, Louis
Walham, Ernest
Fendler, George
Kaliris, John
Karadimitris, Kleanthis
Loidis, Kosntantinos
Naoumis, Stefanos
Koutsoubelis, Georgios
Eleftheriou, Eragelos
Nikolaou, Hristos
Konstantinou, Ilias
Larolas, Nikolaos
Kaskaralas, Dimitrios
Matsikas, Mihail
Giantjos, Panagiotis
Liberis, Anastasios
Filitsis, Vasilios
Vlahopulos, Pantelis
Nicoloudakis, Vasilios
Mihailidis, Emanouil
Hatzialexiou, John
Liakis, George
Molalis, Dimitrios
Saralakis, Efstratios
Keravas, Panagiotis
Athanasiou, Manolis
Daout, Boutros
Michael, Ibrahim
Lamari, Salim
Esapar, Mitri
Saghir, Giorgi
Saghir, Ibrahim
Hannout, Hanna
Olson, Martin
Bjorklund, Johannes
Johnson, Otto
Birsus, H.J.
Pedersen, H.
Larsen, Malen
Helland, Ingeborg
Osgud, K.H.
Osgud, G.
Ilsan, Bertha
Bjorklund, Ellen
Berhlsen, Martin
Berhlsen, Karen
Berhlsen, Chs. J.
Ludvigsen, S.L.
Olsen, Emilia
Olsen, Ch. O.
Olsen, Ch. A.
Helland, S.
Helland, Krisi
Helland, Edward
Helland, Mikal
Helland, Karine
Helland, S.
Helland, Josefine
Helland, Lina
Olsen, Jens
Fenson, T.
Hangen, B.
Hangen, Eli
Hangen, Al...t
Gosling, H.
Ogola, Frans M.
Kason, A.
Sikta, Mikael
Svensk, Samuel
Ylikokka, Yakks
Makki, Isak
Nikkola, Frans
Kalega, Ida
Gasse, Joh
Anderson, Kaisa
Long, Johannes
Fillpus, Johan
Sundell, Johan
Holmlund, Jakob
Nass, Johan M.
Hoglund, Matts
Kass, J.H.
Beck, Gustaf
Jakobson, Simon
Napnan, Anders M.
Blank, Karl J.
Drinker, Gysber
Dame, Gertrude
Dame, Jessie
den Rooyen, Johannes
Aarts, Peter M.
Spoelstra, Wintje
Spoelstra, Hilda
Spoelstra, Jan
Spoelstra, Jennie
Spoelstra, Martha
Spoelstra, Janna A.
Tahedl, Johanna
Koch, Anna
Koch, Rudolf
Stejskal, Christina
Legenstein, Josef
Legenstein, Franz
Kotrosits, Nikolaus
Honicka, Frantiska
Korinek, Katerina
Friedman, Elias
Belemer, Jakob J.
Judelewsky, Josel
Judelewsky, Sora
Sweers, Agnes
Herzer, Pauline
Brener, Kaethi
Parrott, L.
Parrott, Cl.
Parrott, Daisy
Barber, A.
Kelbel, F.
Morris, C.
Morris, Mrs.
Claudins, C.
Steiner, Jacob
Fich, Jacob
Miller, W.S.
Miller, Mrs.

Mgohon, Antonio
Spagnoli, Giustino
Legenstein, Franz
Kotrosits, Nikolaus
Honicka, Frantiska
Korinek, Katerina
Friedman, Elias
Belemer, Jakob J.
Judelewsky, Josel
Judelewsky, Sora
Sweers, Agnes
Herzer, Pauline
Brener, Kaethi
Parrott, Cl.
Parrott, Daisy
Barber, A.
Kelbel, F.
Morris, C.
Morris, Mrs.
Claudins, Mrs.
Claudins, C.
Steiner, Jacob
Fich, Jacob
Miller, W.S.
Miller, Mrs.
Steinhardt, C.C.
Steinhardt, Mrs.
Hahn, Y.W.
Claudins, C.A.
Peschard, Ch.
Lautrec, Toulouse
Kondziola, Anna
Kondziola, Karo
Kondziola, Max
Kondziola, Dom
Kondziola, Valeri
Kondziola, Hein
Konkal, Miloslav
Konkal, Yulie
Auchli, Alois
Yosefson, Leon
Yosefson, Liza
Yosefson, Lisela
Yosefson, Herm
Yosefson, Yacque
Nachbur, Urs
Nachbur, Albert
Nachbur, Bertha
Nachbur, Marie
Nachbur, Paul
Hasck, Emile
De Busscher, Le
De Busscher, Re
Hrzyglud, Yosef
Yudowicz, Leie
Yudowicz, Leib
Czisla, Wladislav
Balachowski, Re
Balachowski, Pu
Rutkowska, Mar
Jacob Landau
Sarah Landau
Raoul Landau
Sara Berson
Morris Wilks
Ruth Landau
Abraham Tarend
Mayer Flasker
Betty Frauendie
Samuel Weinfel
Hannah Rykove
Rachel Smigels
Rose Schwadron
Allen, Louis
Baker, Adelbert
Borkhardt, Hen
Harris, Barney
Hennig, August
Holway, Charle
Jaquith, Harold
Lyon, James
Lyon, Elinor
Maisel, Louis
Maisel, Sophia
Pickford, Helen
Pitzel, Samuel
Ruiz, Rufino
Schonthal, Lee
Schonthal, Irma
Vic, Charles
Banzhaff, Alber
Byrnes, Edward
Carr, Susan
Goadby, William
Goadby, Elsie
Eaton, Francis
Eaton, Harriett
Gibson, Ora
Hunt, William
Johnson, Aymar
Markham, Maud
Roth, Mary
Serrao, Amerigo
Devitt, James M
Devitt, Bridget
Cuun, Mary M
Laughlin, Philip
Laughlin, Mary
Doherty, Joseph
Sheils, Mary
Laughlin, Rose
Laughlin, Sarah
Laughlin, Annie
Laughlin, Pat'k
Houton, Mich.
Ferry, Charles
Sieyes, Bridget
Johnston, Fannie
Caul, Francis M
Robb, Joseph
Conway, Wm
Havin, Patrick
Hart, Honor
Kelly, Hugh
Mc Carthy, Ale
Mc Quade, Ann
Faulkner, Char
Moody, Arthur
Moody, Eliza